Cézanne
and
Poussin:
The Classical Vision
of Landscape

General Accident

Cézanne and Poussin: The Classical Vision of Landscape

Richard Verdi

National Galleries of Scotland
IN ASSOCIATION WITH
Lund Humphries Publishers · London

To my Mother

This catalogue is published to coincide
with the exhibition
Cézanne and Poussin: The Classical Vision of Landscape
held at the National Gallery of Scotland, Edinburgh,
from 9 August to 21 October 1990.

Published by National Galleries of Scotland, Edinburgh,
in association with
Lund Humphries Publishers Ltd
16 Pembridge Road, London W11 3HL

Distributed to the book trade worldwide by
Lund Humphries Publishers Ltd

British Library Cataloguing in Publication Data

Verdi, Richard
Cézanne and Poussin: the classical vision of landscape.
1. French paintings. Cézanne, Paul, 1839–1906
2. French paintings. Poussin, Nicolas, 1594–1665
I. Title II. National Gallery of Scotland
759.4

ISBN 0–85331–569–8

Designed by Cinamon and Kitzinger, London
Typeset by Nene Phototypesetters Ltd, Northampton
Printed by Alna Press Ltd, Broxburn

Contents

Sponsor's Preface

We in General Accident are privileged to be associated with the National Gallery of Scotland in presenting *Cézanne and Poussin: the classical vision of landscape*. Undoubtedly one of the most exciting and ambitious exhibitions to be mounted by the Gallery for many years, it brings together some of the most impressive landscapes ever created.

It also allows us a unique opportunity to enjoy the work of two of France's greatest artists through a careful selection of approximately seventy paintings, drawings and watercolours. The theme is also intriguing, bringing together as it does the works of men separated in date by over two hundred years.

A juxtaposition of the landscapes of Cézanne and Poussin might, at first sight, seem extraordinary. Yet, by uniting the works of the founder of French classicism from the seventeenth century and the master of Post-Impressionism from the end of the nineteenth, we can share in their passionate struggles to create order out of nature and to give their landscapes balance and grandeur, albeit by very different means.

The exhibition explores the relationship between the two artists through loans from collections in Britain, Europe, North and South America and Russia, encompassing masterpieces such as Poussin's great pair of Phocion landscapes (reunited for the first time since 1960) and Cézanne's magnificent *Montagne Sainte-Victoire* from the Metropolitan Museum of Art in New York.

Naturally, as sponsors, we are delighted with the international scope of the exhibition, prompted by our belief that Art has universal appeal, building bridges of understanding between all sections of the community, both on a local and a global level. It is this very essence of international co-operation and understanding that attracted General Accident as sponsors.

We firmly believe that in *Cézanne and Poussin: the classical vision of landscape*, the National Gallery of Scotland is exhibiting a unique collection of paintings which we very much hope you will enjoy.

The Earl of Airlie, KT, GCVO
Chairman
General Accident Fire and Life Assurance Corporation plc

Foreword

With this exhibition we are delighted to celebrate the landscapes of two of France's greatest artists. Although separated in date by two centuries, the affinities between the works of Poussin and Cézanne have been noted by many writers and critics. One of the most fascinating problems in the whole history of art has been the exact meaning of Cézanne's remark that he wished to 're-do Poussin over again according to nature'. Our exhibition, which has been most expertly devised by Professor Richard Verdi of the University of Birmingham, sets out to answer this intriguing question.

I am well aware that in order for such an enterprise to succeed we have needed to borrow very specifically and ambitiously from famous collections around the world. I am deeply grateful to lenders, both institutional and private, who have responded with quite astounding enthusiasm and generosity to our requests.

To our sponsors, General Accident, I extend the sincere thanks of myself and our Board of Trustees for financial support of an order that is unmatched in the Galleries' history. In particular, I thank the Chairman, the Earl of Airlie; the Chief General Manager, W. Nelson Robertson and the Deputy Chief General Manager, Tom Roberts. I am confident that our exhibition justifies the faith they have placed in us.

Cézanne and Poussin has been now three years in the making. Professor Verdi has travelled far and wide in pursuit of the appropriate loans with which to illustrate his chosen theme. Together with Michael Clarke, the Keeper of the National Gallery and organiser of the exhibition, he has laboured long and hard in pursuit of his subject. I offer him our gratitude in the knowledge that visitors to the exhibition and readers of his erudite catalogue will reap the benefits of his efforts on our behalf.

Timothy Clifford
Director

Acknowledgements

'From Poussin to Cézanne! What a fine title for an exhibition in which
the Frenchman's constant need to balance his motifs, to 'compose',
would be demonstrated right throughout two centuries of continuous innovations.'

André Lhote, *De la palette à l'écritoire*, 1946

I would like to record our thanks to the following who have given invaluable help to enable us to 'realise'
(as Cézanne himself might have said) our ambitious project, which examines the beginning and the end of
the classical landscape tradition in French painting through the works of its two greatest masters:

David Alston, Katharine Baetjer, Joseph Baillio, Professor P. M. Bardi, Jacob Bean, Roger M. Berkowitz,
Giovanna Bernard, Professor Henning Bock, Professor Evelina Borea, Sir Alan Bowness, Edgar Peters
Bowron, Jaap Bremer, Richard Brettell, James A. Bridenstine, J. Carter Brown, Françoise Cachin, Beverley
Carter, The Rt Hon. the Viscount Coke, Desmond Corcoran, Denis Coutagne, Professor W. H. Crouwel,
Maureen E. Devine, Gianvittorio Dillon, Barbara Divver, Douglas Druick, Frederik Duparc, Tim Egan,
John Elderfield, Oliver Everett, Everett Fahy, Dennis Farr, Marianne Feilchenfeldt, Georges Frêche,
Christian Geelhaar, Professor Sir Lawrence Gowing, K. Hess, Joseph Holbach, Michel Hoog, Alastair
Hutchison, William Hutton, F. C. Jolly, A. Jourdan, Nicola Kalinsky, Major Nicholas Lawson, Rebecca E.
Lawton, John Leighton, Henri Loyrette, Neil MacGregor, Suzanne Folds McCullagh, Fabio Magahaes,
Peter Mock, Charles S. Moffett, Philippe de Montebello, Yozo Mori, Edward Morris, Theresa-Mary
Morton, Konrad Oberhuber, R. W. D. Oxenaar, Michael Pantazzi, Ann Percy, Ursula Perucchi, Laughlin
Phillips, Jean-François Picheral, Vanessa Pope, Robert Ratcliffe, Eliza Rathbone, Gérard Regnier,
Professor John Rewald, Jean-Marie Richier, Catherine Rickman, Kathryn A. Ritchie, Joseph J. Rishel, The
Hon. Jane Roberts, Andrew Robison, Anne Roquebert, Pierre Rosenberg, Professor Pérez Sanchez,
Helmiriitta Sariola, David Scrase, Nicholas Serota, Arlette Sérullaz, Innis Howe Shoemaker, Timothy
Stevens, Claudio Strinati, Margret Stuffmann, Vitali Suslov, Bernard Terlay, Pierre Théberge, Shirley L.
Thomson, Gary Tinterow, Evan H. Turner, Olli Valkonen, Françoise Viatte, Bryan Ward-Perkins, Giles
Waterfield, Rosemary Watt, Clovis Whitfield, Mrs John Hay Whitney, James Wood.

My colleagues in the National Galleries have given generously of their time. Julia Lloyd Williams,
Assistant Keeper, has been unfailingly helpful and assisted a mediocre linguist; Jonathan Mason and the
staff of the Registrar's Department (most especially Margaret Mackay) ensured the loans safely negotiated
their various paths to Edinburgh; Keith Morrison and his fellow technicians hung the exhibits; Janis
Adams, in collaboration with John Taylor and Lund Humphries, has seen the catalogue to press; Deborah
Hunter chased up photographic orders; Sheila Innes nobly processed countless invoices; Peter Fothering-
ham has supervised the necessary building work, and Sheila Scott and Sheila MacIntyre have cheerfully
and efficiently handled the voluminous correspondence that such an enterprise, of necessity, generates.

The catalogue has been designed by Gerald Cinamon and the exhibition installation has been devised
by Robert Dalrymple in consultation with the curatorial staff.

I am acutely aware that this exhibition would have been impossible without generous and
understanding sponsors. I would like to thank the Chairman of our Patrons, Viscount Weir, for making
the initial and very important approach to General Accident on our behalf. At General Accident I have
benefited throughout from the sympathetic support of Alex Robertson, Publicity Manager, and his
colleagues Tony Kerfoot and Christeen Payne. I would also like to acknowledge the support of Air France
who have generously provided the Galleries with subsidised air travel between Edinburgh and Paris.

Finally, and most importantly, I offer my heartfelt gratitude and admiration to my friend and former
tutor, Richard Verdi, whose exhibition this truly is, and whose vision and scholarship have brought it
successfully to fruition.

Michael Clarke
Keeper, National Gallery of Scotland
Exhibition Organiser

Author's Acknowledgements

Anyone studying Cézanne owes a fundamental debt to the pioneering publications on the artist by John Rewald. In their humanity, insight, and scrupulous scholarship, these are certain to prove an inspiration to others for generations to come. I am grateful to Professor Rewald for sharing his unrivalled knowledge of the artist with me throughout all stages in the planning of this exhibition, which found its initial inspiration in his stimulating seminars on late-nineteenth-century French art at the University of Chicago many years ago.

For their willingness to assist me with specialised points arising in connection with this project, I am indebted to Carolyn Lanchner, Neil MacGregor, Joachim Pissarro, Giles Waterfield, and Clovis Whitfield.

During the early stages in the planning, I benefited greatly from the close collaboration of Julian Paine. Without his energy and optimism, this exhibition might never have assumed its present form.

In ways too numerous to mention – and too generous to acknowledge adequately – I have also received much encouragement and assistance from Monica and Angelo Bertucci, Norman and Jacqueline Hampson, Jennifer Leach, and Judith Nesbitt – all of it warmly appreciated.

I am grateful to the staff of the National Gallery of Scotland for their tireless co-operation throughout the long gestation of this project. Without the enthusiastic support of the Director, Timothy Clifford, so ambitious an undertaking would never have progressed beyond the planning stages. The exhibition was ably guided by my friend and colleague, Michael Clarke, whose unstinting dedication to the project and ceaseless patience with its author made for the most fruitful and congenial of collaborations.

This catalogue is affectionately dedicated to my mother, in gratitude for a lifetime's instruction in the art of perseverance – and for so much more besides.

Inevitably, my greatest debt is to John Brooks, whose comfort and support contributed daily to the realisation of this project and who selflessly provided me with ideal working conditions during the busy, final year. My gratitude to him is limitless.

Richard Verdi

Abbreviations

Chappuis — Adrien Chappuis, *The Drawings of Paul Cézanne, A Catalogue Raisonné*, Greenwich, Conn. and London, 1973. 2 vols.

Correspondance — *Correspondance de Nicolas Poussin*, ed. Ch. Jouanny, Paris, 1911.

CR — Walter Friedländer and Anthony Blunt, *The Drawings of Nicolas Poussin, Catalogue Raisonné*, London, 1939–1974. 5 vols.

Doran — P. M. Doran (ed.), *Conversations avec Cézanne*, Paris, 1978.

Letters — Paul Cézanne, *Letters*, ed. John Rewald, 4th ed., Oxford, 1976.

Rewald — John Rewald, *Paul Cézanne, The Watercolours, A Catalogue Raisonné*, London and New York, 1983.

Venturi (V.) — Lionello Venturi, *Cézanne, son art, son œuvre, catalogue raisonné*, Paris, 1936. 2 vols.

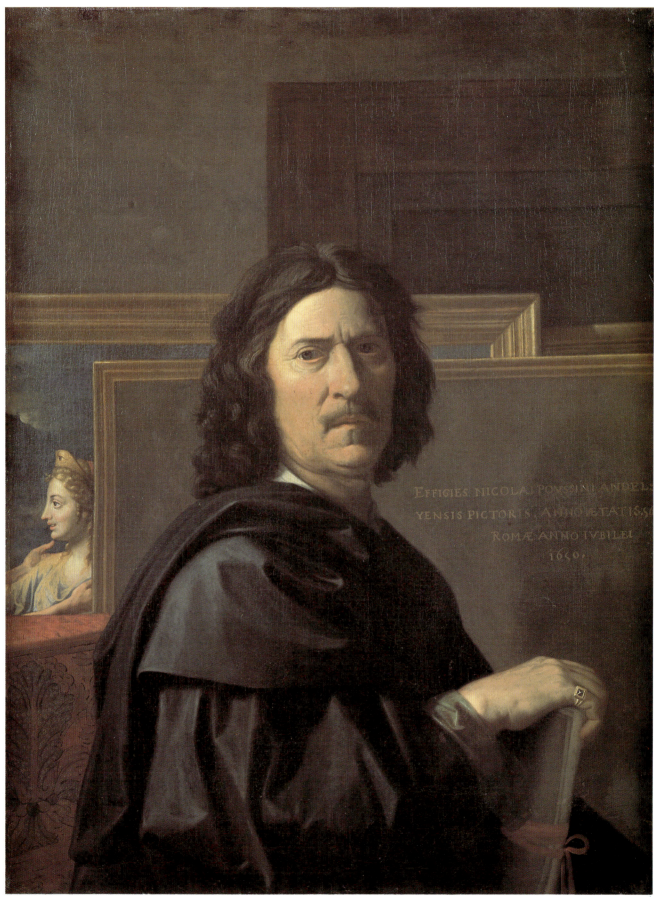

Fig. 1. Poussin, *Self-Portrait*, 1649–50
(Musée du Louvre, Paris)

Nicolas Poussin (1594–1665)

Nicolas Poussin was born in June 1594 in or near the town of Les Andelys in Normandy, the son of a nobleman whose fortunes had been ruined in the wars of religion. His early education included a grounding in Latin and letters, but he soon showed an inclination for art which was fostered by the itinerant painter, Quentin Varin, who visited Les Andelys in 1611–12 and became Poussin's first master. Encouraged by Varin, Poussin departed for Paris in 1612, where he studied anatomy, perspective, and architecture and worked under a variety of masters. Soon after, he was introduced to engravings after Raphael and Giulio Romano. According to Bellori, one of the artist's early biographers, these fired him with such enthusiasm that he could already be described as 'of the school of Raphael' at this early stage of his career. Poussin's veneration for the masters of the Italian Renaissance also led him to make two unsuccessful attempts to reach Rome in the years before 1622.

During his apprenticeship in Paris, the artist executed a number of major commissions, none of which survive. In 1622 he completed six large tempera paintings for the Jesuits, reputedly in only six days. In the same year he was employed to work at the Luxembourg; and, in 1623, he received an important commission for a painting of the *Death of the Virgin* for a chapel in Notre-Dame. The paintings for the Jesuits brought Poussin to the attention of the Italian poet, Giovanni Battista Marino, who had been resident in Paris since 1615. Marino became Poussin's early Maecenas and subsequently commissioned from him a series of drawings based on Ovidian mythology. The so-called Marino drawings, now at Windsor Castle, are the most important surviving works of Poussin's Paris years.

In the spring of 1623 Marino departed for Italy; and, sometime in the autumn of that year, Poussin followed him, spending several months in Venice before arriving in Rome in March 1624.

Poussin's early years in Rome were marked by hardship and misfortune. Soon after his arrival, Marino departed for Naples, where he died in 1625, leaving Poussin without a champion in Rome. To earn his livelihood, the young artist executed a large number of biblical and mythological paintings. He studied anatomy, geometry and perspective, and drew from the live model in the studio of two of the leading classical masters of the day, Domenichino and (after 1631) Andrea Sacchi. He also measured and copied examples of antique sculpture and studied the great works of Italian Renaissance art to be seen in Rome. Chief among these was the celebrated series of bacchanals which Bellini and Titian had painted for Alfonso d'Este early in the preceding century and which were then on view in the Aldobrandini and Ludovisi collections. According to Félibien, Poussin's principal biographer, the young artist avowed a passion for Titian's colour and landscape during this period – a passion which is likewise reflected in his art of this phase, with its sensuous colour and lighting. Further evidence of Poussin's admiration for Venetian art is the existence of a full-scale copy of one of the d'Este bacchanals, Bellini's *Feast of the Gods*, which is attributed to Poussin and now in the collection of the National Gallery of Scotland.

Around 1627 Poussin became acquainted with the scholar, antiquarian, and collector, Cassiano dal Pozzo, who became his chief Italian patron and one of his closest friends. Among Pozzo's early commissions from Poussin was the *Mystic Marriage of St Catherine*, also in the National Gallery of Scotland. In 1627, the artist received a commission from Cardinal Francesco Barberini for the *Death of Germanicus* (Minneapolis Institute of Arts), one of his first great masterpieces; and a year later he was commissioned to paint the *Martyrdom of St Erasmus* for an altar in St Peter's (Vatican, Pinacoteca). This was poorly received and proved to be the artist's only public commission for Rome. Thereafter Poussin specialised in easel paintings for discerning private patrons, first in Italy and then in France, who appreciated the intellectual rigour and refinement of his art.

Poussin spent his early years in Rome in the company of foreign artists, among them Claude Lorrain, who remained a close friend for the rest of his life and – along with Poussin – was to become the greatest master of classical landscape painting in seventeenth-century Italy. Around 1629, the artist suffered a bout of serious illness. The effects of this may be seen in a remarkably candid self-portrait drawing of this period in the British Museum [fig. 17], which also reveals the fiery temperament and somewhat uncouth manner of the youthful Poussin, who was involved in at least one brawl during his early years in Rome and was described by Marino as a young man who possessed 'the fury of a devil'.[1] Poussin was nursed through his illness by the family of Jacques Dughet, a cook from Paris; and, one year later, he married Dughet's daughter, Anne-Marie, who was eighteen years younger than Poussin and died one year before him, in 1664. In a letter of that year Poussin suggests that she was caring and dependable; otherwise, nothing is known of his marriage, which remained childless. Dughet's son, Gaspard (1615–75), received instruction from Poussin between 1631 and 1635 and, under the name of Gaspard Poussin, became one of the leading landscape painters of seventeenth-century Rome.

By the beginning of the 1630s Poussin had established himself as an artist. In 1630–31 he completed the *Plague at Ashdod* (Louvre) and the *Realm of Flora* (Dresden) for Valguarnera; by 1632 he had been elected a member of the Academy of St Luke in Rome; and, in the following year, he signed and dated the large *Adoration of the Magi*, now at Dresden, which marks a clear change of direction in the artist's career. Renouncing the Venetian-inspired style of his romantic early phase, Poussin would henceforward seek his inspiration in the noble, classic art of Raphael and the antique.

In this more rational and restrained manner, the artist executed a succession of major works during the 1630s, including the *Adoration of the Golden Calf* (1634, National Gallery, London), the series of bacchanals for Cardinal Richelieu of 1635–36 (including the *Triumph of Pan*, also in the National Gallery), and *Moses striking the Rock* of c. 1637 (National Gallery of Scotland, on loan from the Duke of Sutherland's collection). From this period, too, date Poussin's earliest surviving landscape paintings [Nos. 1–3]. But the artist's major commission of these years was the series of *Seven Sacraments* for Cassiano dal Pozzo, executed between c. 1636 and 1642 (five at Belvoir Castle, one in the National Gallery of Art, Washington, D.C., and one destroyed). In 1638–39 he also painted one of his most ambitious history pictures, *The Israelites gathering the Manna* (Louvre), for Paul Fréart de Chantelou, who was to become his most important French patron and his most loyal and trusted friend.

Between 1640–42 Poussin spent an unhappy period in Paris working as First Painter to the King, executing designs for the Long Gallery of the Louvre, altarpieces, ceiling paintings, and title-page illustrations. As an artist of fierce integrity and creative independence, Poussin found the range and confusion of the King's commands uncongenial to his temperament and eventually secured permission to return to Rome in 1642.

Two years later, Poussin embarked upon one of the major undertakings of his entire career, the set of *Seven Sacraments* for Chantelou [figs. 22, 23], completed in 1648 and now on loan to the National Gallery of Scotland from the Duke of Sutherland's collection. These are among the artist's noblest and most deeply considered works and cost him much effort. 'In contrast to others', confessed Poussin in a letter to his patron of 1644, 'the older I get the more I feel enflamed with the great desire to do well'.[2]

This desire is nowhere more apparent than in the outstanding series of pictures Poussin produced between 1648–51, the most austere and heroic phase of his art. Among these are two painted self-portraits [cf. fig. 1] and his great series of classical landscape compositions [Nos. 18–24]. Also of these years are some of the artist's most rarified figure paintings,

including the *Holy Family on the Steps* (Cleveland Museum of Art) and *Rebecca and Eliezer at the Well* (Louvre) of 1648 and the *Judgement of Solomon* (Louvre) of the following year – works of a harmony and nobility which make it easy to see why Poussin had earned the title of 'the Raphael of our century' by 1650.[3]

In marked contrast to the excesses of his youth, the mature Poussin led a modest and regulated existence, keeping no servants and disdaining immoderation of any kind. According to Bellori, he divided his day between painting and discoursing with his friends on a variety of learned subjects, all of which he had mastered through his 'fine mind and wide reading'. He painted slowly, employing no assistants or collaborators and normally admitting no one into his studio while he was working. Unlike many of his greatest contemporaries, Poussin preferred to take complete responsibility for the conception and execution of his pictures.

Although Poussin was increasingly ill during the last years of his career, he continued to paint between three and four pictures a year throughout the 1650s, a significant number of them devoted to the theme of the Holy Family, a subject ideally suited to his contemplative style of this period. He also enjoyed his highest reputation and greatest financial success during these years; and, in 1655, was named again First Painter to the King.

During the last ten years of his life Poussin was haunted by the fear of death and makes frequent mention of it in his letters. In 1657 he wrote plaintively to Chantelou: 'a swan sings more sweetly when it is near to death'.[4] Though his output diminished with age, his imagination deepened, with the result that his late canvases are among the most personal and poetical of his entire career. This is especially true of a group of mythological landscapes which includes the *Birth of Bacchus* of 1657 (Fogg Art Museum, Cambridge, Massachusetts) and the *Landscape with the Giant Orion* (Metropolitan Museum of Art, New York) of the following year. The chief occupation of the end of his life was the set of landscapes depicting the *Four Seasons*, executed for the duc de Richelieu in 1660–64 and now in the Louvre [cf. figs. 5, 56]. An unfinished *Apollo and Daphne*, also in the Louvre, was given to Cardinal Massimi by the artist when he realised he could not complete it.

Poussin died on 19 November 1665 and was buried in the church of San Lorenzo in Lucina, Rome, in accordance with his own wishes 'without any pomp'.[5] Equally modest were the contents of his studio at his death. These consisted of nineteen books and manuscripts on painting plus three pictures by the artist – nothing to indicate the stature and achievements of a man who, only three years earlier, had been acclaimed 'the most accomplished and the most perfect painter of all the moderns'.[6]

Poussin's surviving works consist of around 220 paintings and 400 drawings. The majority of these treat themes from the bible, mythology, or ancient history, and reflect the artist's belief that the noblest art should concern itself with the most elevated themes. Already within his own lifetime, this facet of Poussin's achievement had earned the admiration of the French Academicians, who recognised in him the father of French painting. In this form the 'learned' and 'philosophical' Poussin would likewise be venerated by the Neo-classical painters of the late eighteenth century. More recent generations, however, have come to regard him as one of the supreme masters of formal design in Western art; and it is in this respect that he appears to us as a spiritual ancestor of Cézanne.

1. Roger de Piles, *Abrégé de la vie des peintres ... et un Traité du Peintre parfait*, Paris, 1699, p. 740.

2. *Correspondance*, p. 289.

3. Roland Fréart de Chambray, *Parallèle de l'architecture antique et de la moderne*, Paris, 1650. Reprinted in Jacques Thuillier, 'Pour un "Corpus Pussinianum"', *Actes du Colloque International Nicolas Poussin*, Paris, 1960, Vol. II, p. 86.

4. *Correspondance*, p. 445.

5. *Ibid.*, p. 469.

6. Roland Fréart de Chambray, *Idée de la perfection de la peinture*, Mans, 1662, p. 121. Reprinted in Thuillier, *op. cit.*, p. 111.

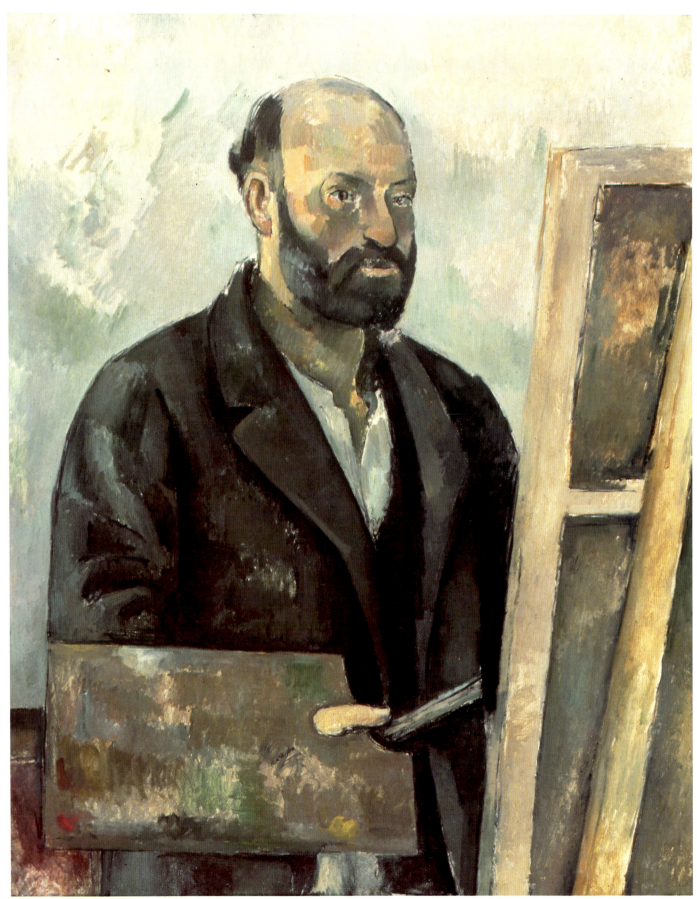

Fig. 2. Cézanne, *Self-Portrait*, *c.* 1890
(The Bührle Foundation, Zürich)

Paul Cézanne (1839–1906)

Paul Cézanne was born on 19 January 1839 in Aix-en-Provence, the eldest of three children of Louis-Auguste Cézanne and Anne-Elisabeth Aubert. His father was a dealer and exporter of hats who, by 1848, was wealthy enough to buy the only bank in the town and whose fortune left Cézanne financially secure for the rest of his life. After an early education in Aix, where he formed a close friendship with the young Emile Zola, Cézanne enrolled at the University in the town in 1859 to study law, in accordance with his father's wishes. By this time he was already working at the municipal drawing school in Aix, where he obtained a prize for a figure study in 1859. Disillusioned with his law studies, Cézanne abandoned university in 1861 and travelled to Paris, where Zola had resided since 1858. Determined to devote himself entirely to painting, Cézanne visited the Louvre and the Salon and began working at the Atelier Suisse, where he made the acquaintance of Pissarro. In September 1861, however, he returned to Aix, discouraged with his progress, and briefly took up employment at his father's bank.

Cézanne resumed painting and returned to Paris in the following year. In 1863 he exhibited at the Salon des Refusés, where he appears to have attracted no attention, and met Monet, Degas, and Renoir. Also in that year, he applied for permission to make copies in the Louvre – an activity he was to pursue tirelessly to the end of his career. During the next ten years Cézanne resided largely in Paris and made frequent journeys to his native Aix, where his father had acquired the Jas de Bouffan, an eighteenth-century manor house on the outskirts of the town, in 1859.

Cézanne's earliest paintings consist of portraits of his family and friends, landscapes, and a few still-lifes. His chief creative efforts of this period, however, were directed towards imaginary subjects, often of a violent and erotic nature, which reveal the turbulence of his own inner life during these years. All of these works are executed in a thick impasto, often employing a palette knife to build up a coarse and congealed surface texture, as though in defiance against traditional modes of painting. Regularly submitted to the Salon, these disturbing canvases were repeatedly rejected. Yet they possess an authority and conviction, coupled with an irrepressible desire to unburden himself of emotion, that already reveals the tremendous power of Cézanne's art. Moreover, in a handful of works of the years around 1870 – the *Overture to Tannhäuser* (Leningrad), the *Still-life with a Black Clock* (Private Collection), and the *Railway Cutting* (Munich) [fig. 29] – the artist succeeded in harnessing his youthful vehemence to a prevailing compositional order; and the result is a masterpiece.

The impassioned style of Cézanne's early paintings mirrored his own volatile emotional states. 'Those who knew him at that time', wrote Joachim Gasquet years later, 'described him to me as frightening, full of hallucinations, almost bestial … He was in despair because he could not satisfy himself. He suffered from those combinations of violence and timidity, of humility and pride, of doubts and dogmatic assertions, which shook him all his life. He shut himself up for weeks, not wanting to let a living soul enter his studio, shunning any new acquaintance'.[1]

One acquaintance Cézanne did make during these years was Hortense Fiquet, a model from the Jura eleven years his junior, with whom the artist lived from c.1869 and who bore him a son, Paul, in 1872. The couple eventually married fourteen years later. Though Madame Cézanne was a frequent and patient sitter for her husband, their relationship does not appear to have been close and, in later years, they chose to live apart.

In 1872, Cézanne moved to Pontoise, outside Paris, to work alongside Pissarro, whom he was always to regard as his chief artistic mentor. Later in the same year, he moved to the nearby village of Auvers-sur-Oise, where he remained until 1874, painting directly from nature and making a number of etchings on a printing press owned by his friend, Dr Paul Gachet, one of the first collectors of Cézanne's works.

During these years, Cézanne overcame the brooding emotionalism of his works of the 1860s and his art entered its most purely Impressionist phase. Encouraged by Pissarro to become more attentive to his sensations before nature, Cézanne lightened his palette and modified his technique to convey the flickering effects of light and colour he observed before him. This more objective approach to painting proved to be a turning-point in the career of a man who would increasingly strive to portray 'the manifold picture of nature'.[2]

Cézanne exhibited three paintings at the first Impressionist exhibition in 1874, one of which – the well-known *House of the Hanged Man* in the Musée d'Orsay – found an immediate buyer. Nonetheless, he attracted the most hostile criticism of any of the exhibiting artists, with one visitor describing him as a 'sort of madman who paints in delirium tremens'. One year later, Cézanne made the acquaintance of Victor Chocquet, a customs official, who owned an important collection of works by Delacroix and Renoir and became the first major collector of Cézanne's paintings. Chocquet purchased his first Cézanne from père Tanguy, champion of the new painters, who, until his death in 1894, remained the only dealer in Paris to stock Cézanne's works.

Cézanne's portrait of Chocquet of 1876–77 (V.283; Private Collection) was one of 16 works by the artist exhibited at the third Impressionist exhibition in 1877, the majority of them loaned by Chocquet himself. On this occasion, Cézanne earned a favourable review from Georges Rivière and was even described as 'certainly the greatest colourist of the group' by his old friend Zola,[3] who had grown increasingly disillusioned with the artist's progress. The majority of critics, however, ridiculed Cézanne's submissions, leading him never again to exhibit with the Impressionists. Instead, he regularly submitted his works to the annual Salon – as though seeking official recognition of his art – and was almost invariably rejected.

During the mid-1870s, Cézanne embarked upon a series of bather compositions in apparent emulation of the multi-figure pictures of nudes in a landscape setting by the Old Masters. Together with the landscapes, portraits, and still-lifes which he had been painting from the start of his career, these were to comprise the fourth major category of his art. They were also the only group of the artist's mature works that could not be studied directly from life – a constraint which constantly tested Cézanne's powers of invention.

After the critical condemnation his works had aroused at the two Impressionist exhibitions, Cézanne retreated from Paris during the middle years of his career. From 1876 he worked regularly at the town of L'Estaque, outside Marseilles, which was eventually to prove the site of some of his grandest landscape paintings [Nos. 14, 35–37, 45]. In 1879–82, he paid repeated visits to Zola at Médan; and, from 1883–87, he worked almost entirely in Provence, painting the house and grounds of the family residence, the Jas de Bouffan, the picturesque town of Gardanne south of Aix, and the imposing view of the Valley of the Arc framed by the Mont Sainte-Victoire to the immediate south of the town. The harmony and serenity of these works becomes even more remarkable when one considers that the mid-1880s were among the most personally troubled years of the artist's career.

In 1885, Cézanne had an unhappy love affair, about which nothing more is known. Shortly before his marriage to Hortense Fiquet in April of the following year, the artist broke with Zola, whose novel L'OEuvre, published in March 1886, took as its hero a deluded artist who eventually commits suicide, modelled in part on Cézanne. Though Zola had been the artist's oldest and closest friend, the appearance of this work deeply wounded Cézanne and confirmed his suspicions that the novelist regarded him as a creative failure. The two were never again to meet; and, as late as 1896, Zola referred to Cézanne in print as 'this abortive great painter'.[4] Yet, when Cézanne learned of Zola's death in September 1902, he confined himself to his studio for a day, grieving. Finally, in October 1886, Cézanne's father died, leaving a substantial fortune to be divided among his widow and three children.

'I had resolved to work in silence until the day when I should feel myself able to defend theoretically the results of my attempts' declared Cézanne in 1889.[5] The later years of the artist's career are largely those of a recluse, living (as one critic put it) 'on the margin of life' and quietly altering the course of painting.

In 1890 Cézanne made his only journey abroad, spending five months in Switzerland with his wife and son. Except for a visit to the Lac d'Annecy in Taillores in the summer of 1896, the artist was to divide the rest of his life between Paris and its surroundings and (increasingly) his native Aix, working initially at the Jas de Bouffan, where he began his series of card-player compositions early in the 1890s. In 1899, he was forced to sell the Jas de Bouffan and moved into an apartment in the centre of the town. Two years later he purchased some land on a hillside site at Les Lauves, overlooking Aix, and had a studio built for him there, where he worked to the end of his life.

From the late 1880s onwards, Cézanne's art began to attract increased attention from an informed minority of artists and critics. In 1888 he was made the subject of a short article by J.–K. Huysmans, who praised his contribution to the Impressionist movement and regretted that he was 'too much ignored'. In 1889 and 1890 he was invited to exhibit with the Belgian group Les XX in Brussels; and, two years later, in 1892, he was made the subject of a short biographical study by Emile Bernard. But the tide turned decisively only with the death of père Tanguy in 1894. At the auction of the dealer's studio six works by Cézanne were acquired by the unknown Ambroise Vollard, who in the following year convinced the painter to lend 150 of his works to an exhibition at his premises in Paris. This attracted considerable critical discussion; and, for the remaining ten years of his life, Cézanne's reputation steadily grew, especially among artists themselves and among a handful of enlightened and vociferous critics. Two of the most notable of these, Gustave Geffroy and Vollard himself, became the subjects of portraits by Cézanne in 1895 and 1899 (V.692 and 696).

By 1896 two of Cézanne's paintings had entered the Luxembourg with the Caillebotte bequest; and, in 1897, the Berlin National Gallery also owned two of his works. At the sale of the Chocquet collection in 1899, Cézanne's canvases fetched high prices; and, in the same year, the artist was invited to exhibit three paintings at the Salon des Indépendants. Thereafter Cézanne's works were regularly to be seen not only in Paris but in Brussels, Berlin, Vienna, and London, where the large Impressionist exhibition at the Grafton Galleries in 1905 included ten paintings by the artist.

During the last years of his life Cézanne lived in seclusion at Aix, working on three large compositions

of female bathers at his Les Lauves studio and painting the surrounding countryside, the quarry at Bibémus, the park at the Château Noir, and (above all) the ever-beckoning peak of the Mont Sainte-Victoire, landmark of his native Aix. Visited by an increasing number of critics, collectors, and disciples during these years, he was prompted by many of them to outline his ideas on painting, though to the end he admitted: 'my work must prove that I am right'.[6]

'I am old, ill, and I have sworn to myself to die painting', confessed Cézanne in a letter to Emile Bernard of 21 September 1906.[7] One month later, fate granted him this wish. Working outside, near his studio at Les Lauves on 15 October, Cézanne collapsed during a sudden thunderstorm and was taken to his bed, where he died eight days later, on 23 October 1906.

Cézanne's œuvre consists of approximately 850 paintings, 650 watercolours, 1200 drawings, and a handful of prints. Few of these works are exactly datable due to the secrecy and solitude in which the artist worked and to his lack of recognition in his own lifetime. Fewer still were signed, presumably because Cézanne regarded them as unfinished or unsuccessful – and because they rarely left his possession. Already within the last years of the artist's life, however, his works had begun to exert a decisive influence upon developments in early twentieth-century painting; and he is now regarded as the father of modern art – or, as Cézanne himself reputedly put it to Bernard, as 'the primitive of the way that I have found'.[8]

1. Quoted from: John Rewald, *Cézanne, A Biography*, London, 1986, p.62. (Orig. Joachim Gasquet, *Cézanne*, Paris, 1921, pp. 49, 50, 53.)
2. *Letters*, p. 303.
3. Rewald, *op. cit.*, p. 113.
4. *Ibid.*, p. 176
5. *Letters*, p. 231.
6. *Ibid.*, p. 312.
7. *Ibid.*, p. 330.
8. Doran, p. 73.

Comparative Illustrations

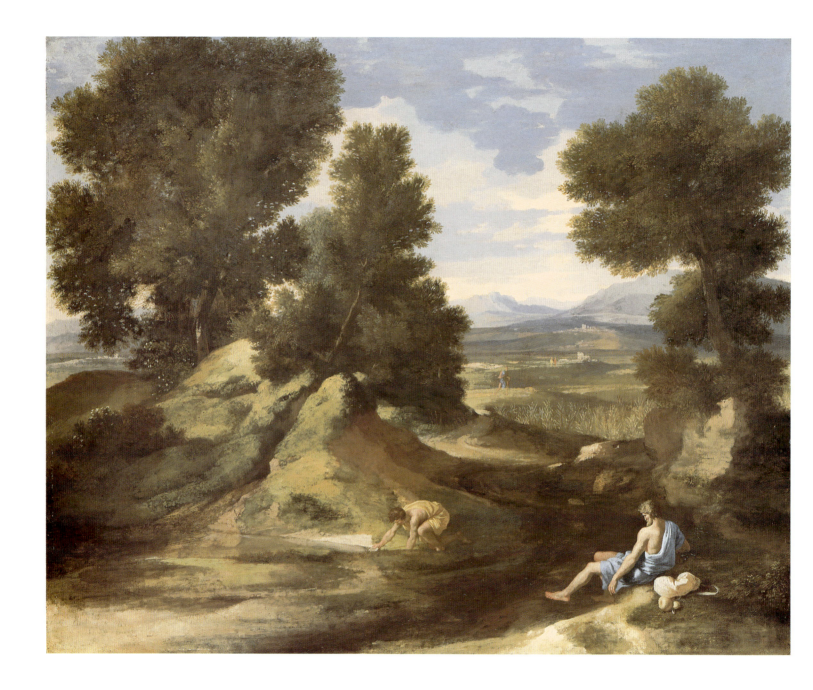

Fig. 3 [No. 1]. Poussin, *Landscape with a Boy drinking from a Stream, c.* 1635
(The National Gallery, London)

Fig. 4 [No. 9]. Cézanne, *Landscape, c.* 1865
(Vassar College Art Gallery, Poughkeepsie, New York)

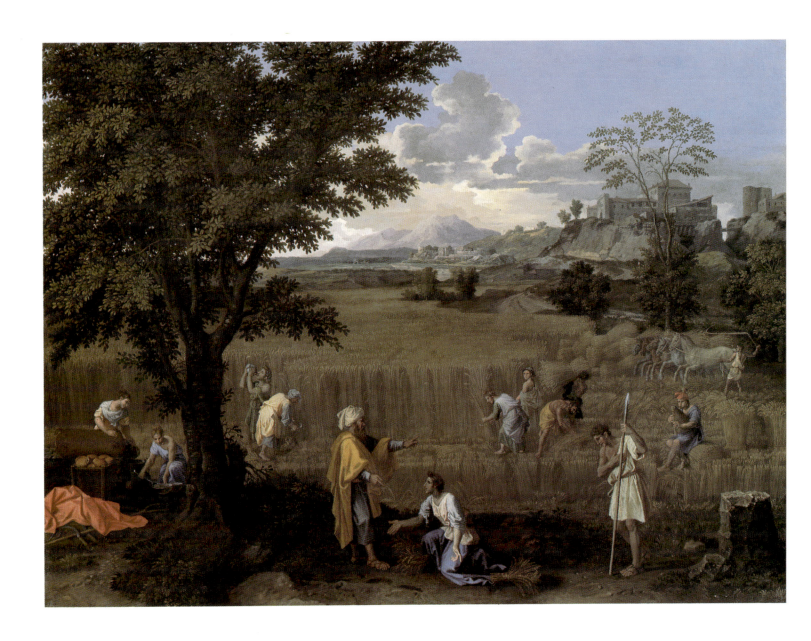

Fig. 5. Poussin, *Summer, or Landscape with Ruth and Boaz*, 1660–64
(Musée du Louvre, Paris)

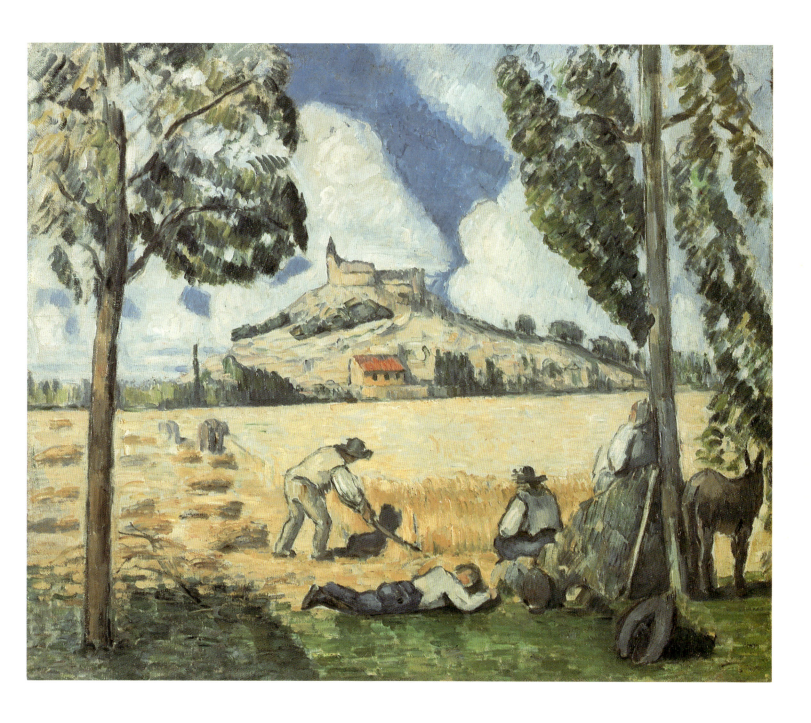

Fig. 6. Cézanne, *The Harvest*, c. 1875–77
(Private Collection, Japan)

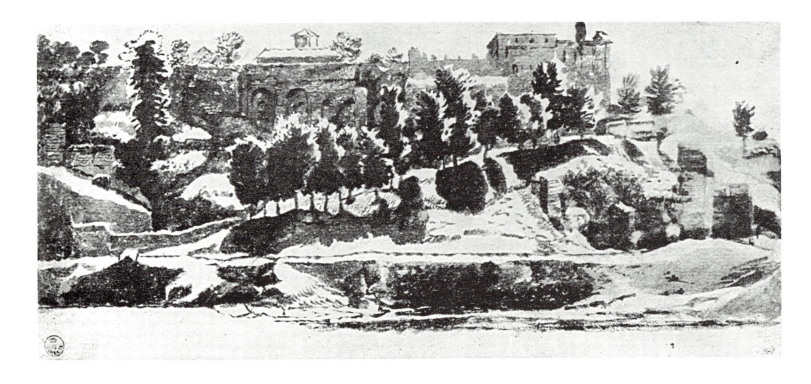

Fig. 7 [No. 26]. Poussin, *View of the Aventine*, c. 1645
(Gabinetto Disegni e Stampe degli Uffizi, Florence)

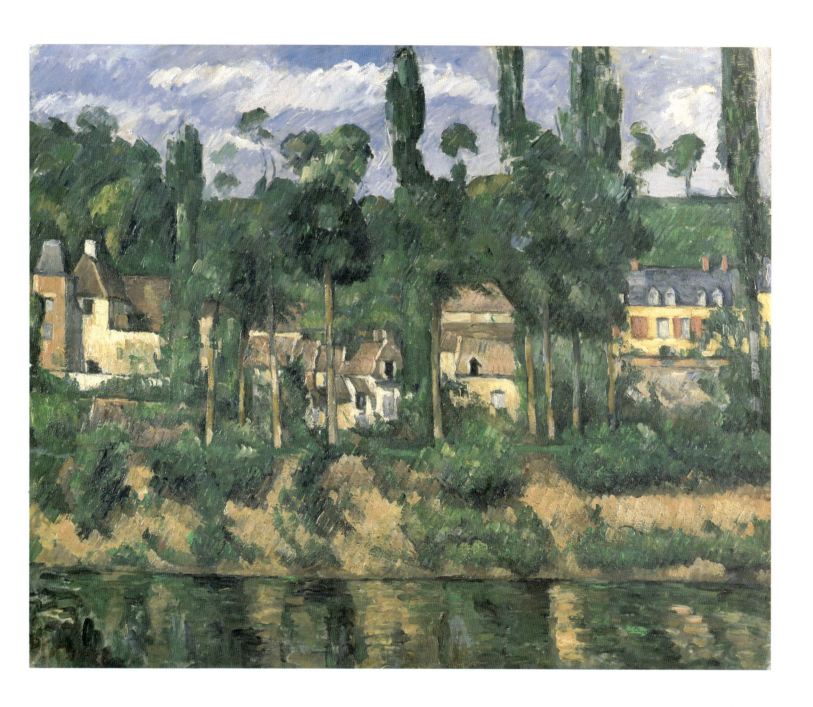

Fig. 8 [No. 29]. Cézanne, *Le Château de Medan*, c. 1880
(The Burrell Collection, Glasgow Art Gallery and Museum)

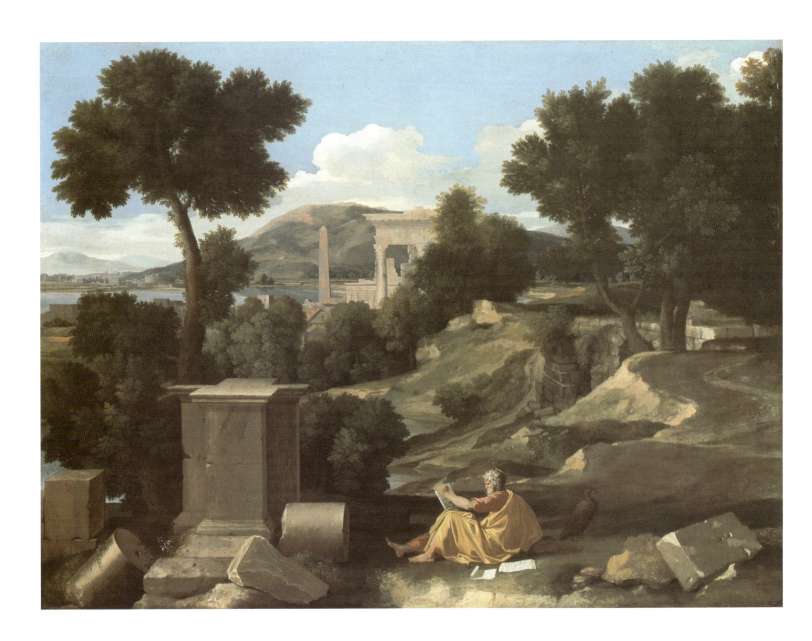

Fig. 9. Poussin, *Landscape with St John on Patmos*, 1640
(Art Institute of Chicago)

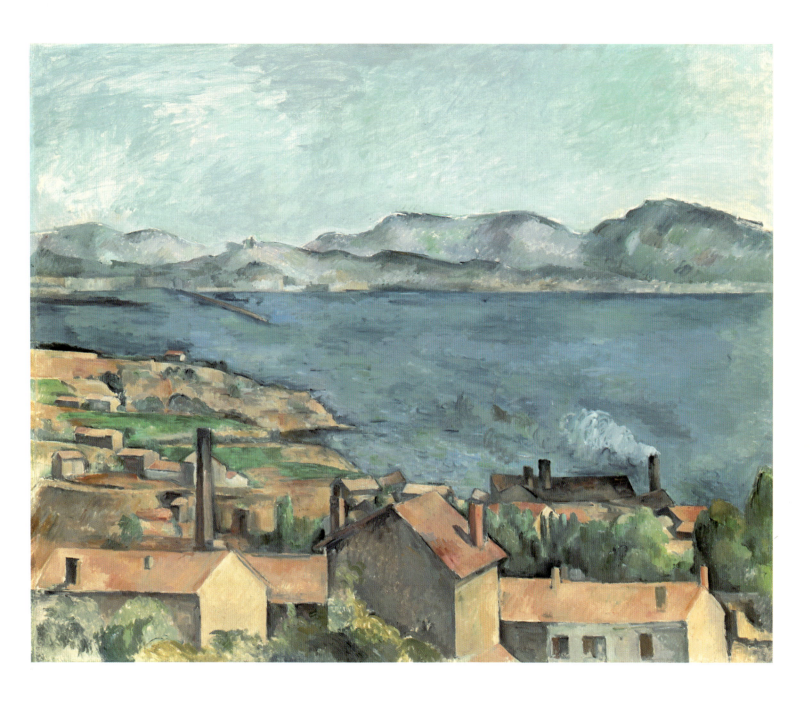

Fig. 10 [No. 45]. Cézanne, *The Gulf of Marseilles, seen from L'Estaque,* c. 1886–90
(The Art Institute of Chicago)

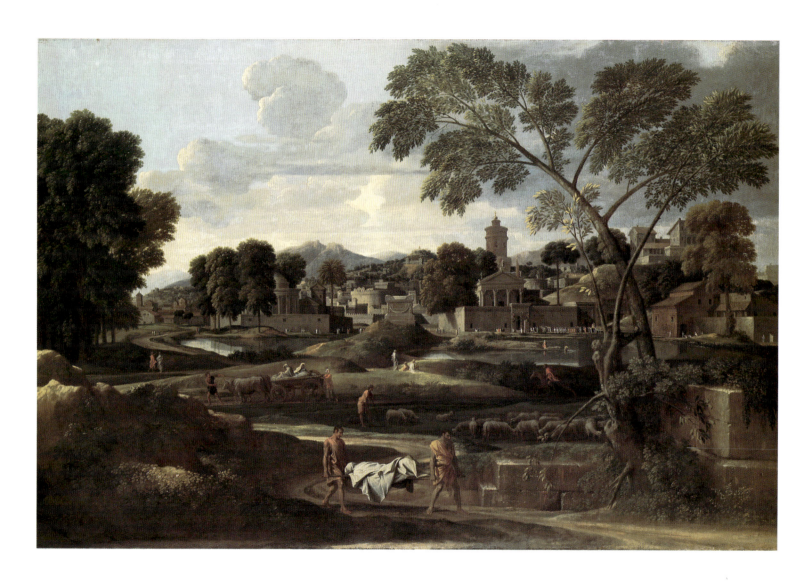

Fig. 11 [No. 18]. Poussin, *Landscape with the Body of Phocion carried out of Athens*, 1648
(The Earl of Plymouth, Oakly Park, Shropshire;
on loan to the National Museum of Wales, Cardiff)

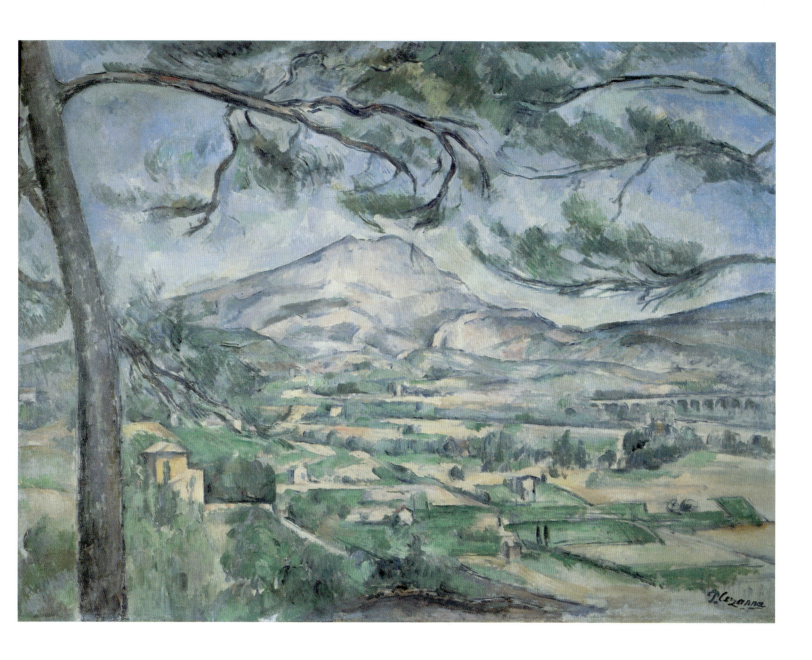

Fig. 12. Cézanne, *La Montagne Sainte-Victoire*, c. 1885–87
(Courtauld Institute Galleries, London)

Fig. 13 [No. 55]. Poussin, *Landscape with Hagar and the Angel*, c. 1660–64
(Galleria Nazionale, Palazzo Barberini, Rome)

Fig. 14. Cézanne, *Park at the Château Noir*, c. 1900–04
(National Gallery, London)

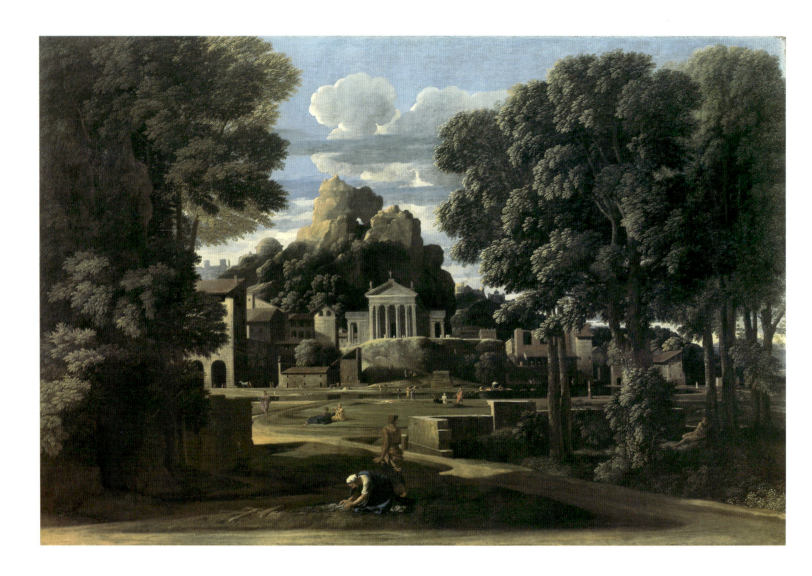

Fig. 15 [No. 19]. Poussin, *Landscape with the Gathering of the Ashes of Phocion*, 1648
(Walker Art Gallery, Liverpool)

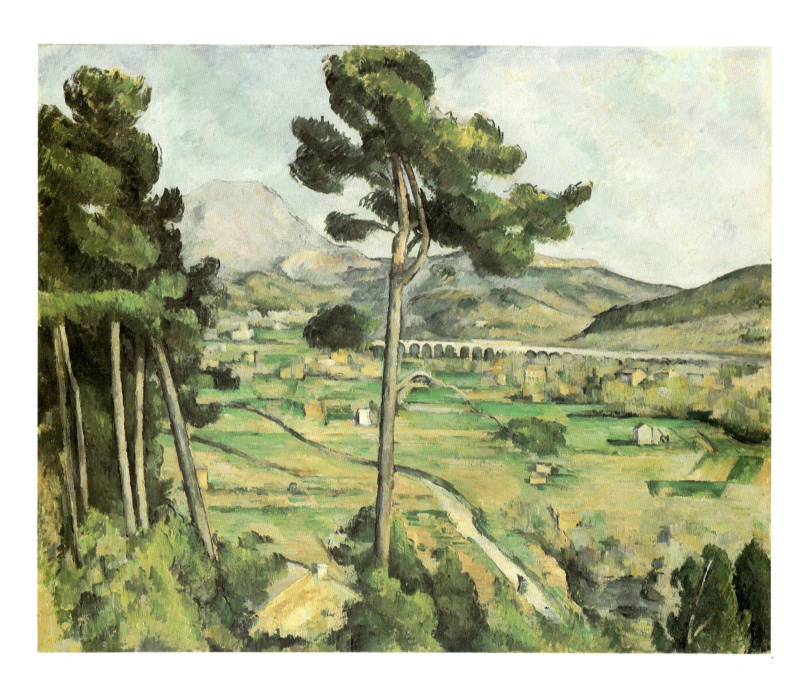

Fig. 16 [No. 38]. Cézanne, *La Montagne Sainte-Victoire*, c. 1885–87
(The Metropolitan Museum of Art, New York)

Cézanne and Poussin:
the classical vision of landscape

*'To my mind one does not put oneself
in place of the past,
one only adds a new link.'*

Cézanne, letter to Roger Marx,
23 January 1905

Cézanne's position as the father of modern painting is so much a part of our inheritance that it is easy to overlook the debt he owes to tradition. Alone among the pioneers of Post-Impressionism, Cézanne maintained a lifelong interest in the art of the Old Masters, making nearly 400 copies after them from his apprenticeship in the early 1860s to his very last years, when one might have expected him to have exhausted all that tradition could teach. Further evidence of this interest may be found throughout the artist's letters and in the numerous accounts of those critics and disciples who visited him in his reclusive old age, one of whom noted that the aged Cézanne spoke of the Old Masters as though he had known them.[1] But the most enduring testimony to Cézanne's reverence for the past are his own pictures. Though the majority of these were painted directly from nature, in the manner of the Impressionists, they bring to mind instead the imaginary and more deeply considered art of the museums. Like the great masterpieces of Renaissance and Baroque formal design which Cézanne repeatedly studied in the Louvre, his own canvases possess a solidity and seriousness which recall the monumental art of the past. In this respect Cézanne's achievement embraces both the past and the future. Standing at the threshold of the revolutionary art of our own century, it may also be seen as a synthesis of the ideals of Impressionism and of the Old Masters – or, as Emile Bernard described it, as 'a bridge ... which brought Impressionism back to the Louvre'.[2]

Of all the Old Masters with whom Cézanne has been associated, none affords a more fundamental precedent for his own art than the founder of French classicism, Nicolas Poussin. Both were supreme masters of landscape painting, Poussin standing at the beginning and Cézanne at the end of the great tradition of the French landscape school. At the start of this development, in the mid-seventeenth century, Poussin created a group of landscape compositions which were destined to found a new category of painting – that of the heroic or classical landscape. In the landscape paintings which form the largest single category of Cézanne's art he too created works of a grandeur and austerity which recall the classic art of Poussin and remind us that one of Cézanne's self-styled ambitions was to 're-do Poussin over again according to nature'.[3] It is not difficult to understand why this pronouncement has become one of the canonical explanations of Cézanne's art; for at the deepest level of his creative being, Cézanne inhabits something of Poussin's own world. Two centuries – and two fundamentally different approaches to landscape painting – may separate the art of these two great masters. Yet both are capable of arousing in us a sense of nature's majesty and permanence and of its hidden and unassailable truths. Their mature landscape paintings are among the most elevated visions of nature ever conceived.

A comparison between Cézanne's *La Montagne Sainte-Victoire* [fig. 16; No. 38] of 1885–87 and Poussin's *Landscape with the Gathering of the Ashes of Phocion* [fig. 15; No. 19] of 1648 may serve to demonstrate how both artists create this impression. Though different in style and content, these two works are comparable in conception.

Our immediate impression is of a sealed and self-contained world. Both scenes are bounded by an outcrop of mountains or rocks and firmly framed to either side, the Poussin by two groups of trees and the Cézanne by a group of trees at the left and an ascending hill at the right whose contour appears inverted in the land below, effectively closing off this side of the composition. Atmospheric perspective is avoided, with distant objects appearing as distinct in outline and intense in colour as those in the foreground of each scene. Minus the limitless vistas and less confined compositions favoured by more naturalistic painters, Cézanne and Poussin create an image of remarkable compression and concentration which insistently stresses the overall surface design. Another departure from naturalism is the comparative indifference of both artists to the passing phenomena of nature. The landscapes are bathed in a steady, noonday light and neither the time of year nor the conditions of weather occupy the painters' attentions. To be sure, Poussin spans his scene with a passing group of clouds. But even these seem primarily intended to mirror the solid forms of the surrounding trees and hills rather than to create the impression of a fleeting moment. Cézanne, on the other hand, hardly

ever paints clouds in his mature landscapes, which, like those of Poussin, portray a timeless vision of nature.

The stability of these landscapes is further aided by their principles of construction. Both scenes are organised around the central axis and arranged in a series of planes receding parallel to the picture plane. When combined with the balance and symmetry of the overall construction, this lends to them a commanding frontality. The result is an image of remarkable equilibrium and repose, which calls to mind the prevailing order and harmony of nature.

In addition to presenting us with an eternal vision of landscape, Cézanne and Poussin also present us with a truly comprehensive one. Both pictures consist of a rhythmically integrated arrangement of trees, mountains, buildings and terrain which appear welded together, with the soft and rounded forms of the natural world contrasted with the hard and geometric shapes of the man-made elements to afford an image of nature's prevailing unity and diversity. All of these forms have been reduced to solid, simple shapes which are devoid of many of those features which distinguish them in nature – surface texture, material substance, or even function. Thus, a mountain or tree as painted by either artist is pre-eminently a form co-existing with other forms in the picture rather than an object of status and significance in its own right. This ability to give to all elements of their pictures the maximum of plastic expression – and to deprive them of any concerns unrelated to painting – adds to the purity and impersonality of both artists' works.

Closely related to this concern with the most essential features of a form is the desire of both Cézanne and Poussin to relate these to other forms in the landscape and to achieve by this an abstract unity over the entire picture surface. In Cézanne's *La Montagne Sainte-Victoire* the shape of the central pine mirrors that of the distant mountain, while the branch at the lower right of this tree aligns itself with the road below. In Poussin's *Phocion*, the groups of trees to either side of the scene frame the central buildings, the road leading diagonally into the picture appears parallel to the line of hills at the right, and all elements of the scene are rendered with an equal clarity and accentuation which stresses the two-dimensional harmony of the construction. It is as though all of these forms have found their ordained place in the scheme and are bound up ineluctably with every other element in the picture to create the impression of a supremely well-ordered world – one endowed with a finality and formal perfection which characterise the essence of the classical vision of landscape.

For all their similarities, there are equally important differences between the landscape art of Cézanne and Poussin. The most obvious of these is the contrasting size of their pictures, one which reflects the differing traditions and circumstances in which they worked.

Like the majority of his contemporaries, Poussin painted his pictures on commission, creating medium to large-scale works in his studio for a group of discerning private patrons, who appreciated the intellectual rigour and refinement of his art – and who inhabited dwellings large enough to accommodate it. Cézanne, on the other hand, received hardly any commissions for his pictures, which found few buyers until the last decade of his career, and painted his landscapes out-of-doors on modestly sized canvases which were well suited to this manner of working.

These differences also account in part for the contrasting subject-matter of the two artists' works. In Poussin's *Landscape with the Gathering of the Ashes of Phocion* the artist treats an important theme from ancient history. The widow of the great Athenian general, Phocion, is shown gathering her husband's ashes on the outskirts of Megara after he had been condemned to death by his detractors in Athens and refused burial within the city walls. Poussin's choice of theme reflects the belief of both himself and his patrons that the noblest art should concern itself with elevated subjects from the bible, mythology, or ancient history. Cézanne, however, portrays nature devoid of any literary content or even of any trace of humanity. As an artist of the nineteenth century, he is willing to depict it on its own terms. Admittedly, Cézanne is rare among artists of his time in excluding humanity entirely from his landscape paintings. But this only serves to lend to them a remoteness and austerity comparable to that which Poussin achieves by locating his scene in the classical past. In either case the artist seeks a vision of nature which appears removed from ordinary human concerns. Inviting neither entry nor participation, it demands only contemplation.

These disparities in subject-matter also reflect the artists' differing intentions in painting these scenes. Before turning to landscape, Poussin specialised in figure pictures of important historical themes, which were intended to edify and instruct his audiences – in short, to serve a moral purpose. In his mature landscape paintings, this desire is also apparent through the combination of a didactic theme with an image of perfected nature which reflects the artist's own moral aspirations and serves to elevate both the mind and soul of the viewer. In contrast, Cézanne chose simply to portray 'the manifold picture of nature';[4] and, rather than making landscape the expression of a human idea, sought to reveal its own underlying logic and reason.

Cézanne's desire to remain faithful to the essence of nature also led him to explore an additional dimension of the living world in his mature landscape paintings. This is its dynamic vitality and its ceaseless capacity to change. In the *Montagne Sainte-Victoire* these aspects of nature are evoked by the pulsating brushstrokes and seemingly infinite colour modula-

tions which build up the scene, as also in the emerging forms of the landscape itself. All of these endow his picture with a sense of the formative processes of nature which contrasts with Poussin's more static and intellectual approach to the theme.

Cézanne's immersion in the world of living nature also points to the most fundamental of all differences between these two artists. Although Poussin was an attentive observer of nature, which he regularly drew in his walks around Rome, his landscape paintings were created in the studio through the joint efforts of the intellect and the imagination. Cézanne followed a more arduous path. Faced with a confusing scene in nature, he sought to wrest from it an underlying order and harmony through a careful process of selection and discrimination which gradually revealed hidden affinities between the most disparate elements in the scene. Thus, if Poussin's classicism was *made*, Cézanne's had to be *found*. As the artist reputedly admitted to Bernard, his goal was 'to become classical by way of nature, that is to say by sensation'.[5] This explains why Poussin's principles of landscape composition re-emerge in Cézanne in a radically altered guise. Far from being the products of imitation – or even conscious emulation – the essential similarities one observes between the landscape paintings of these two artists spring from a common desire to reveal the most enduring facets of creation. Because this relationship exists on so fundamental a level, it strikes one as the profoundest of all bonds between two great creative minds – one founded on a true kinship of spirit.

Poussin was over fifty when he turned his attentions seriously to landscape painting in 1648. Already in his earliest figure pictures, however, landscape often figures prominently as the background to a human subject. This is especially true of a group of romantic early mythologies datable to Poussin's first years in Rome. In their rich colour and lighting and intensely poetical mood, these works reflect the influence of Titian and his fellow Venetians and contrast with the severely classical art of Poussin's maturity, which took its inspiration instead from the art of Raphael and the antique. Many of these pictures treat Ovidian themes of unrequited love and reveal Poussin's own ardent and passionate nature at this youthful stage of his career. One of the finest of them, the *Echo and Narcissus* [fig. 18] of 1629–30 in the Louvre, depicts the dying Narcissus lying beside the pool in which he had admired his reflection. Behind him appears Echo, the nymph who loved him unrequitedly. She is here shown withering away, her bones turning to stone and only her voice (or 'echo') remaining. At the right, a mournful putto holds a silent vigil over the dying couple. The group is set against a landscape whose smouldering evening sky and gradually waning light breathes the very atmosphere of romantic loss, reflecting the pathos of the theme and the fragility and

transience of human life – and love. In its sensuality and emotionalism the picture reveals a streak of wild poetry in the youthful Poussin which is confirmed by an early self-portrait drawing [fig. 17] of *c.* 1630 in the British Museum. In this the artist appears at once

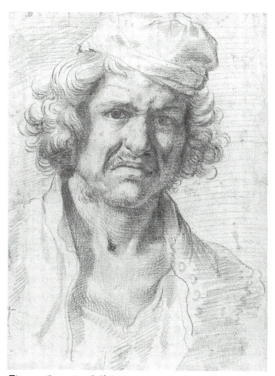

Fig. 17. Poussin, *Self-Portrait, c.* 1630 (British Museum, London)

uncouth and uncompromising, the turbulence of his nature evident in his knotted brow and petulant lip – a dramatic contrast to the sobriety of his painted *Self-Portrait* [fig. 1] of 1649–50 in the Louvre and one which reminds us that, like Cézanne after him, this great classical master of painting only came into being by wilfully suppressing the darker and more romantic side to his genius.

The sensitive portrayal of nature of the *Echo and Narcissus* suggests an early interest in landscape which is confirmed by Poussin's first biographers, who note that in the years around 1630 the artist frequently undertook sketching expeditions into the Roman campagna with his friends and fellow-painters, among them Claude Lorrain and Poussin's brother-in-law, Gaspard Dughet. Although none of Poussin's drawings from nature have been unanimously assigned to this stage of the artist's career, the fruits of these studies are evident in his earliest surviving landscape paintings, which date from around 1635.

Among these are the two landscapes with travellers resting and a youth drinking from a stream in the National Gallery and the related canvas with a man pursued by a snake at Montreal [Nos. 1–3]. In all of these the scene is organised around a receding road or

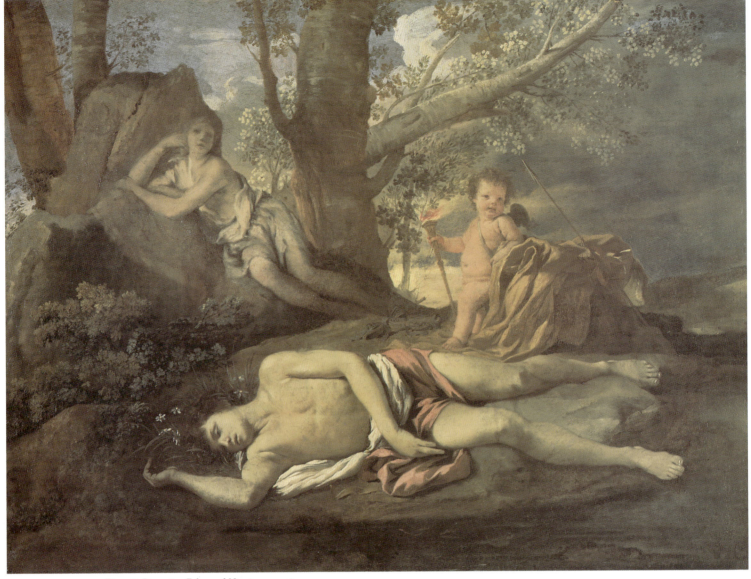

Fig. 18. Poussin, *Echo and Narcissus, c.* 1629–30
(Musée du Louvre, Paris)

river lined by hillocks and trees and bounded by a row of distant hills. Space is defined by outcrops of land which slot into the composition from the sides, like a series of wings, and limit the extent of the view. Though the transitions between planes appear somewhat arbitrary, Poussin creates a semblance of naturalism through the undulating contours of the land and the thick and textured application of paint. The latter reveals a sensuous delight in the material properties of objects in nature which the artist was soon to renounce in favour of a more idealised vision of landscape. The former creates the impression that one is glimpsing an unprepossessing stretch of the Roman campagna peopled with anonymous travellers. In keeping with their modest size and ambition, none of these works is concerned with a specific literary

theme but only with the activities of ordinary man set into an imaginary landscape which appears designed to look topographical. Already at this stage of his career, however, Poussin reveals his inherently classical approach to landscape painting in the balance and firmness of the construction of these pictures, the clear use of framing elements to close off the composition, the clarity of the light, and the simplified forms of the trees and terrain.

Many of these features are also apparent in Poussin's rare landscape drawings. Only about twenty of these survive, the majority of them datable to the 1630s and 1640s, the period when Poussin was most active as a landscape painter. Although some of these are invented compositions and a few may be related to paintings, most are independent studies done directly

from nature and executed in pen and bistre wash, a technique which Poussin presumably derived from Dutch artists working in Rome and one much favoured by Claude. This permitted Poussin to capture the most intense effects of light with an unparalleled boldness and immediacy. Among the most striking of the artist's landscapes drawings are the *Five Trees* [fig. 19] in the Louvre of 1635–40 and the *View of the Aventine* [No. 26] in the Uffizi of the mid-1640s. In both of these, saturated areas of wash interspersed with the white of the paper reduce the wayward forms of the landscape to summary shapes and reveal Poussin's unerring desire to penetrate to the most essential features of a scene. In the *View of the Aventine* the framing horizontals of the buildings and river bank at the top and bottom of the sheet are linked by an ascending hill lined with trees. Intense sunlight playing over the scene is captured in a bold sequence of washes which forms haloes around the trees and connects the main axes of the composition. In the even more economical *View of the Tiber Valley* [No. 27] of this same period Poussin reduces the motif to a striated sequence of washes bounded by the framing diagonals of the foreground and the distant hills. Here he uncovers an abstract order in nature comparable to that which he created from his imagination in the landscape paintings devised in his studio.

Poussin's rapid development as a landscape painter may be seen if one compares the three little landscapes of around 1635 with the pendant compositions with *St Matthew and the Angel* [No. 5] and *St John on Patmos* [fig. 9] which date from the year of the artist's departure for Paris, 1640. In their principles of construction and their range of interest, these works anticipate the heroic landscape style of Poussin's maturity. Both portray an expansive landscape setting seen from a high viewpoint, which permits the eye to progress unimpeded from the seated figures in the foreground to the distant hills. Even more importantly, Poussin introduces into both compositions motifs which will figure prominently in all of the most classically conceived landscapes of the end of the 1640s – namely, buildings and architectural remains. With their prevailing verticals these provide an effective counterbalance to the horizontals of the land; while their straight lines and sharp edges afford a contrast to the soft and irregular forms of the natural world and enhance the gravity of the impression. This is particularly true in the foreground of each picture, where Poussin places a group of architectural fragments whose cubic and cylindrical shapes echo the forms of the distant buildings and serve to strengthen and stabilise the entire design. In the more intricate *Landscape with St John on Patmos* the arrangement of these forms mirrors the pose of the evangelist, adding further to the clarity and cohesion of the composition. The result is the most rigorously designed landscape so far encountered in Poussin's career – one in which

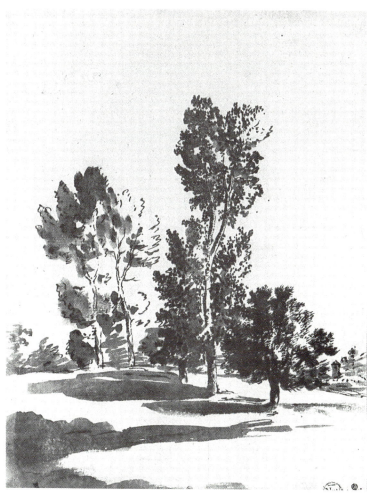

Fig. 19. Poussin, *The Five Trees*. Drawing (Musée du Louvre, Paris)

even the insubstantial forms of clouds and trees are reduced to solid, impenetrable shapes, as though bending their will to the hidden geometry of the whole.

Poussin's heroic conception of nature clearly owes much to the pioneering achievements of two of the founders of the classical landscape tradition in Rome, Annibale Carracci (1560–1609) and his pupil Domenichino (1581–1641). In Annibale's lunette of the *Flight into Egypt* [fig. 20] of c. 1604 or Domenichino's landscape of the same subject [fig. 21] of the mid-1620s one observes a comparable desire to create a lucidly bounded space and harmoniously integrated surface design through a careful balancing of vertical and horizontal accents and an orderly arrangement of all elements of the composition. In Annibale's landscape the gently undulating contours of the land and the rounded forms of the trees and buildings create a tender and lyrical impression which befits the subject. Domenichino aims at a more imposing effect in his own *Flight into Egypt*, with its massive outcrop of mountains and buildings and its almost bewildering

40

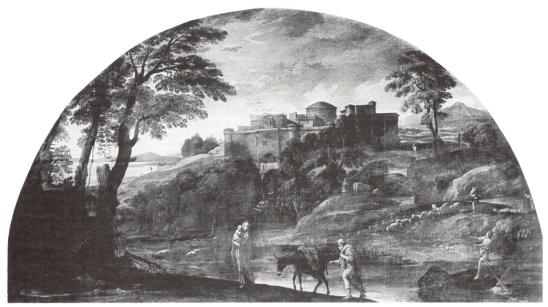

Fig. 20. Annibale Carracci, *Landscape with the Flight into Egypt*, c. 1604
(Galleria Doria Pamphili, Rome)

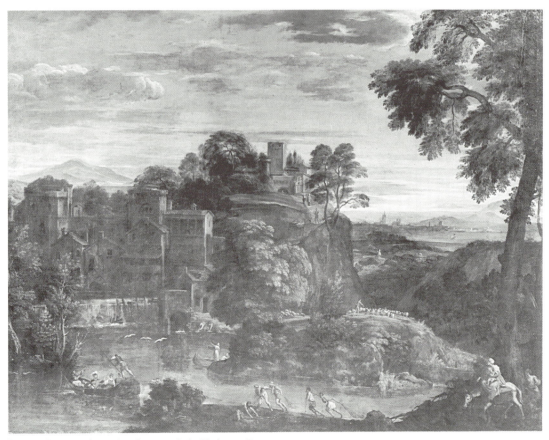

Fig. 21. Domenichino, *Landscape with the Flight into Egypt*
(Musée du Louvre, Paris)

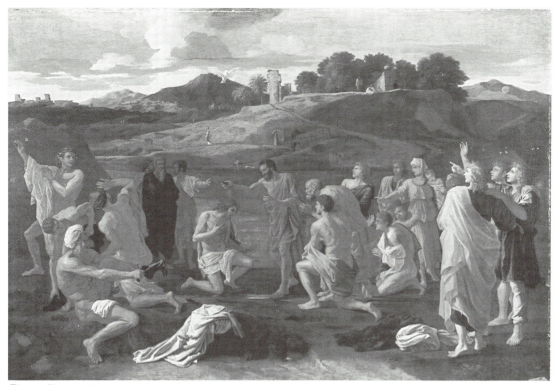

Fig. 22. Poussin, *Baptism*, 1646
(Duke of Sutherland; on loan to the National Galleries of Scotland)

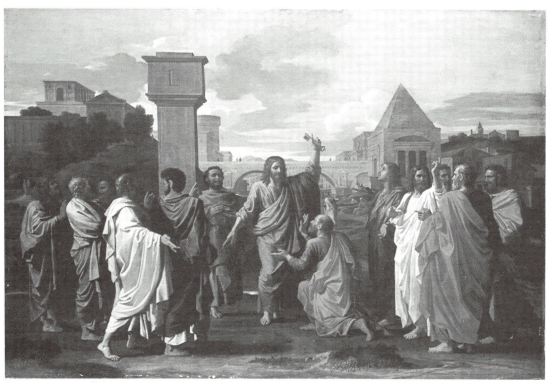

Fig. 23. Poussin, *Ordination*, 1647
(Duke of Sutherland; on loan to the National Galleries of Scotland)

range of motifs. So scattered and animated are its numerous figures that it is easy to overlook the all-important group of the Holy Family at the lower right of the picture. Although Poussin's evangelist landscapes appear indebted to both of these masters in their compositional methods and their choice of motifs, they already surpass them in concentration and control. In the Chicago *St John*, especially, Poussin combines the harmony of Annibale with the grandeur and diversity of Domenichino to create a scene which is at once both unified and varied.

The years which separate these pictures from the great series of landscapes Poussin embarked upon in 1648 were occupied largely by the artist's unhappy visit to Paris and by the creation of the second series of *Seven Sacraments* [cf. figs. 22 and 23], painted for Paul Fréart de Chantelou between 1644–48 and now on loan to the National Gallery of Scotland from the Duke of Sutherland's collection. These are among the most deeply meditated compositions of Poussin's career and represent one of the summits of his achievement as a classical painter.

One feature of the *Sacraments* which makes them so intensely satisfying as designs is the integral relationship which exists throughout them between the figures and their setting. In the one member of the series which includes a landscape background, *Baptism* [fig. 22], the configuration of the land on the opposite bank of the River Jordan follows that of the figure group below, with the diagonals of the hills at the left echoing the animated poses of the figures donning their garments and the prevailing horizontals at the right following the line of heads of those awaiting baptism on this side of the design. Even the architectural elements on the distant hillside or the glancing shadow which traverses it appear positioned to emphasise the centrally placed figures of Christ and the Baptist. Such a methodically integrated arrangement may be compared with Poussin's earlier combination of figures and landscape in the Louvre *Echo and Narcissus* [fig. 18], where the two appear more informally composed and loosely related, and where colour and light serve instead to unify the scene. In contrast, *Baptism* relies upon a rhythmic disposition of elements which add rigour and coherence to the scheme and prepare the way for the rationally conceived landscapes of Poussin's maturity.

The years between 1648 and 1651 marked the most productive phase of Poussin's career as a landscape painter. During this period the artist completed more than a dozen major landscapes. In their range and complexity, these surpass any of his previous achievements in this field and were destined to provide a model for artists into the nineteenth century.

This is especially true of the pendant compositions illustrating the story of Phocion [Nos. 18 and 19], in which Poussin matches the nobility of his hero with two of the most majestic landscapes of his career. The first of these portrays an earlier moment in the story to the Liverpool canvas with which we began and centres upon two servants bearing Phocion's body out of Athens. Above them rises a panoramic view of the outskirts of the city organised in a series of strictly receding planes and containing the most diverse range of elements so far encountered in Poussin's art.

The spatial construction of this picture is of the greatest clarity and contains none of the somewhat abrupt transitions between planes still evident in the two evangelist landscapes of 1640. Instead, Poussin delineates the sweeping progression back into space through an orderly sequence of figures, pathways, hillocks, and buildings which gradually diminish in size and carefully mark the extent of the view.

Poussin's treatment of individual motifs in this picture testifies to the control which he exercised over all aspects of the design. Tufted trees dot the landscape at regular intervals, standing as erect as the surrounding architecture. Buildings and masonry reveal their clean edges and smooth surfaces, enhancing the rhythmic exactitude of the whole. At the upper right a tree resembling a greatly magnified branch fans out flatly across the sky, its movement continued in the slowly moving clouds which span the scene. Adding to the rhythmic articulation of the composition are the light accents, which are carefully distributed to the centre and sides of the design, where they aid the methodical progression back into space. Finally, the diminutive figures which inhabit the landscape are themselves subtly diversified. The majority of them are in attitudes of repose, which reflect the contemplative nature of the scene. But a few are caught in motion and charge the scene with tension.

Although the Phocion landscapes portray an imaginary and highly idealised view of nature they also reveal a profound understanding of its prevailing order and richness. This is apparent in the animation and variety of both scenes, the vivacity of their lighting and handling, and the clarity and coherence of their construction. The last of these features may be usefully compared with that of Domenichino's *Flight into Egypt* [fig. 21]. The landscape in this picture consists of a somewhat disjunct arrangement of elements which appear to have been conceived as separate units and brought together to form a larger whole. This impresses us more as an anthology of natural motifs than as a convincing scene. When Poussin devises a landscape, however, he endows it with a logic and rationality which parallel nature's own order and reason and make his ideal landscape look believable.

Poussin applies these same strict methods of composition to two more modestly sized landscapes of 1648 which depict no identifiable literary theme. These are pendant pictures with a *Man washing his Feet at a Fountain* in the National Gallery and a *Roman Road* at Dulwich [Nos. 20 and 21]. The latter demonstrates

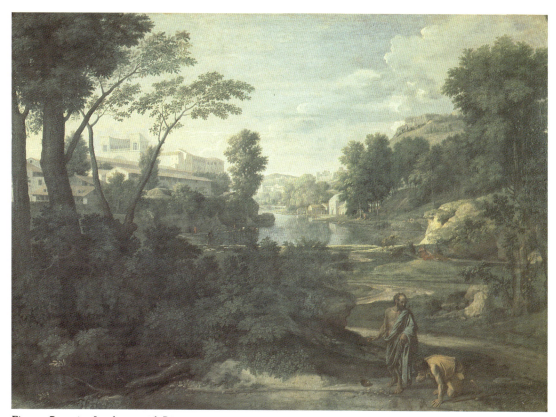

Fig. 24. Poussin, *Landscape with Diogenes*, 1648
(Musée du Louvre, Paris)

in its purest form a device Poussin regularly relied upon during these years to reconcile the spatial illusion of his pictures with the two-dimensional surface design. The deeply receding space of this work is marked by an orderly progression of vertical and horizontal elements lining the roadside. Regardless of their position in space, all of these elements are aligned parallel with the edges of the frame and stress the taut surface unity of the construction. The result is a strict integration of space and surface which, as we shall see, also appealed to Cézanne's rigorous methods of landscape composition.

Little is known of Poussin's procedure in devising his landscape paintings, though there is some evidence that he may have evolved these pictures more intuitively than their order and rationality might lead one to suspect. Preparatory drawings for one of them indicate that the artist embarked upon the composition with no clear theme in mind and worked out both the subject and the design as he went along.[6] Yet another landscape of this period shows extensive revisions on the canvas itself, indicating that Poussin did not devise this composition through a series of preparatory drawings in the painstaking manner he invariably adopted for his figure pictures of this period.[7] Until X-ray evidence of many more of the artist's landscapes is available it will be impossible to know how widely he adopted this method; but the

possibility should not be discounted that Poussin devised these pictures by mocking them up in his studio, using fragments of natural objects arranged before him in much the same way as he employed wax models for this purpose when devising his figure paintings.[8] This theory gains support from at least one early writer on the artist, who observed Poussin transporting pebbles, bits of moss, and flowers back to his studio, where they may have been intended to serve such a purpose.[9] It is further strengthened by the fact that certain of the motifs that appear in his landscape paintings look like greatly enlarged fragments of nature and add to the veracity of even his most idealised scenes. In the *Landscape with a Man washing his Feet at a Fountain*, for instance, the artist reveals a delight in the accidents and irregularities of life which cannot fail to engage the viewer. This may be seen in the mixture of animated and self-absorbed figures which inhabit the scene, as also in the congenial nature of their surroundings, with its winding pathways, roadside shrines, and sheltering trees.

Two other landscapes of these years show nature in a wilder and more primitive state. These are the *Landscape with Diogenes* [fig. 24; No. 22] of 1648 and the undated *Landscape with Buildings* [No. 23]. The former is one of the most imposing of all Poussin's landscapes, with its luxuriant vegetation, intoxicating range of greens, and soft and atmospheric touch.

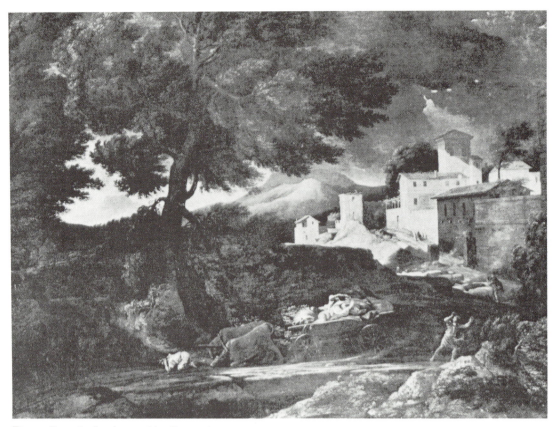

Fig. 25. Poussin, *Landscape with a Storm*, 1651
(Musée des Beaux-Arts, Rouen)

Despite the splendour and clarity of its construction, the picture possesses a pristine beauty which reveals Poussin's familiarity with original nature. This is apparent in the subordinate role accorded to architecture and in the tonal and colouristic subtlety of the scene. The same may be said of the *Landscape with Buildings*. Though Poussin here depicts a craggy and uncultivated landscape, the picture is as strictly designed as any of his compositions of this period, with framing trees and a clear emphasis upon the central axis. This basic scheme is enlivened through the welter and variety of natural motifs which Poussin includes in the picture – blasted tree-stumps, windswept branches, dense undergrowth, and a conscious mixture of bare and leafy trees. Though none of these species may be identifiable, they afford a convincing parallel to nature's own richness and diversity and remind us that one of the features of Poussin's art which renders his classicism so compelling is the degree to which it is guised in the semblance of ordinary life.

Poussin's mastery of the diverse moods of nature also led him to create two storm landscapes during this period. These explore the effects upon mankind of the most malevolent states of nature. One of them, the *Landscape with a Storm* [fig. 25] of 1651 at Rouen, portrays a dramatic scene of terror and violence in nature which anticipates the visionary landscape style of the artist's last years. The pendant to this picture, the *Landscape with a Calm* [No. 24] centres upon the figure of a goatherd guarding his flock in a mood of peaceful contentment with nature. Taken together, these two contrasting scenes illustrate a theme which was to become a central concern of Poussin's late landscapes: that of the relationship between the vicissitudes of human life and the changing cycles of nature. The *Calm* landscape itself looks even further forward than this. In this pristine portrayal of uneventful nature, Poussin gently nudges the classical landscape of the seventeenth century in the direction of Corot and Cézanne by investing it with a delicacy and luminosity which anticipate the achievements of those later generations of artists who would increasingly seek to wed the principles of classical landscape painting to the direct observation of nature.

Cézanne is first recorded studying Poussin's art in 1864, when he applied for permission to copy the celebrated *Arcadian Shepherds* [fig. 26] in the Louvre.[10] By this time he may already have been familiar with Delacroix's important essay on Poussin of 1853, which praises the French master as one of the most revolutionary of artists, and with Balzac's short story of more than twenty years earlier, *Le chef-d'œuvre inconnu*

(1831), in which the young Poussin witnesses the creative struggles of the mad genius Frenhofer – a tale that reputedly moved Cézanne to tears in later years.[11] He is also likely to have been aware of the importance which Poussin's art held for the landscape painter of his native Aix, François-Marius Granet, who had died in 1849, bequeathing his collection to the museum in that town (now the Musée Granet), where the curator was Joseph Gibert, Cézanne's first drawing master.

Although Cézanne's early copy of Poussin's *Arcadian Shepherds* no longer survives, he made two partial copies of this composition in drawings of 1887–90 [figs. 27, 28] and also copied a portion of Poussin's *Concert of Putti* during these same years.[12] In all of these – as in so many of his drawings after the Old Masters – Cézanne explores the formal principles which unite the figures with their surroundings, analysing the sequence of parallels which link the arm, neck, and head of Poussin's shepherdess with the tree behind her or the converging diagonals of the body and staff of the bending shepherd, which lend such stability to this figure – as though seeking to lay bare the underlying order and armature of Poussin's monumental design. Later in life, Cézanne also hung a reproduction of the *Arcadian Shepherds* up in his studio. According to Rivière and Schnerb, who observed it there a year before Cézanne's death, 'the beauty of the subject pleased him. He loved Poussin, in whom reason substituted for facility.'[13] Obsessed with thoughts of death during these years, Cézanne was surely aware that the 'beauty' of Poussin's allegorical theme comprised the essence of his own daily struggles – that of reconciling man's inescapable fate with the enduring life of nature.

Many of the artists and critics who visited Cézanne in his last years note that the artist spoke repeatedly of Poussin and confessed to having modelled his art on that of the French master. Though the reliability of certain of these accounts has been questioned, circumstantial evidence suggests that they are essentially true and that Cézanne regarded Poussin as an important precursor of his own approach to landscape painting.[14] Even less disputable is the fact that the landscape art of both masters developed along parallel paths and eventually led Cézanne to be regarded as the spiritual heir of Poussin – or, as Maurice Denis put it only a year after the artist's death, as 'the Poussin of Impressionism'.[15]

Cézanne's earliest essay in landscape painting, the *Landscape with a Fisherman* [fig. 49] of 1860–62, which until recently decorated a wall in the family's former residence, the Jas de Bouffan, is a conventional composition in the academic landscape tradition of the mid-nineteenth century which claimed direct descent from Poussin.[16] His earliest paintings from nature, however, reveal a much more independent spirit, reducing the forms of the landscape to summary shapes laid down with the broad strokes of a palette knife or the sweeping force of a heavily loaded brush – both techniques familiar in the art of Courbet and Pissarro, two of the young Cézanne's chief models. Though modest in size and experimental in handling, these works possess a passionate sincerity which already reveals Cézanne's determination to penetrate to the most essential features of his chosen motif. Already, too, those motifs are his own. Humanity is largely banished from these youthful exercises in landscape painting, and man-made elements themselves rarely seen, with Cézanne preferring scenes of undisturbed nature – meadows, river banks, and rolling hills – and rendering these with a vigour and defiance which amount to an assault upon the scene. In the little *Landscape* [No. 9] of c. 1865 at Vassar, abrupt changes of hue combine with the repeated curves of rocks, hillocks, and trees to create a loosely interlocking arrangement of shapes which define the broad contours of the land. As these areas overlap, space is engendered. Denying it already, however, is the strength and insistence of Cézanne's vehement brushwork.

The unbridled energies of this very early style appear subordinated to a prevailing formal order in the Tate Gallery's *Avenue at the Jas de Bouffan* [No. 10] of c. 1869–70. In this boldly designed work Cézanne alights upon one of the favourite motifs of his career – the view of a receding road lined with trees whose repeated verticals form an effective counterbalance to the horizontal divisions of the land. As in Poussin's *Roman Road*, this permits the artist to create space without the use of converging diagonals and aligns all the forms of the picture with the axes of the frame. In the Tate canvas Cézanne adopts a more dynamic arrangement, which includes a third series of parallels formed by the criss-crossing diagonals of the foliage and pathway. Adding to the strictness of the composition are the emphatic colour divisions and the equally striking contrasts of tone. The result is a rigorously – if somewhat schematically – ordered scene which, in its clarity of conception, recalls the undisputed masterpiece among the artist's early landscapes, the *Railway Cutting* [fig. 29] of c. 1870 in Munich. The latter reveals an even more conscious application of the principles of classical landscape painting to an observed scene in nature in its three-fold division of the motif, the centrally placed cutting and signal box flanked on the left by the house and hill and, on the right, by the imposing profile of the Mont Sainte-Victoire. In the rigid alignment of all elements of the scene Cézanne attains a grandeur and equilibrium before nature which already reveal the power and seriousness of his landscape art.

At this stage of his creative development, however, both of these are achieved through a domination of the motif which scarcely heeds nature's own subtlety – or prodigality. For all its undoubted accomplishment, the *Railway Cutting* betrays that 'exaggerated fierceness'

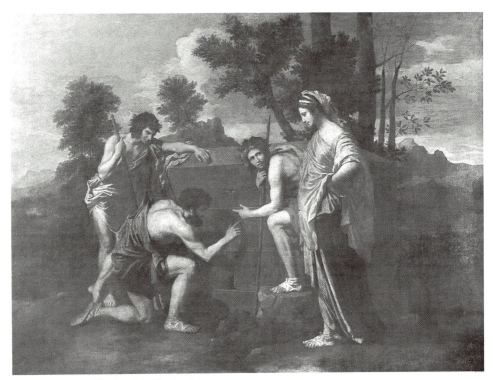

Fig. 26. Poussin, *The Arcadian Shepherds*
(Musée du Louvre, Paris)

Fig. 27. Cézanne, *Arcadian Shepherd* (after Poussin),
c. 1887–90. Drawing (Kunstmuseum, Basel)

Fig. 28. Cézanne, *Arcadian Shepherdess* (after Poussin),
c. 1887–90. Drawing (Kunstmuseum, Basel)

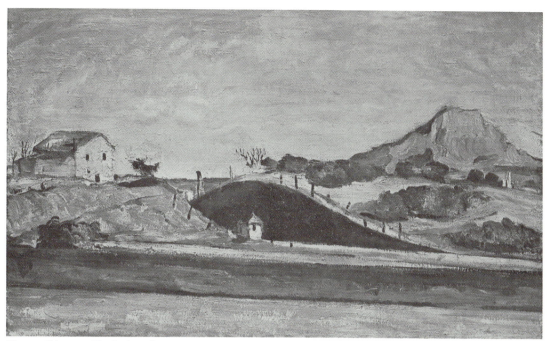

Fig. 29. Cézanne, *The Railway Cutting*, *c*. 1870
(Bayerische Staatsgemäldesammlungen, Munich)

Cézanne's contemporaries detected in his youthful temperament and which the artist himself portrayed in a *Self-Portrait* [fig. 30] of *c*. 1872, now in the Musée d'Orsay. As an image of aggressive defiance and unflinching determination, it is reminiscent of Poussin's early self-portrait drawing [fig. 17] and concludes a romantic early phase in Cézanne's career when he – no less than Poussin – painted with 'the fury of a devil'.

During the early 1870s Cézanne's landscape style underwent a fundamental change. In 1870 he began painting in the little town of L'Estaque on the shores of the Mediterranean outside Marseilles, which was subsequently to furnish him with some of his grandest landscape subjects. Two years later he moved to Pontoise, outside Paris, where he began to work alongside Pissarro, whom he was always to regard as his chief artistic mentor. By the autumn of that year he had moved to nearby Auvers, where he remained until 1874 and painted his first major group of landscapes, among them the well-known *House of the Hanged Man*, exhibited at the first Impressionist exhibition in 1874 and now in the Musée d'Orsay.

Under the influence of the 'humble and colossal' Pissarro, Cézanne abandoned the dramatic and impassioned style of his youth and became increasingly attentive to the nuances of light and colour to be found in nature. His palette brightened to include light greens, yellows, greys, and vibrant reds and blues; and the prevailing tonality of his pictures lightened and acquired a new subtlety of range in response to the variegated play of light he observed

before him. The surface texture of his pictures likewise altered. Although Cézanne continued to favour a thick application of paint, which gives power and authority to his images, he gradually dispensed with the flowing brushstrokes of his earlier landscapes in favour of a layered application of mosaic-like touches which lend a flickering intensity to his canvases.

The delicacy and luminosity of this approach led to the creation of Cézanne's most purely Impressionist pictures. But the artist's new-found humility before nature was not without its attendant dangers. In a style concerned to record the surface phenomena of nature, pictorial structure might be lost. As though to safeguard against this, Cézanne invariably chose to paint scenes which were themselves highly structured during these years. In the majority of them architecture figures prominently, as in the *Small Houses at Auvers* [No. 12] of 1873–74. And, in a whole series of intimate and somewhat prosaic views, Cézanne returned to the motif of a receding road lined with buildings and trees, which assured him of a balanced composition. One of these, the *Road at Auvers* [No. 11] at Ottawa, is painted in muted and wintry greys – the hue which Cézanne had admitted to Pissarro in 1866 'alone reigns in nature, but is terrifyingly hard to catch'.[17] Even in his most panoramic landscapes of these years, he often chose to portray a distant view of a town framed by trees, the inherent classicism of his vision asserting itself even during the most naturalistic phase of his art.

As though to reaffirm this, Cézanne painted one of his rare imaginary landscapes during this same period.

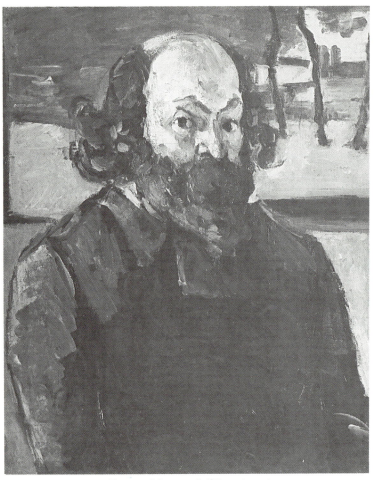

Fig. 30. Cézanne, *Self-Portrait*, c. 1872
(Musée d'Orsay, Paris)

This is the *Harvest* [fig. 6] of 1875–77, a scene of such order and harmony that Poussin himself would not have disavowed it. Indeed, both the theme and design of this work have frequently been related to *Summer* [fig. 5] from Poussin's *Four Seasons* in the Louvre, a picture which (according to Gasquet) Cézanne especially admired and strove to emulate.[18] With its centrally positioned figures and buildings, its parallel recession, and its framing trees, the *Harvest* remains Cézanne's most studious application of the principles of classical landscape painting, even to the point of employing that favourite device of Poussin himself – cloud formations which echo the shapes of the surrounding trees and ensure the rhythmic continuity of the composition. Although the picture remains an exceptional work in Cézanne's career, it affords tantalising evidence of the form his landscape paintings might have taken had he chosen to have his own way with nature and paint from the imagination.

No less revealing of Cézanne's unwavering commitment to pictorial structure is one of the most intimate and spontaneously handled landscapes of these years, the *Pool at the Jas de Bouffan* [No. 13] of 1875–77 at Sheffield. The choice of motif – a single tree surrounded by shrubs and fields and overlooking a tranquil pool – would hardly appear to contain much potential for geometry. Yet out of this Cézanne has fashioned a composition which is almost naive in its simplicity. Faced with the foliage, flowers, and reflections which animate this scene, he has focused upon the only two certainties in the construction, the horizontal of the path and the vertical of the tree. These subdivide the composition into clearly defined areas, wresting mathematical order from nature's confusion. Small wonder that, within a year or two of the completion of this work, Cézanne was dubbed 'a Greek of the great period' by one of his rare early admirers.[19]

Towards the end of the 1870s Cézanne's desire to give added strength and firmness to his pictures is apparent in his modified technique and careful choice of landscape subjects. Increasingly these combine architectural elements with the forms of the natural world to lend both gravity and stability to the scene. Reinforcing this impression is a uniform, diagonal brushstroke which endows the entire picture surface with a taut unity. It is as though, having diversified his style to accommodate the manifold richness of nature, Cézanne now wished to consolidate these new discoveries in a more systematic manner. If his landscapes of c. 1870 had concerned themselves with nature's prevailing order and those of the mid-1870s with its infinite variety, the works which follow them combine both of these approaches.

Among these are the *Château de Médan* [No. 29] of c. 1880 at Glasgow and the *Road with Trees and Pond* [No. 32] of 1879–82 at Otterlo. In their wilful symmetry and grid-like division of the picture surface,

these are among the most rigidly ordered of the artist's works. Comparison of the former with the drawings and watercolour Cézanne made of this same subject [Nos. 30 and 31] are sufficient to convince one that, for him, much of the creative act rested with the choice of a motif and the vantage-point he adopted before it. Within this pattern of intersecting verticals and horizontals Cézanne introduces a diagonal gradient of intensely coloured strokes which conjoin the forms of the landscape like the threads of a densely woven carpet, linking foreground with background and bottom with top. The effect asserts both the binding logic of nature and its sensory richness.

For all its authority, this style runs the risk of appearing schematic in its desire for pictorial certainty – a desire which even led Cézanne to reinforce the basic divisions in one of his landscape drawings of these years [No. 47] with a straight-edge, to ensure the mathematical alignment of the construction. Something of this strictness may still be seen in his *L'Estaque* [No. 35] of 1883–85, with its erect and framing trees and its broad division of the scene into land, sea, and sky. Yet a new respect for the integrity of the elements which comprise the view is apparent in the more varied brushwork of this picture. In the treatment of the rocks and foliage Cézanne still employs the diagonally striated strokes of the immediately preceding years. In the buildings and water, however, he alters the force and direction of his brushwork to follow the prevailing contours of the form. There is still no loss of order. It is there in the classical balance of the composition, the uniform intensity of the colour, and the pulsating vitality of the brushwork. But what has been sacrificed is the conscious intervention of the artist upon the scene. In place of the insistent parallelisms of the *Château de Médan* there now appears a new awareness of the distinctness of things in nature which adds a greater serenity and monumentality to the picture. With works such as *L'Estaque* Cézanne appears poised at a point in his own creative development comparable to that which Poussin attained in 1648 – one in which the magnitude and diversity of the natural world are viewed objectively as part of a unified whole.

This style finds its fullest expression in the magnificent series of landscapes Cézanne completed between 1885–90, by general agreement the most austere and classical phase of his art. A number of features set these works apart in the artist's career. The most obvious is the epic grandeur of their motifs. Two of Cézanne's favourite subjects during these years were panoramic views of the Gulf of Marseilles seen from L'Estaque and of the Valley of the Arc framed by the majestic peak of the Mont Sainte-Victoire. Both are broad, expansive scenes containing a wide range of natural and architectural elements seen from a distant viewpoint and inviting epic treatment. In addition to the ambitiousness of their subjects, many of these works are among the largest and most highly finished landscapes of Cézanne's career, their scale and resolution attesting to the artist's mastery. Scarcely less impressive is the combination of clarity and coherence which endows these works with their commanding authority.

In 1885–86 Cézanne painted a series of views of the town of Gardanne, near Aix. Dominated by the cubic forms of the buildings nestled against the hillside of this town, these are among his most severely geometric works. In them – as in the watercolour of a similar view exhibited here [No. 50] – even the natural forms of the landscape are made to conform to the laws of architecture and are reduced to solid, compact shapes which interlock with the adjacent bridges and buildings.

In the more diversified views of the Mont Sainte-Victoire and the Gulf of Marseilles of these same years, Cézanne likewise endows the landscape with an unshakable stability through a concentration upon the most architectonic features of the scene. A number of these adopt Poussin's device of framing the distant view with foreground trees which tie all elements of the landscape to the surface of the picture and stress the autonomy of the construction. In the great version of the *Gulf of Marseilles, seen from L'Estaque* [No. 45] at Chicago, the composition is anchored by a row of buildings at the bottom, the central one of which is the most solidly modelled form in the entire picture. Bounding it at the top is a distant mountain range. Between these rises the land and sea, its intense blue aligning the far-off mountains with the foreground houses to establish the surface unity of the design. Within this spacious scene Cézanne uncovers further analogies which link all elements of the view. Trees and smoke-stacks stand equally erect; windows and chimneys declare their hidden affinities; the slope of the shore at the left echoes that of the highest mountain; and the vegetation along this shore turns bluer as it approaches the sea. Even that most unexpected of phenomena in Cézanne's world – a fleeting puff of smoke – reaches out across the waters towards a distant jetty. Strength and serenity pervade the scene. From this seemingly infinite series of correspondences, Cézanne expresses the co-existence of all things in nature – that greater reality which he sensed and sought beneath appearances.

In his views of the Mont Sainte-Victoire of these same years, the soaring profile of the mountain itself functions as a form of natural architecture, embracing and stabilising the entire scene. In the versions of this theme in the Phillips and Courtauld Collections [No. 41 and fig. 12] the unfurling branches of two pine trees fan out ecstatically across the sky to crown the contour of the distant mountain, in the manner of Poussin's Phocion landscapes. In the valley below, the lines of roads, fields, and viaduct converge upon that

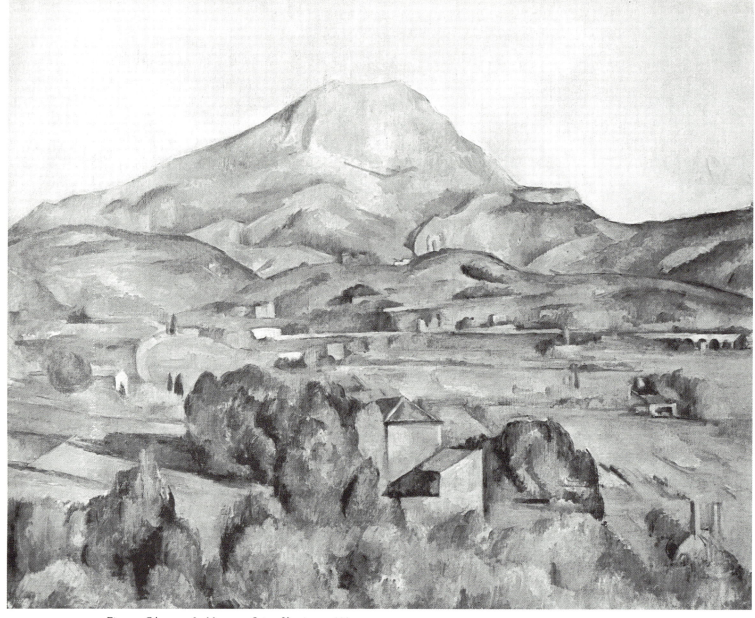

Fig. 31. Cézanne, *La Montagne Sainte-Victoire*, c. 1888–90 (Barnes Foundation, Merion, Pennsylvania)

point at the left where tree and mountain overlap, space and surface meet, and the blue domed roof of a solitary house declares its solidarity with the mountain beyond. Such harmony and equivalences can never have existed in nature. Here Cézanne is not so much 're-doing' Poussin over again according to nature as following his predecessor's own rules of pictorial composition, albeit *sur le motif*. 'Art is a harmony which runs parallel with nature',[20] declared Cézanne in 1897, as though confessing that, even in his divergences from it, he went in search of a higher goal.

The impassioned lyricism and decorative unity of the Phillips and Courtauld canvases are rare among Cézanne's most heroic views of the Mont Sainte-Victoire of this period. More often – as in the Metropolitan Museum's picture [No. 38] already discussed – these scenes are pervaded by a serenity and stillness which reveal the intrinsic beauty of nature. In certain of these the scene is framed by a single tree at the left, a device familiar from Poussin's *Diogenes* or *St John*. But, in what is perhaps the grandest of them all – the version in the Barnes Foundation [fig. 31] – Cézanne sets the mighty silhouette of the mountain squarely in the centre of the picture and surveys the scene from an unimpeded view of unparalleled simplicity – and solemnity. In the foreground, trees and houses take on something of the mountain's own clarity

and curvature, the whole forming an overpowering image of nature's impregnable strength and endurance.

The severity and concentration of this picture are characteristic of Cézanne's landscapes of the years around 1890, which generally forsake the panoramic views of the immediately preceding years in favour of more isolated themes, often focusing upon a solitary motif in nature, as in the *Great Pine* [No. 59] from São Paulo or the Cleveland *Pigeon Tower at Bellevue* [No. 46]. In the former Cézanne employs the interweaving trunks and branches of a group of trees, dominated by a large pine, to link all elements of the scene with a turbulent intensity that anticipates the darker moods of his final years. In the *Pigeon Tower*, however, he creates a remarkably austere and hermetic image through the rigorous symmetry and planarity of the construction and the ruthless simplicity of his approach to form. Stripping away everything from the motif that could not find its correspondence somewhere else in the picture, he reduces the trees to scalloped shapes which mirror the sloping roof of the tower or streamlines them to slender verticals which align themselves with its central edge. A horizontal band across the middle of the building corresponds to the stratified planes of colour which frame the scene below; and a clump of trees at the immediate right of the tower forms a mirror-image of the building itself. From a landscape of this same subject by Renoir of 1889 [fig. 52] we learn that nature's straggling confusion had not spared this secluded hillside site near Aix. But in Cézanne's Doric image, all is reduced to order.

The geometric regularity of the *Pigeon Tower at Bellevue* and the cubic construction of such related watercolours of this period as the *Lime Kiln* [No. 54] inevitably bring to mind Cézanne's oft-quoted advice to Bernard in 1904 to 'treat nature by means of the cylinder, the sphere, the cone'[21] a prescription for reducing the imperfect forms of the living world to essential shapes which, as Theodore Reff has observed,[22] was a standard method of creating order and harmony in painting and one long sanctioned by tradition and training. Poussin was familiar with this tradition and portrayed it in a drawing of an imaginary artist's studio reproduced here from a copy in Leningrad [fig. 32], which shows one artist drawing from a statuette, another painting at an easel, and a third (at the left) drawing the three geometric solids mentioned in Cézanne's letter. Neither artist has claims to great originality in endorsing this procedure. Yet it is fitting that both should have affirmed their belief in it. For in the heroic landscapes of their maturity, which form the centre-piece of the present exhibition, this theory found its most exalted expression.

By the third and penultimate decade of their careers, Cézanne and Poussin had attained a state of equanimity before nature which made it possible for them to confront it without desire. Having overcome the

Fig. 32. *An Artist's Studio* (copy after Poussin). Drawing (The Hermitage, Leningrad)

passionate emotionalism of their youth, which repeatedly led them to imbue their pictures with the conflict or restiveness of their own inner states, they now turned an objective eye upon the world of nature and sought to reveal its essential being. The aloofness and imperturbability which characterised this vision are also apparent in their most austere self-portraits of these years, both of which attest to the life of renunciation and withdrawal which now marked their existences.

In Poussin's well-known *Self-Portrait* [fig. 1] of 1649–50 in the Louvre, the aged artist gazes unflinchingly out at the viewer and grips his portfolio, as one critic has noted 'like Moses gripping the tablets of the Law'.[23] He is surrounded by attributes of his profession, including stretchers and canvases, one of which portrays an allegorical figure of Painting being embraced by Friendship – a reference to Poussin's unwavering affection for the patron of this picture, Chantelou. The artist portrays himself as a stern and formidable figure, one obviously not given to compromise or deviation from his chosen path. The severity of the impression is enhanced by the mane-like treatment of his hair and the straight and sober folds of his garments. Adding to the rigour of the composition are the intersecting verticals and horizontals which pervade the scene. Pictorial rectitude here becomes an expression of moral rectitude and reminds us of the reason and discipline which marked all aspects of Poussin's art and life. 'My nature compels me to seek and love things that are well ordered', confessed the artist in 1642, 'fleeing confusion, which is as contrary and inimical to me as is day to the deepest night'.[24] For the creator of the *Phocion* landscapes or the *Diogenes*, order was a manifestation of reason and reflected the order and harmony of nature itself.

Cézanne too believed passionately in the power of reason, which he described as 'this clarity which permits us to penetrate the problems submitted to us'.[25] Believing himself lacking in both the 'intellectual equilibrium' and the 'stability' which permitted others 'to achieve with certainty the desired end',[26] he nonetheless attained the ability to alienate himself before his subjects in order to explore their inner truth. Moreover, like Poussin before him, he sought refuge from the world around him through art. 'Art is a religion', observed Cézanne to Larguier, 'its goal is the elevation of thought'.[27]

Assimilated into this world, the artist portrays himself in a *Self-Portrait* [fig. 2] of *c.* 1890 shielded behind his palette and easel, the contour of the former continuing the line of his arm as an extension of his very being. He stares out at us with a mask-like expression of almost inhuman fixity, the curve of his head and beard echoing the rounded shape of his palette, and the constraining lines of his head and body welded to the rectangles which surround him. It would be hard to imagine a more impersonal state of being; for even Poussin himself does not erect such a barricade. In both portraits, however, one confronts that combination of control, self-denial, and tremendous inner strength which made possible the lofty, classic art of their maturity.

In their late landscapes Cézanne and Poussin move beyond the rational and ordered conception of nature of their middle years towards a more visionary one. Characteristic of this style is a new-found awareness of the elemental power of nature and of those forces of destruction and regeneration which pervade it. In their choice of landscape settings, both artists depart from the elaborate and complex scenes of their maturity, filled with a variety of contrasting things, and prefer instead more undifferentiated views of nature, as though no longer seeking unity in oppositions but, rather, in the seamless contiguity of life. Hand in hand with this more all-embracing vision comes a concern with the most impalpable aspects of nature – its vastness and mystery, and its limitless capacity to change. It is as though, having applied reason and intellect to comprehend the order of nature in their maturity, both artists concede, with the deepened wisdom of old age, that nature's mysteries ultimately defy human understanding, its richness and complexity forever eluding man's grasp.

Poussin ceased painting landscapes in 1651. When he returned to them, six years later, he devoted himself almost exclusively to landscape painting until his death in 1665. In both style and mood, these very late works differ markedly from the noble, classically conceived compositions of the late 1640s. Architecture is almost entirely absent from them and, instead, nature is portrayed before it had been subjected to the civilizing hand of man. Space is no longer conceived in the logical and measured progression of, for instance, the *Phocion* pictures but in a more fluid and illusory manner, which lends an otherworldly quality to these scenes. With this, the artist often adopts a looser and freer disposition of elements within the picture, which evokes more powerfully the untramelled richness of nature. Reinforcing this impression is Poussin's late handling. Soft, moist, and trembling in touch, it movingly suggests the growth and mutability of life itself.

But the greatest change comes in the states of nature upon which Poussin dwells in his late landscape paintings. These are seen at their most extreme in the *Landscape with Two Nymphs and a Snake* [fig. 33] of 1659 at Chantilly and the *Landscape with Hercules and Cacus* [fig. 34] *c.* 1660 at Moscow. In the former the artist portrays a lush and motionless scene of virginal nature, bursting with life and growth and pervaded by a mood of meditative calm. But the beauty and tranquillity of this scene are deceptive. Nestled in the undergrowth to the left of the seated water nymphs is a large serpent devouring a bird. This provides an ominous reminder of those forces of evil and destruction which lurk undetected even in the midst of benevolent nature.

In the *Hercules and Cacus* the artist portrays a rugged and dramatic landscape of demonic power – a scene of immensity and terror which is appropriate to its mythological theme. This depicts Hercules slaying the monster Cacus outside the lair in which the latter had hidden the oxen he stole from Hercules. Poussin mirrors the malevolent nature of this deed in a wild, primeval landscape which stresses the most monstrous and irrational forces in creation. So recklessly anti-classical a vision of nature could hardly afford a greater contrast to the methodically ordered landscape of the *Phocion* pictures or the seemingly benign world of the *Two Nymphs*. Yet in both of these late works Poussin portrays a scene of elemental nature linked with those forces of change and decay which shape all aspects of existence.

Closely related in style to the *Hercules and Cacus* is the *Hagar and the Angel* [fig. 13; No. 55] from the Palazzo Barberini, in which the artist depicts Hagar being delivered from the wilderness by an angel – a theme of human destiny and frailty set against a background of threatening nature. In keeping with the majority of Poussin's late landscapes both of these works are executed in monochromatic hues – in this case, sombre greys and dull greens, which lend a deathly aspect to these scenes. This mood of philosophical resignation before the mysteries of life forms a striking contrast to the clarity and certainty of Poussin's classical landscape style and finds its fullest formulation in the cycle of *Four Seasons* of 1660–64 in the Louvre, the artist's last completed works. Fittingly, they take as their broad theme the progress of human life seen against a background of the continuing cycles of nature.

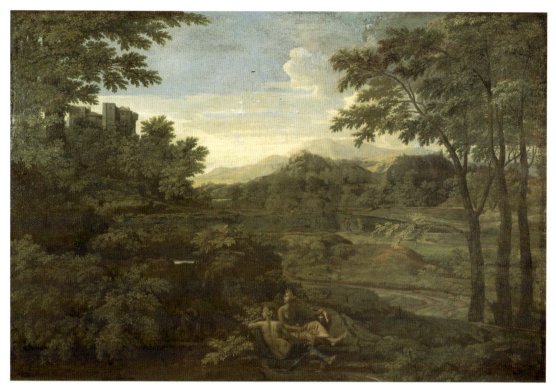

Fig. 33. Poussin, *Landscape with Two Nymphs and a Snake*, 1659
(Musée Condé, Chantilly)

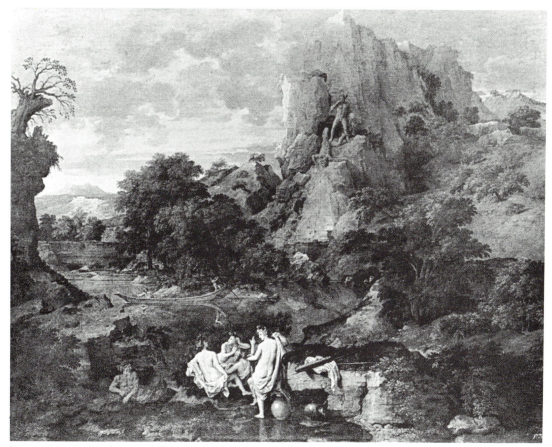

Fig. 34. Poussin, *Landscape with Hercules and Cacus*, c. 1660
(Pushkin Museum, Moscow)

If the pantheistic landscapes of Poussin's last years are still concerned with a philosophical interpretation of the phenomena of the universe, those of Cézanne appear even more personal and emotionally charged. In his late years – old, ill, and alone – Cézanne returned repeatedly to the landscape around his native Aix, by his own admission like Moses within sight of the promised land, stalking his sensations before nature. Passionately in love with 'this old native soil', he confessed in a letter to his son, written only six weeks before his death:[28]

Finally I must tell you that as a painter I am becoming more clear-sighted before nature, but that with me the realization of my sensations is always painful. I cannot attain the intensity that is unfolded before my senses. I have not the magnificent richness of colouring that animates nature.

His late landscapes contain something of both the exultation and the despair hinted at in this letter, together with more of nature's 'magnificent richness of colouring' than has been vouchsafed to any other painter.

The style of these pictures becomes increasingly complex, with dense, flickering, and interpenetrating strokes covering his canvases in a weft of vibrant colour – a kind of mystic notation dedicated to revealing those ineffable qualities in nature which Gasquet tells us were the object of the artist's final quest, the 'thrill of its continuance' and the 'appearance of all its changes'.[29] Through these ceaseless colour modulations – this infinite pulsing of nature – the forms of the visible world often appear scarcely discernible. Only the colour chords evoked by them emerge in Cézanne's continuing search (as he put it) to put in 'as much inter-relation as possible'.[30]

The greater subjectivity of this style is mirrored in the artist's late choice of motifs. These move from the ordered and attractive views characteristic of the 1880s towards extremes of expansiveness or oppressiveness – exultation or despair. Like those of Poussin, they reveal correspondingly less interest in nature as a setting for human habitation and dwell instead upon its destructive force or its eternal glory. In either case, Cézanne turns his attentions to the primal beauty of nature, as though seeking to uncover its original state.

In certain of these works – among them *In the Park of the Château Noir* [No.63] in the Orangerie or the National Gallery of Scotland's own *Big Trees* [No.64] – the artist focuses upon a dense, overgrown site in nature and explores those dramatic and conflicting forces which struggle to maintain it. Others, such as the *Park of the Château Noir* in the National Gallery [fig.14] or the great version of *La Montagne Sainte-Victoire* [No.62] from Ford House, adopt an almost monochromatic palette of slaty-greys and browns which (like the comparable works by Poussin) enhances their mood of impending doom.

The oppressive grandeur of these pictures finds its counterpart in Cézanne's many late versions of the Mont Sainte-Victoire as seen from Les Lauves. In design these no longer adopt the intricate and impeded viewpoints of the great pictures of this theme of the mid-1880s. Instead, they typically portray an uninterrupted view which shows the mountain soaring majestically over the valley and linking earth with sky, as though embodying the artist's own spiritual strivings. In the delicate and luminous watercolour of this motif in the Tate Gallery [No.69], the contour of the mountain appears inverted in a sequence of blue-violet touches of pigment which converge upon the bottom centre of the sheet – a moving reminder of Cézanne's belief in the invisible order which permeates all facets of existence. And, in the more impassioned painting of this same theme at Basel [No.66], the colours of the land are discharged into the sky, with Cézanne wringing from them all earthly impurity and permitting them simply to ascend, ecstatic affirmations of both human aspiration and universal harmony. In outpourings such as these, Cézanne exceeds the limits of his own great classicism and – like Poussin before him – confronts the unfathomable mysteries of life. Without the strictures and discipline of that earlier phase, however, neither artist might have attained the transcendent spirituality of their final visions.

1. Emile Bernard, letter to his mother, 4 February 1904. (Reprinted in Doran, pp. 23 ff.)

2. Emile Bernard, 'Souvenirs sur Paul Cézanne et lettres inédites', *Mercure de France*, N. S., 69, 1 and 16 October 1907, p. 627.

3. For the history and controversy surrounding this statement, see especially: Theodore Reff, 'Cézanne and Poussin', *Journal of the Warburg and Courtauld Institutes*, XXIII, 1960, pp. 150 ff., idem., 'Cézanne et Poussin', *Art de France*, 3, 1962, pp. 302 ff., and Richard Shiff, *Cézanne and the End of Impressionism*, Chicago and London, 1984, pp. 175 ff. Cf. also p. 57 below.

4. *Letters*, p. 303.

5. Emile Bernard, 'Paul Cézanne', *L'Occident* 6 (July 1904), p. 28.

6. This is the *Landscape with a Man killed by a Snake* of 1648 in the National Gallery, London [fig.38]. For the complicated gestation of this picture, see *CR*, Vol. IV, pp. 46 f.

7. The picture in question is the *Landscape with Pyramus and Thisbe* of 1651 in Frankfurt, for which see: *Nicolas Poussin, Claude Lorrain, Zu den Bildern im Städel*, Frankfurt am Main, 1988, pp. 25 ff.

8. See the accounts of Poussin's working methods by La Blond de la Tour (1669) and Joachim von Sandrart (1675) reprinted in Jacques Thuillier, 'Pour un "Corpus Pussinianum"', *Actes du Colloque International Nicolas Poussin*, Paris, 1960, Vol. II, pp. 145 ff., 160 ff.

9. *Ibid*, pp. 236, for an account of this procedure attributed to Bonaventure d'Argonne (1700).

10. Theodore Reff, 'Copyists in the Louvre, 1850–1870', *Art Bulletin*, 46, December 1964, p. 555.

11. Emile Bernard, 'Souvenirs sur Paul Cézanne', *Mercure de France*, 1904–06. (Reprinted in Doran, p. 65.)

12. Chappuis, Vols. I and II, 1011–1013.

13. R. P. Rivière and J. F. Schnerb, 'L'atelier de Cézanne', *La Grande Revue*, 1905. (Reprinted in Doran, p. 91.)

14. Cf. note 3 above and the bibliography cited in those studies.

15. Maurice Denis, 'Cézanne', trans. Roger Fry, *The Burlington Magazine*, XVI, 1910, p. 280.

16. On the classical landscape tradition between Poussin and Cézanne, see Prosper Dorbec, 'La tradition classique dans le paysage au milieu du XIX siècle', *La revue de l'art*, XXIV, July–December 1908, pp. 259 ff., 357 ff. and R. Verdi, *Poussin's Critical Fortunes, The study of the artist and the criticism of his works from c. 1690 to c. 1830 with particular reference to France and England*, Ph.D. dissertation, Courtauld Institute of Art, University of London, 1976, pp. 269 ff. (with further bibliography).

17. *Letters*, p. 115.

18. Joachim Gasquet, *Cézanne*, Paris, 1921, pp. 73, 95, 118, 193. Cf. also p. 76 on Cézanne's own *Harvest*.

19. Georges Rivière (1877), quoted in John Rewald, *Cézanne, A biography*, London and New York, 1986, p. 113.

20. *Letters*, p. 261.

21. *Ibid*., p. 301.

22. Theodore Reff, 'Painting and Theory in the Final Decade', *Cézanne, The Late Work*, ed. William Rubin, The Museum of Modern Art, New York, 1977, p. 47.

23. Paul Desjardins, *Poussin*, Paris, 1903, p. 96.

24. *Letters*, p. 134.

25. *Ibid*., p. 278.

26. *Ibid*., p. 224.

27. Léo Larguier, *Le Dimanche avec Paul Cézanne*, Paris, 1925. (Reprinted in Doran, p. 15.)

28. *Letters*, p. 327.

29. Gasquet, *op. cit*., p. 130.

30. *Letters*, p. 323.

Cézanne and Poussin:
the critical context

Comparisons between Cézanne and Poussin are a commonplace in the literature and already existed within Cézanne's own lifetime. But the context in which they occur is unusual and points to the nature of the relationship between these two great masters. This differs fundamentally from other familiar pairings between a nineteenth-century painter and the art of an Old Master, such as Delacroix and Rubens or Turner and Claude. For whereas Delacroix and Turner made numerous copies after their predecessors and frequently emulated both their styles and themes, the tangible links between Cézanne and Poussin are few. Evidence of Cézanne's direct involvement with Poussin's art is meagre and suggests that the French master had no overriding importance for him, except perhaps at the deepest level – that of sharing Cézanne's own aesthetic ideals. Moreover, even the earliest writers to link the two artists did not regard Cézanne as creatively dependent upon Poussin. Rather, they saw him as a Poussin re-born at the end of the nineteenth century – one who, as Maurice Denis put it, was 'spontaneously classic' rather than derivatively so.[1]

Documented evidence of Cézanne's interest in Poussin is limited to the copy of the *Arcadian Shepherds* he apparently made in 1864[2] and the three drawings he executed after the master in 1887–90, two after details from this same picture and one after a portion of Poussin's *Concert of Putti*.[3] In addition, sometime after 1893 Cézanne acquired a reproduction of the *Arcadian Shepherds*, which was still in his studio at his death and, according to Rivière and Schnerb,[4] was much admired by him. Also among the effects found in Cézanne's studio were two engravings after Jean-Victor Bertin (1775–1842), a classical landscape painter of the early nineteenth century whose art claimed direct descent from that of Poussin and who was to prove a formative influence upon the young Corot.[5] In the landscape art of the latter, whom Pissarro acknowledged as his unofficial mentor,[6] one encounters a crucial link between the academic landscape tradition of the early nineteenth century and the intuitive classicism of Cézanne. Beyond this, there are no firm connections between Cézanne and Poussin. Poussin is nowhere mentioned in Cézanne's letters, though other Old Masters whom he clearly revered are, among them Veronese, Tintoretto, and Rubens. And, if Cézanne made three drawings after Poussin, he made nearly thirty after Rubens, whom he also declared to be his favourite painter in a questionnaire of *c.*1870.[7] All of this suggests that, if there was a close

bond between Cézanne and Poussin, it did not exist on the level of direct inspiration or influence.

In apparent contradiction to this is the well-known statement, recorded by many early writers on Cézanne, that he sought to 're-do Poussin over again according to nature' – a remark which soon entered the canon of Cézanne criticism and has been repeatedly used to explain his art ever since. Though the authenticity of this statement has occasionally been questioned[8] – and though it was wilfully elaborated by such later writers on the artist as Gasquet – there can be little doubt that it is essentially true, especially when seen in relation to certain of Cézanne's other remarks on art at the end of his life.

The famous comment on Poussin first entered the literature in a statement about Cézanne by Charles Camoin of 1905 and a recollection of a conversation with the artist by Francis Jourdain during the preceding year.[9] Both of these writers were aspiring young painters who visited Cézanne in his old age, Camoin in 1901 and 1904, on the latter occasion accompanied by Jourdain. Much later, in 1925, Cézanne's remark is also recorded by Léo Larguier, a poet who had close contact with the artist in 1901–02, when Larguier was doing military service in Aix.[10] Since there is no reason to believe that any of these men had personal leanings towards Poussin – and every reason to assume that they were both impressionable and responsive to Cézanne's own views on art – the accuracy of the statement seems undeniable. Moreover, it would appear to be confirmed by a remark Cézanne reputedly made to Karl Ernst Osthaus, director of the Folkwang Museum in Essen, who visited the artist in 1906, when he purchased two pictures by Cézanne for his museum. On this occasion Cézanne is said to have confessed that, since he could not rival the art of Holbein, he had instead taken Poussin as his model in painting.[11] If this is not a pure fabrication by Osthaus, based on the published remarks of Jourdain and Camoin, then it is hard to doubt its validity. Though deference to the nationality of his patron may account for Cézanne's mention of Holbein, nothing that one knows of Osthaus suggests that he would have been prompted to connect Cézanne with Poussin had Cézanne himself not made this link.

Cézanne's statement acquires added significance when considered in the light of the advice he offered to Camoin in 1903. 'Couture used to say to his pupils', observed Cézanne, apparently endorsing this view, '"Keep good company, that is: go to the Louvre. But after having seen the great masters who repose there,

we must hasten out and by contact with nature revive within ourselves the instincts, the artistic sensations which live in us".'[12] When taken together with his remark on Poussin this suggests that Cézanne regarded his own artistic sensibility as having most in common with that of the French master, whose essential qualities were 'revived' by Cézanne in front of nature. This may also explain Cézanne's small number of copies after his great predecessor. Recognising that he had less to learn from Poussin *because he was spiritually most akin to him*, Cézanne turned instead to copying the great decorative masters in the Louvre. In the dynamic and rhythmically integrated figure paintings of Rubens in particular, Cézanne found a model for his own efforts to devise a complex group of figures, especially in his bather compositions.

Cézanne's spiritual affinity with Poussin is also repeatedly stressed by his earliest critics. With few exceptions, these writers did not attribute this to direct influence but, rather, to a common creative position arrived at by fundamentally different means. Thus, in the earliest of all comparisons between the two artists, an article by the otherwise unknown François-Charles of 1902, Cézanne is characterised as 'grave and classical, like Poussin, of whom, it is said, he thinks constantly'.[13] Two years later, in a review of the Salon d'Automne which Cézanne read and apparently endorsed,[14] Roger Marx spoke of his 'cult of Poussin';[15] and, in the following year, Maurice Denis characterised him as the 'Poussin of still life and green landscape'[16] – a remark which anticipates his more famous description of Cézanne as 'the Poussin of Impressionism' in 1907.[17] But perhaps the most revealing appraisal of the relationship between the two artists came from Louis Vauxcelles, who declared in an obituary on Cézanne: 'Fully to appreciate Paul Cézanne's strength, one must perhaps compare him to Poussin, whom everybody talks about without ever looking at'.[18] From these remarks it is clear that there was an unusual degree of unanimity among critics that Poussin deserved to be seen as Cézanne's spiritual ancestor and kin, rather than as his creative mentor. In the words of Pérate, Cézanne was a 'classic obsessed by the real'[19] – that is to say, an artist who shared Poussin's fundamental aims and sought to realise these in the immediate presence of nature.

Vauxcelles's assertion that Poussin was much talked about by members of Cézanne's generation also forms an essential aspect of the context in which the relationship between the two artists must be seen; for, notwithstanding his own isolation and creative independence, Cézanne cannot have been entirely unaware of the high esteem Poussin's art enjoyed among his contemporaries. 'People talk a great deal about Poussin', observed Van Gogh in a letter to his brother of 1885, 'the French call Poussin the very greatest painter among the Old Masters'.[20] Later Van Gogh declared: 'As to Poussin, he is a painter and a thinker

Fig. 35. Léon Benouville, *Poussin sur les bords du Tibre, trouvant la composition de son 'Moïse sauvé des eaux'*, 1857 (Engraving by Pilchard)

who always gives inspiration, in whose pictures all reality is at the same time symbolic'.[21] Though confessing himself 'very fond' of Poussin, Van Gogh derived no more direct inspiration from the French master. Other artists of his time, however, unquestionably did.

Characteristic of Poussin's elevated reputation among French painters is the fact that later generations of artists and critics have regularly assessed their own achievements according to the standards set by the father of the French school.[22] In the nineteenth century Poussin's art enjoyed undiminished popularity. But the reasons for this were often very different and testify to the many-sided nature of his achievement. Thus, if the arch-classicist, Ingres, admired Poussin as an upholder of the venerable tradition of the ancients among the Old Masters,[23] the romantic Delacroix responded instead to the more passionate and innovative aspects of his genius.[24] With the advent of realism in painting during the middle of the century, the master's reputation underwent a further transformation. No longer focusing upon the classical masterpieces of Poussin's maturity or the romantic creations of his youth, the realists looked instead at the artist's landscape paintings and drawings and discovered in these an indebtedness to nature which anticipated their own creative aims. Among Poussin's many admirers of this generation were Corot, Couture, Millet, Bracquemond, and a host of lesser critics, who praised the master's ability to imitate the effects of nature in such landscapes as the *Diogenes* [No. 22] or the *Deluge* [fig. 56].[25]

Another artist of this time even went so far as to suggest that Poussin had derived the inspiration for one of his noblest history paintings from a chance

Fig. 36. Poussin, *The Finding of Moses*, 1638
(Musée du Louvre, Paris)

Fig. 37. K.-X. Roussel, *The Arcadian Shepherds*
(Private Collection, Paris)

encounter in nature. This was Léon Benouville, whose *Poussin sur les bords du Tibre, trouvant la composition de son 'Moïse sauvé des eaux'* [fig. 35] of 1857 shows Poussin 'discovering' the motif for his *Finding of Moses* [fig. 36] of 1638 in the Louvre in the mundane scene of a woman bathing her child in the Tiber. As proof of the prevailingly naturalistic bias of Poussin's art, this idea was subsequently cited by Charles Blanc as a model of 'how a scene in everyday life suddenly becomes raised to the dignity of a history painting'.[26] Unwittingly, Benouville and Blanc here cast Poussin as a Cézanne of his time, finding classicism in the direct observation of life around him.

With the coming of Cézanne's own generation, interest in Poussin focused once again upon the order and precision of his art.[27] This was the aspect of the master's genius which most appealed to Degas, who made at least ten copies after Poussin and confessed of his predecessor in 1872: 'I am thirsting for order ... I am dreaming of something well done, a whole well organized (style Poussin) and Corot's old age'.[28] Also among Poussin's deepest admirers at this time was Seurat, who executed four copies after the master in the late 1870s[29] and whose kinship with Poussin was acknowledged by his earliest critics, one of whom observed that Seurat shared the desire of his seventeenth-century predecessor 'to make a more logical art out of painting'.[30] Even the young Matisse copied three Poussins in the Louvre in the 1890s[31] – an activity which Georges Dralin observed in 1904 had now become widespread among the younger generation of artists, who could regularly be seen setting up their easels before Poussin's bacchanals and landscapes in the Louvre, in order to absorb his method and discipline.[32]

Interest in Poussin also took other forms during the closing years of the nineteenth century. The 300th anniversary of the artist's birth, in 1894, provided the occasion for a commemorative celebration at Poussin's birthplace, Les Andelys, where Roger Marx – who was later to write of Cézanne's 'cult of Poussin' – delivered a lengthy oration praising Poussin as the embodiment of the French spirit in painting and noting his continuing relevance for discerning artists, from Corot to Puvis de Chavannes.[33] In the same year, Philippe de Chennevières-Pointel published an important study of the master;[34] and, during the next decade, no less than five major books on Poussin appeared throughout Europe. These included two classic works by Paul Desjardins, which still repay close study, and a translation into French of Bellori's early life of the artist.[35] This activity culminated with the publication of the definitive edition of Poussin's letters in 1911 and the appearance three years later of the pioneering monographs on the artist by Grautoff, Friedländer, and Magne, which paved the way for modern research.[36]

Less significant than these – but much closer to Cézanne – was the publication in 1903 of a poem on Poussin by Cézanne's close friend, Joachim Gasquet, which the artist presumably read.[37] This celebrates Poussin as the creator of an idyllic, arcadian vision in painting which the Neo-classical painters and poets of the 1890s had sought to revive. Among these were Bernard, Denis, and Gasquet himself, all of them regularly given to emphasising the links between Cézanne and Poussin.[38] In the earliest attempt to draw a parallel between the two artists, Denis

observed in 1898 that Poussin and the poets contemporary with him represented a tradition of order and discipline to which present-day painters should return and acknowledged Cézanne as a recent representative of this tradition.[39] Eight years later, Denis visited Cézanne at Aix in the company of another artist of decidedly classical leanings, Ker-Xavier Roussel. Perhaps inspired by Cézanne's own remarks on Poussin during this visit, Roussel proceeded to base two figure paintings of this period on designs by the French master: an *Arcadian Shepherds* [fig. 37] and a *Diana and Actaeon* of 1911, which takes as its inspiration Poussin's unfinished *Apollo and Daphne* in the Louvre.[40]

Many years later, in 1938, Denis confessed that in discovering the grandeur of Cézanne the artists and critics of his generation were ultimately paying homage to Poussin.[41] But a more immediate result of his visit to Aix was a penetrating essay on Cézanne himself, which repeatedly draws attention to the affinities between the two artists.[42] At one point in this discussion, Denis reminds his readers of the two distinct ways of seeing that Poussin had outlined in a letter of 1642 and applies them to the art of Cézanne. For Poussin, vision took the form of either receiving light rays into the eye – which he called Aspect – or of applying reason and judgement to the evidence of one's senses – a function he called Prospect.[43] In Cézanne, Denis noted perceptively, 'the two operations … are no longer separate'.[44]

By 1907, the year of Denis's article and of the great Cézanne retrospective at the Salon d'Automne, the comparison of his art with that of Poussin had established itself in the literature, where it rapidly became one of the foregone conclusions about Cézanne's creative aims. In this form it even appeared in the biography of the artist in Thieme-Becker, written by the noted Poussin scholar Otto Grautoff and published in 1912.[45] With the purchase of Poussin's *Inspiration of the Epic Poet* for the Louvre in the preceding year, the master's continuing relevance for French painting became the subject of renewed consideration. In a long article celebrating this acquisition, Jacques Rivière extolled Poussin as the antithesis of Impressionism and noted that his rightful heirs were Denis, Roussel, Gauguin, and Cézanne, who shared Poussin's desire to render visible both 'the position of objects and that mysterious bond which unites them'.[46]

Though Rivière makes no mention of Poussin's continuing importance for artists of the Cubist generation, a more influential English critic of these years did. This was Roger Fry, who, in a review of the second Post-Impressionist exhibition at the Grafton Galleries in 1912, noted: 'a classic spirit is common to the best French work of all periods from the twelfth century onwards, and though no one could find direct reminiscenses of a Nicholas Poussin here, his spirit seems to revive in the work of artists like Derain'.[47] Soon to become one of the most illuminating of all writers on Cézanne, Fry would inevitably be led to make this connection in his classic biography of the artist in 1927. Aware of the decisive impact Cézanne's art had exerted upon such modern masters as Picasso and Vlaminck, Fry wondered what the master of Aix would have made of such spiritual progeny. In an effort to answer this, Fry set out to disassociate his perceptions of Cézanne from all more recent developments in painting, and confessed:[48]

when I had removed the scales of vague and distorted memories; when, at last, I seemed to be face to face with the artist himself – what surprised me was the profound difference between Cézanne's message and what we have made of it. I had to admit to myself how much nearer Cézanne was to Poussin than to the Salon d'Automne.

Despite Fry's provocative assertion, Cézanne's fundamental importance for the art of our own century remains indisputable. Yet it is his links with the past which have most preoccupied recent writers on the artist and inspired a bibliography of their own,[49] dedicated to exploring the connections between Cézanne's art and that of a wide variety of earlier masters. At its most misguided, this takes the form of tracing the sources of Cézanne's imagery in the art of his predecessors – an exercise which rarely proves conclusive because of the nature of the dialogue which Cézanne himself held with the past. This was admirably summarised by Maurice Denis in 1907, when he observed of the artist:[50]

That which others have sought, and sometimes found, in the imitation of the old masters, the discipline that he himself in his earlier works sought from the great artists of the past, he discovered finally in himself. And this is the essential characteristic of Cézanne. His spiritual conformation, his genius, did not allow him to profit directly from the old masters. He finds himself in a situation towards them similar to that which he occupied towards his contemporaries. His originality grows in his contact with those whom he imitates or is impressed by …

In this regard, too, Cézanne's creative position parallels that of Poussin, who emulated the ancients throughout much of his career without ever resorting to the need to imitate them, so deeply had he assimilated the essential spirit of their art.

Viewed in this way, Cézanne's originality discloses hidden resonances between his own art and that of the past which elude precise identification but can often lead us to see the Old Masters themselves in a new light. This is particularly true in the case of Poussin, whose reputation underwent a decisive transformation among artists and critics of Cézanne's own generation. Long celebrated as a learned and philosophical painter – as an adherent of classicism or as a precursor of certain strains of romanticism – Poussin awaited the advent of Cézanne's art to come to be

regarded as one of the greatest masters of formal design in the Western tradition. In this guise he was placed alongside Piero della Francesca and Cézanne by critics such as Roger Fry and Clive Bell, seeking to discover the chief exponents of 'significant form' in painting.[51] Indeed, Fry himself went so far in his pursuit of the abstract qualities of Poussin's pictures as to speak of the 'consummate sense of formal relations' in the master's landscapes and to declare Poussin's once-venerated choice of subjects a mere 'pretext for purely plastic construction'.[52]

Though this approach to Poussin is just as imbalanced as one which regards him as a wholly intellectual painter, it has added a further dimension to our understanding and appreciation of his art, for which Cézanne's achievement is largely responsible. Thus, in an article on Poussin's historical landscapes of 1960, Pierre Francastel could find no more appropriate way of extolling the French master's genius for formal composition than by resorting to a comparison with his nineteenth century heir. 'Les très beaux Poussins annoncent les beaux Cézannes', declared Francastel, in an illuminating reversal of the theme of the present exhibition.[53]

1. Maurice Denis, 'Cézanne', trans. Roger Fry, *The Burlington Magazine*, XVI, January 1910, p. 214.

2. Theodore Reff, 'Copyists in the Louvre, 1850–1870', *Art Bulletin*, XLVI, 4, December 1964, p. 555.

3. Chappuis, Nos. 1011–13.

4. R. P. Rivière and J. F. Schnerb, 'L'atelier de Cézanne', *La Grande Revue*, 25 December 1907, pp. 811–17. (Reprinted in Doran, pp. 85–91.)

5. Theodore Reff, 'Reproductions and Books in Cézanne's Studio', *Gazette des Beaux-Arts*, LVI, November 1960, p. 304.

6. Pissarro described himself as a 'pupil of Corot' in his Salon entries for 1864 and 1865, despite having received only informal tutelage from the master.

7. Reprinted in Chappuis, Vol. I, pp. 25 ff., 49 ff. For Cézanne's drawings after Rubens, see: Gertrude Berthold, *Cézanne und die alten Meister*, Stuttgart, 1958, pp. 114–20, Nos. 204–30.

8. Especially by Theodore Reff ('Cézanne and Poussin', *Journal of the Warburg and Courtauld Institutes*, XXIII, 1960, pp. 150 ff.), who later withdrew his objections (*idem.*, 'Cézanne et Poussin', *Art de France*, II, 1963, pp. 302 ff.) For the complex history of Cézanne's statement, see in particular: Richard Shiff, *Cézanne and the End of Impressionism*, Chicago and London, 1984, pp. 180–83.

9. Charles Morice, 'Enquête sur les tendances actuelles des arts plastiques', *Mercure de France*, n.s., 56, 1 August 1905, pp. 353 f. (for Camoin); Francis Jourdain, 'A propos d'un peintre difficile, Cézanne', *Arts de France*, No. 5, 1946, p. 7. (Reprinted in Doran, pp. 81 ff.)

10. Léo Larguier, *Le Dimanche avec Paul Cézanne*, Paris, 1925, p. 40.

11. Karl Ernst Osthaus, 'Une visite à Paul Cézanne', *Das Feuer*, 1920–21, pp. 81–85. (Reprinted in Doran, pp. 96–100.)

12. *Letters*, pp. 297 f.

13. François-Charles, 'L'Exposition des artistes indépendants', *L'Ermitage*, 13, May 1902, p. 398.

14. Cf. *Letters*, p. 313.

15. Roger Marx, 'Le Salon d'Automne', *Gazette des Beaux-Arts*, 32, December 1904, p. 463. It was this review that prompted from Cézanne himself the statement which heads the introductory essay to the catalogue of the present exhibition, as though in humble acceptance of the belated recognition being paid to him on this occasion. As a further indication of the artist's growing stature, Roger Marx chose to illustrate his review with Cézanne's *Aqueduct* (Pushkin Museum of Fine Arts, Moscow; V. 477), providing the artist with one of the few opportunities he enjoyed to see one of his works reproduced.

16. Maurice Denis, *Théories, 1890–1910*, Paris, 1920 (orig. ed. 1912), p. 204.

17. Maurice Denis, 'Cézanne', *L'Occident*, September 1907. (Reprinted in Doran, pp. 166–80. Cf. p. 179.)

18. Louis Vauxcelles, 'La Mort de Paul Cézanne', *Gil Blas*, 25 October 1906. (Quoted from: John Rewald, *Cézanne and America, Dealers, Collectors, Artists and Critics 1891–1921*, London, 1989, p. 102.)

19. André Pérate, 'Le Salon d'Automne', *Gazette des Beaux-Arts*, XXXVIII, 1907, p. 389.

20. *The Complete Letters of Vincent Van Gogh*, London, 1958, Vol. II, p. 412.

21. *Ibid.*, p. 416.

22. Three instances of this from the broad chronological period covered by this essay are: Alexandre Joly, 'Le Poussin et l'art en 1868', *L'Artiste*, XXIX, I, 1869, pp. 397–420.; Jacques Rivière, 'Poussin et la peinture contemporaine', *L'Art décoratif*, 27, 1912, pp. 133–48.; Maurice Denis, 'Poussin et notre temps', *L'Amour de l'art*, 19, June 1938, pp. 185–90.

23. For Ingres and Poussin, see: R. Verdi, *Poussin's Critical Fortunes, The study of the artist and the criticism of his works from c.1690 to c.1830 with particular reference to France and England*, Ph.D. dissertation, Courtauld Institute of Art, University of London, 1976, pp. 344–47 (and the bibliography cited there).

24. *Ibid.*, pp. 339–44 (with further bibliography).

25. Félix Bracquemond, *Du dessin et de la couleur*, Paris, 1885, pp. 203–09 (for Bracquemond and Corot).; Thomas Couture, *Conversations on Art Methods*, trans. S. E. Stewart, New York, 1879, pp. 169 ff.; Alfred Sensier, *Jean-François Millet*, Paris, 1881, p. 220.

26. Charles Blanc, *Grammaire des arts du dessin*, Paris, 1867, p. 10.

27. For two highly orthodox views of the artist from these years, see: Henri Bouchitté, *Le Poussin, sa vie et son œuvre …*, Paris, 1858. and Georges Berger, 'Le Poussin. Cours donné à l'Ecole Nationale des Beaux-Arts', *L'Art*, IV, 1877, pp. 73 ff.

28. *Lettres de Degas*, ed. Marcel Guérin, Paris, 1931, Vol. II, p. 11. For Degas's copies after Poussin, see: R. Verdi, *op. cit.*, p. 483, n. 121.

29. C. M. de Hauke, *Seurat et son œuvre*, II, Paris, 1961, Nos. 224, 225, 285, 340.

30. Theodor de Wyzewa, 'Georges Seurat', *L'Art dans les deux mondes*, 18 April 1891, p. 263.

31. Alfred H. Barr Jr., *Matisse: his art and his public*, New York, 1951, p. 33.

32. Georges Dralin, '"La vie de Nicolas Poussin d'Andeli …" traduit par Georges Rémond', *L'Occident*, 30, May 1904, pp. 237 f.

33. Quoted in 'Le IIIe centenaire de Nicolas Poussin', *L'Artiste*, June 1894, p. 464.

34. Philippe de Chennevières-Pointel, *Essais sur l'histoire de la peinture française*, Paris, 1894.

35. Paul Desjardins, *Poussin*, Paris, 1903. *Idem.*, *La Méthode des classiques français: Corneille, Poussin, Pascal*, Paris, 1904. The translation of Bellori's Life of Poussin was by Georges Rémond (Paris, 1903). Another major study of the artist of these years was Elizabeth Denio, *Nicolas Poussin, his life and work*, London, 1899 (orig. Berlin, 1898).

36. Otto Grautoff, *Nicolas Poussin: sein Werk und sein Leben*, Munich, 1914. Walter Friedländer, *Nicolas Poussin. Die Entwicklung seiner Kunst*, Munich, 1914. Emile Magne, *Nicolas Poussin, premier peintre du roi, 1594–1665*, Brussels and Paris, 1914. The edition of Poussin's letters, edited by Charles Jouanny (Paris, 1911), is the one cited throughout this catalogue.

37. Joachim Gasquet, *Les chants séculaires*, Paris, 1903, pp. 15 f. Cézanne acknowledges the receipt of a copy of this work in a letter to Gasquet of 25 June 1903 (*Letters*, p. 296.)

38. A selection of early writings on Cézanne by Emile Bernard, who visited the artist in 1904, is reprinted in Doran, *passim*.

39. Maurice Denis, 'Les arts à Rome ou la méthode classique', *Le Spectateur catholique*, Nos. 22, 24, 1898. (Reprinted in Denis, *Théories*, pp. 45–56.)

40. Cf. *Edouard Vuillard, Xavier Roussel*, Munich and Paris, 1968, Nos. 232 and 236.

41. M. Denis, 'Poussin et notre temps', p. 186.

42. M. Denis, 'Cézanne', *L'Occident*, Sept. 1907. (All references are to the English edition cited in note 1 above.)

43. *Correspondance*, p. 143.

44. M. Denis, 'Cézanne', p. 280.

45. U. Thieme and F. Becker, *Allgemeines Lexikon der bildenden Künste*, Leipzig, Vol. VI, 1912, p. 320.

46. Rivière, *op. cit.*, p. 144.

47. Roger Fry, *Vision and Design*, London, 1920, pp. 156–59. (Orig. 1912).

48. Roger Fry, *Cézanne, A study of his development*, London, 1927, p. 2.

49. *Infra*, p. 201.

50. M. Denis, 'Cézanne', p. 214.

51. Clive Bell, *Art*, London, 1914, p. 8.

52. Roger Fry, *French, Flemish and British Art*, London, 1951, p. 25. *Idem., Transformations*, London, 1926, pp. 18 ff.

53. Pierre Francastel, 'Les paysages composés chez Poussin: académisme & classicisme', *Actes du Colloque International Nicolas Poussin*, Paris, 1960, Vol. 1, p. 206.

Catalogue

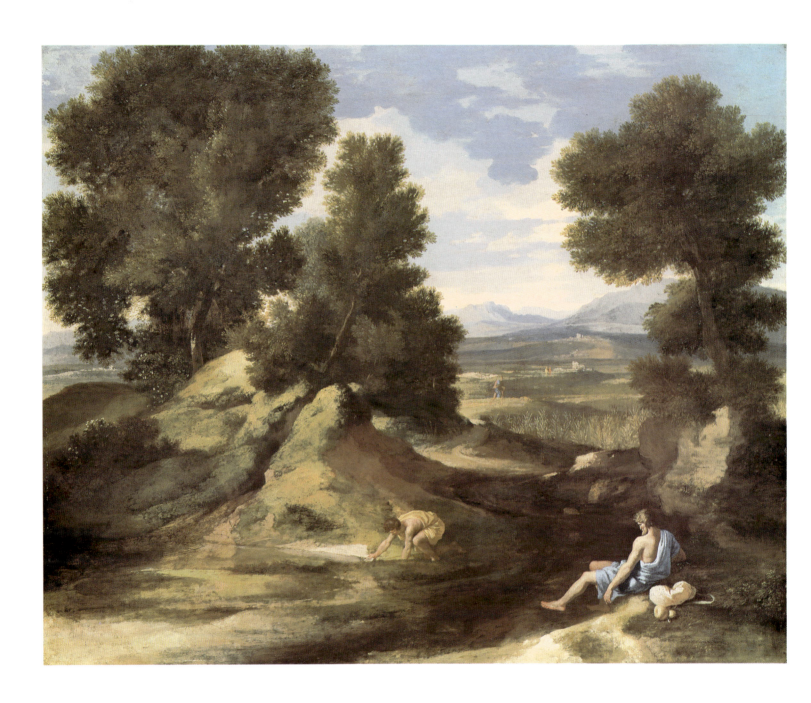

1

Landscape with a Boy drinking from a Stream

Oil on canvas; 63.1 x 77.8 cm.

Trustees of the National Gallery, London

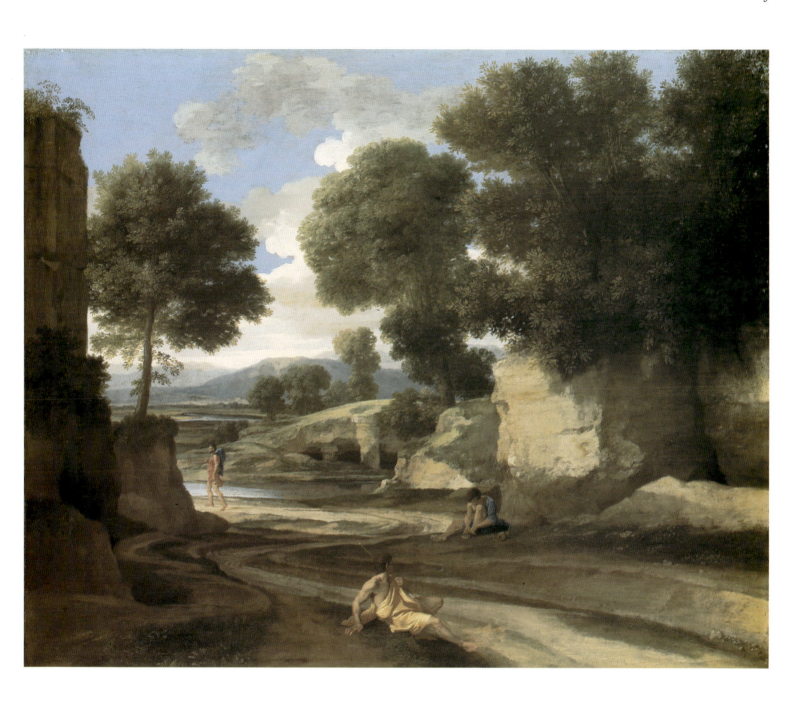

2

Landscape with Travellers resting

Oil on canvas; 62.8 x 74.4 cm.

Trustees of the National Gallery, London

With a related canvas at Montreal [No. 3], these two works are generally regarded as Poussin's earliest surviving landscape paintings. Both bear inscriptions on the back which trace them to the collection of Cassiano dal Pozzo, one of the artist's first champions in Rome and his most important Italian patron. They were still in the collection of the heirs of the Pozzo family in 1779[1] and are first recorded in England between 1792 and 1834. Unmentioned by any of the earliest writers on the artist, the pictures were first

published in 1945[2] and acquired by the National Gallery from the collection of Sir George Leon in 1970.

The London landscapes contain a number of features which distinguish them as early works in Poussin's career. Among these are their small size and non-literary theme. Both works consist of anonymous figures engaged in ordinary occupations, which suggests that they were intended to serve a primarily decorative function. In keeping with this, the landscapes themselves are modest in conception and consist of a sequence of hillocks and trees which proceed towards the horizon by means of a receding road or stream. Architecture is almost entirely absent from them, with Poussin creating a view of rural nature which calls to mind the landscape of the Roman campagna, the site of his early sketching expeditions of c.1630. Though both are imaginary scenes, they reveal a fascination with the surface texture of objects in nature, together with an interest in the irregular contours of the land, which owes much to the tradition of topographical painting practised by Poussin's Dutch contemporaries in Rome and primarily associated with the art of his brother-in-law, Gaspard Dughet, whose earliest landscapes of this type date from the mid-1630s.

The National Gallery landscapes would likewise appear to be datable to the years around 1635. A comparison of the background of the *Landscape with a Boy drinking from a Stream* with that of the *Triumph of Pan* of 1635–36, which normally hangs next to it in the National Gallery, reveals a strikingly similar treatment of the hills and sky. In both cases, the latter is dominated by flat, smoothly painted clouds and the hills below are crisply delineated and rendered in a slaty bluish-grey broken by patches of creamy pink. Prominent areas of blue cloud further enliven the surface design in this portion of both pictures – a feature of his earliest landscape backgrounds which is not to be found in the *Landscape with Travellers resting*, which contains the grey and white cloud formations familiar in Poussin's later art.

The relationship of the two London landscapes has given rise to some discussion. Despite their similar size and provenance, the pictures do not share the common horizon normally associated with pendants; nor do their compositions obviously complement one another. However, they seem to portray two different times of day. Adding to the confusion is the fact that the *Landscape with Travellers resting* appears more highly formalised in conception, with its firm framing elements and orderly spatial recession contrasting with the freer and more loosely designed *Landscape with a Boy drinking from a Stream*. The methodical placement of the figures, clad in the primary triad of red, yellow, and blue, adds further to the clear articulation of the whole and anticipates Poussin's mature methods of landscape composition.

Given Poussin's rapid advances in landscape be-
tween 1635 and 1640, the date of the evangelist
landscapes at Berlin and Chicago [No. 5 and fig. 9],
the London canvases are unlikely to be widely separ-
ated in date. Rather, their differences may be ex-
plained by the artist's determination to create two
contrasting and independent compositions, together
with his willingness to improve upon one landscape
when devising the other. Moreover, if the design of
the *Landscape with Travellers resting* appears slightly
more mature, the companion picture is more forward-
looking in subject-matter. For the motif of a boy
scooping water from a stream, observed by a medita-
tive old man, whose humble belongings rest by his
side, inevitably calls to mind the theme of one of
Poussin's greatest classical landscapes, the *Diogenes* of
1648 [No. 22]. In this respect, the *Landscape with a Boy
drinking from a Stream* may be connected with a third
work by the artist belonging to this early Pozzo group,
the *Landscape with a Man pursued by a Snake* [No. 3],
which anticipates the theme of another of Poussin's
mature landscape paintings, the National Gallery's
Landscape with a Man killed by a Snake [fig. 38], also of
1648.

1. Timothy J. Standring, 'Some pictures by Poussin in the
Dal Pozzo collection: three new inventories', *The Burlington
Magazine*, CXXX, 1025, August 1988, pp. 619 ff.
2. Anthony Blunt, 'Two newly discovered landscapes by
Nicolas Poussin', *The Burlington Magazine*, LXXXVII, 1945, pp.
186 ff.

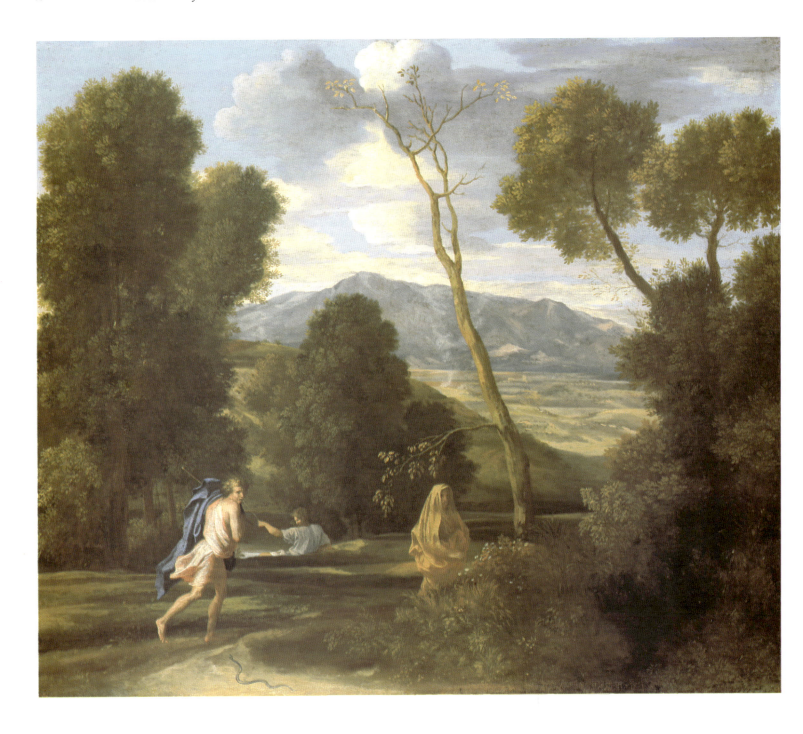

3

Landscape with a Man pursued by a Snake

Oil on canvas; 65 x 76 cm.

The Montreal Museum of Fine Arts Collection

Similar in size and style to the two London landscapes [Nos. 1 and 2], this picture appears to have formed part of the same early commission from Cassiano dal Pozzo and, like them, was sold by his heirs to the Scottish painter and antiquarian, Gavin Hamilton, in 1779.[1] Its later history cannot be traced further back than 1920, when it was purchased in Paris by the painter, Duncan Grant.

The Montreal canvas shares with the two National Gallery landscapes its rural setting, comprised of a loosely interlocking sequence of hillocks and trees, and its somewhat arbitrary spatial recession, which progresses towards the horizon through a series of abrupt leaps which reveal Poussin's comparative immaturity as a landscape painter in the years around 1635. If anything, the Montreal picture would appear to be the most tentative of this early group of Pozzo landscapes, with its firmly bounded foreground and isolated, central vista.

Other features of the picture seem more advanced in conception. One of these is the conscious diversity of the trees and, above all, the inclusion of a spindly and largely leafless tree in the centre of the composition, whose 'crown' is supplied by a formation of billowing cloud in the distant sky which mirrors the rounded contours of the framing trees.

Most prophetic of all, however, is the theme of the picture, which shows a man startled by a serpent, whose presence is undetected by the woman at the centre right and the fisherman in the middle distance. This would appear to be an early experiment on

humanity from any number of classical sources, among them the *Iliad* (III, 33 ff.; XXII, 93 ff.) and *Aeneid* (II, 378). The idea also appears in Dante's *Inferno* (Canto VII, 83 ff.); but it finds its most memorable expression in Virgil's *Eclogues* (III, 92 ff.):

You lads there, gathering flowers and strawberries from their earthy beds, take to your heels! There's a clammy snake lurking in the grass.

In all of these sources it serves as a reminder of the need for vigilance in the face of unpredictable nature and of those sudden blows of fortune which may befall even the most favoured of men. It also alludes to the presence of death, even in the midst of the most idyllic natural surroundings – an idea which may account for the prominent bare tree in the centre of the Montreal picture. Poussin was to explore this general theme in his celebrated *Arcadian Shepherds* in the Louvre [fig. 26] and a number of his mature landscape paintings, often with explicit reference to the notion of a 'snake lurking in the grass'. Among these are the National Gallery picture already mentioned, the *Landscape with Orpheus and Eurydice*

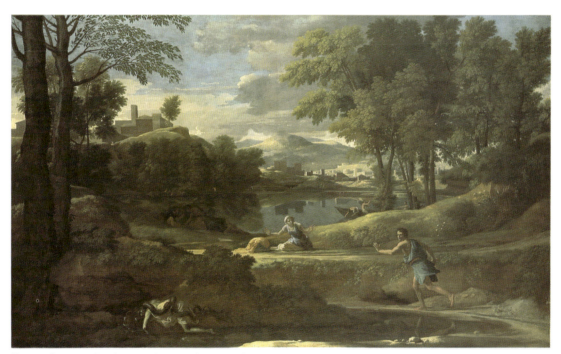

Fig. 38. Poussin, *Landscape with a Man killed by a Snake*, 1648 (National Gallery, London)

Poussin's part in the general theme of the dispersal of fear through a landscape which was to find its fullest formulation in the *Landscape with a Man killed by a Snake* of 1648 [fig. 38].

Poussin may have derived the idea of a serpent lurking in the grass to prey upon unsuspecting

(Louvre) of 1650, and the *Landscape with Two Nymphs and a Snake* (Chantilly) of 1659 [fig. 33].

1. Timothy J. Standring, 'Some pictures by Poussin in the Dal Pozzo collection: three new inventories', *The Burlington Magazine*, CXXX, 1025, August 1988, pp. 621 f.

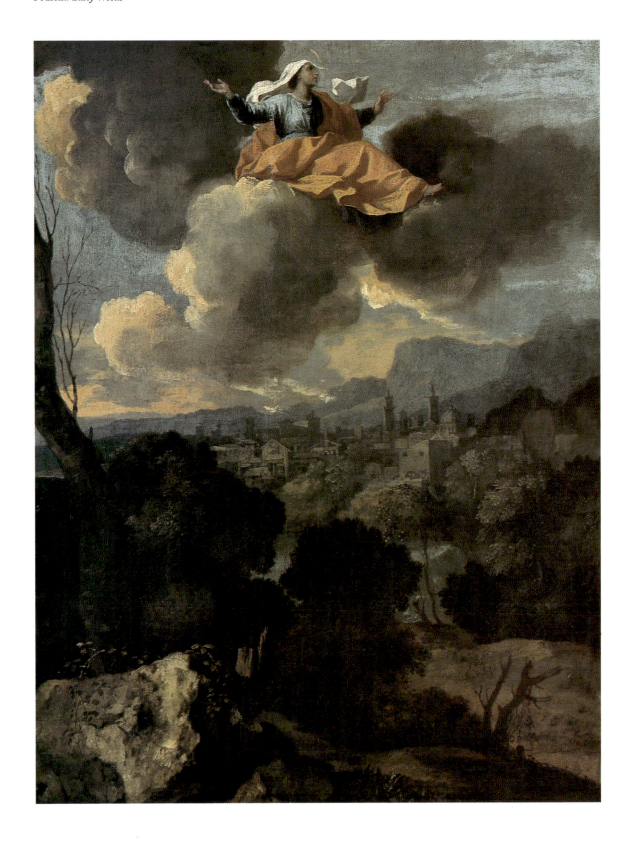

Sta Rita of Cascia

Oil on panel; 48.8 x 37.8 cm.

By permission of
the Governors of Dulwich Picture Gallery

Poussin's development as a landscape painter followed an orderly and systematic progression characteristic of his eminently rational approach to painting. After completing a series of modest-sized canvases depicting anonymous figures in a campagna-like setting, he embarked upon a group of more ambitious compositions in which isolated religious figures are shown in more strikingly diversified surroundings. In both of these pursuits, he was following in the footsteps of Northern and Italian artists working in Rome during the first thirty years of the seventeenth century. The former specialised in small landscapes of an essentially topographical character which featured figures engaged in a variety of genre occupations. The latter, on the other hand, preferred more imaginary views peopled with incidents from the bible or mythology. As a Frenchman working in Rome, Poussin was to follow the path of his countryman, Claude Lorrain, and try his hand at both of these types of composition before finding a landscape style which was truly his own.

The *Sta Rita of Cascia* of *c.* 1637 marks a transitional phase in the artist's development. Its small size and wooden panel support link it with the tradition of Northern artists working in Rome; while its choice of theme – which shows Sta Rita of Cascia above a view of the city of Spoleto – has a distinguished ancestry in Italian art. Raphael and Annibale Carracci had both portrayed the Virgin in majesty above the cities of Foligno and Bologna (Vatican, Pinacoteca, and Christ Church, Oxford, respectively); and Poussin's picture, which was formerly thought to depict the Assumption of the Virgin, may be related to this tradition. Unlike the monumental altarpieces of either of his predecessors, however, Poussin's Dulwich panel relegates the figure of the saint to the upper reaches of the picture and concentrates instead upon an imposing view of the city of Spoleto, with its castle, cathedral, and magnificent mountain setting. Although Poussin is not known to have visited Spoleto, he would easily have had access to views of the city.

Sta Rita of Cascia was a fifteenth-century saint who was miraculously transported through the air to join the nuns of the Augustinian convent at Cascia, near Spoleto, having initially been rejected by them. The re-identification of the subject of the Dulwich picture is due to Peter Murray,[1] who argues that the work may have been commissioned from Poussin by a member of the Barberini family, two of whom (Pope Urban VIII and Cardinal Francesco Barberini) were bishops of Spoleto during the early seventeenth century. Although this identification has been widely accepted, it is worth noting that Sta Rita is traditionally depicted in the black and white habits of a nun and shown with a thorn from Christ's crown of thorns in her forehead. Surprisingly, Poussin's figure bears no such attribute and is clad in the red and blue garments usually associated with the Virgin.

Poussin portrays Sta Rita above a wild and mountainous landscape which is appropriate to the setting and to her hermetic existence. With its carefully delineated trees and terrain, the picture appears closest in style to the artist's *Landscape with St Jerome* of *c.* 1637 in the Prado. Both works reveal a preoccupation with the accidents and irregularities of nature which make them two of Poussin's most proto-Romantic creations in landscape.

For all its naturalism and topographical interest, the *Sta Rita of Cascia* also reveals Poussin's infallible sense of pictorial order. The composition is bounded on the left by a diagonal outcrop of land which appears inverted in the line of the trees and hills in the middle distance and the pattern of clouds above. As a further unifying device, the artist employs the blue and copper tones of the saint's garments throughout the landscape. Filtering through the sky, mountains, and terrain, they serve to link the miraculous religious theme with its surroundings and enhance the coherence of the composition.

The Dulwich picture is painted over a large-scale figure of a nymph asleep in a landscape. Poussin turned the panel upside down and probably trimmed it before using it for the present composition.

1. Peter Murray, *Dulwich Picture Gallery, A Catalogue*, London, 1980, pp. 95 f.

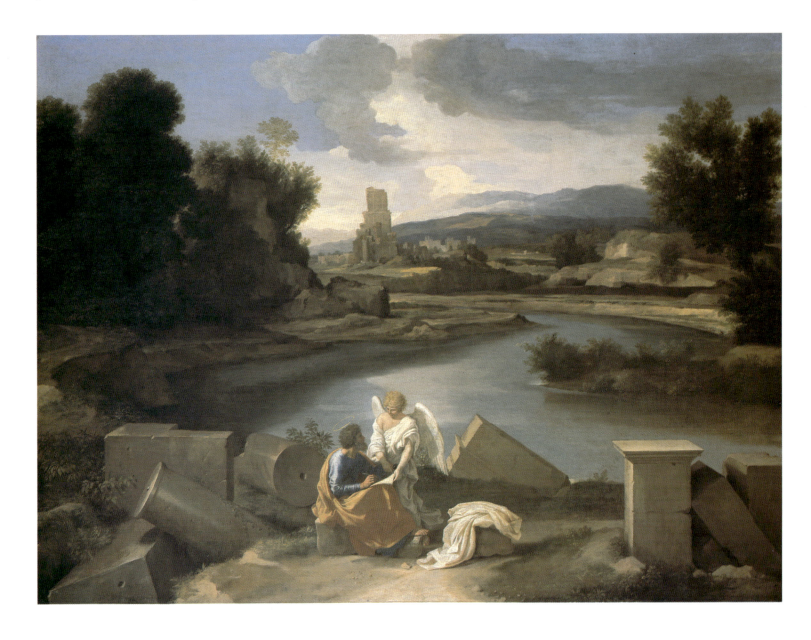

Fig. 39. Corot, *La promenade de Poussin*
(Musée du Louvre, Paris)

Fig. 40. Domenichino, *Landscape with St Jerome*
(Glasgow Art Gallery and Museum)

Landscape with St Matthew and the Angel

Oil on canvas; 99 x 135 cm.

Staatliche Museen Preussischer Kulturbesitz,
Gemäldegalerie, Berlin

Poussin's chief occupation during the second half of the 1630s was the commission for a set of *Seven Sacraments* for Cassiano dal Pozzo, completed between c.1636 and 1642. Although the artist was to surpass these in the more majestic set of *Sacraments* for Chantelou of 1644–48 (on loan to the National Gallery of Scotland from the Duke of Sutherland's collection), the Pozzo series ranks among Poussin's most impressive achievements of the 1630s and clearly made exceptional demands upon him. The task of creating a series of interrelated canvases in which a group of noble and self-consciously diversified figures are seen before an architectural or landscape setting required Poussin to pay careful attention to the relationship between the figures and their surroundings and to the overall harmony of the composition.

The fruits of these labours are apparent in the *Landscape with St Matthew and the Angel* and its pendant, the *Landscape with St John on Patmos* [fig.9], which were completed by 1640, the year of Poussin's departure for Paris. In contrast to his earliest landscapes, these are spaciously designed scenes providing an unimpeded view into the distance and combining architectural forms with elements of the natural world to add to the grandeur and austerity of the impression. In their solemnity and monumentality, these works reflect the mood of the Pozzo *Sacraments* and contrast with the more animated and informally designed landscapes of the mid-1630s to signal a new tone of high seriousness in Poussin's landscape art.

The Berlin picture portrays St Matthew writing his gospel with the assistance of an angel, his traditional attribute, against a landscape setting which depicts the Tiber Valley above the Milvian Bridge and alongside the Acqua Acetosa. Although Poussin has taken some liberties with this site, his choice of a topographical setting for the scene may be related to his earlier landscape paintings and to his own sketching expeditions around Rome. A comparable motif appears in the drawing of a *View of the Tiber* at Montpellier [No. 6]; and the identical site of the Berlin canvas occurs in a drawing by Claude in the Cleveland Museum of Art.[1] According to a nineteenth-century tradition, Poussin himself was so fond of this stretch of the Tiber Valley that he frequented it regularly. It subsequently came to be known as *La promenade de Poussin* and, in this form, was painted by Corot [fig.39], in apparent homage to his great predecessor and countryman.[2]

Although Poussin's evangelist landscapes follow a well-established tradition of portraying contemplative religious figures in a natural setting, they surpass those of his predecessors through their avoidance of anecdotal interest and through the clarity and focus of their construction. A comparison with Domenichino's *Landscape with St Jerome* of c.1610 in the Glasgow Museum and Art Gallery [fig.40] reveals how much is gained in Poussin's Berlin canvas through the central placement of the figure group and the organization of the landscape into a series of balanced masses, which relate the figures to their surroundings in a lucid and coherent manner. Thus, the imposing form of the Torre di Quinto in the middle distance of Poussin's landscape rises directly above the evangelist and the groups of trees to either side of it reflect the disposition of the architectural elements in the foreground of the scene. In contrast, Domenichino creates a more loosely composed and digressive landscape – one in which the relationship between the saint and his surroundings appears almost haphazard by comparison.

The landscapes with St Matthew and St John are first recorded in October 1640 in the collection of Gian Maria Roscioli, chamber master and secretary to Pope Urban VIII, and the owner of at least three other canvases by the artist.[3] All of these were figure paintings purchased at roughly three times the price of the evangelist landscapes – a revealing indication of the comparatively low esteem in which even such dignified landscapes as these were held by Poussin's contemporaries. It is conceivable that the artist intended them to form part of a series of canvases depicting all four evangelists in a landscape setting which was interrupted by his visit to Paris in 1640–42 and by Roscioli's untimely death in September 1644.

A chalk drawing after the Berlin picture by Gaspard Dughet is in the Kunstmuseum, Düsseldorf, and affords a rare instance of Dughet's close study of a specific landscape composition by his brother-in-law.[4]

1. Marcel Roethlisberger, *Claude Lorrain, The Drawings*, Berkeley and Los Angeles, 1968, Vols. I and II, No. 591 (recto).

2. Alfred Robaut, *L'œuvre de Corot, catalogue raisonné et illustré*, Paris, 1905, Vol. II, No. 53. (Cf. Nos. 76 and 95).

3. Liliana Barroero, 'Nuove Acquisizioni per la cronologia di Poussin', *Bollettino d'Arte*, No. 4, 1979, pp. 69 ff.

4. *Gaspard Dughet und die ideale Landschaft*, Kataloge des Kunstmuseums Düsseldorf Handzeichnungen, 1981, No. 24, p. 48.

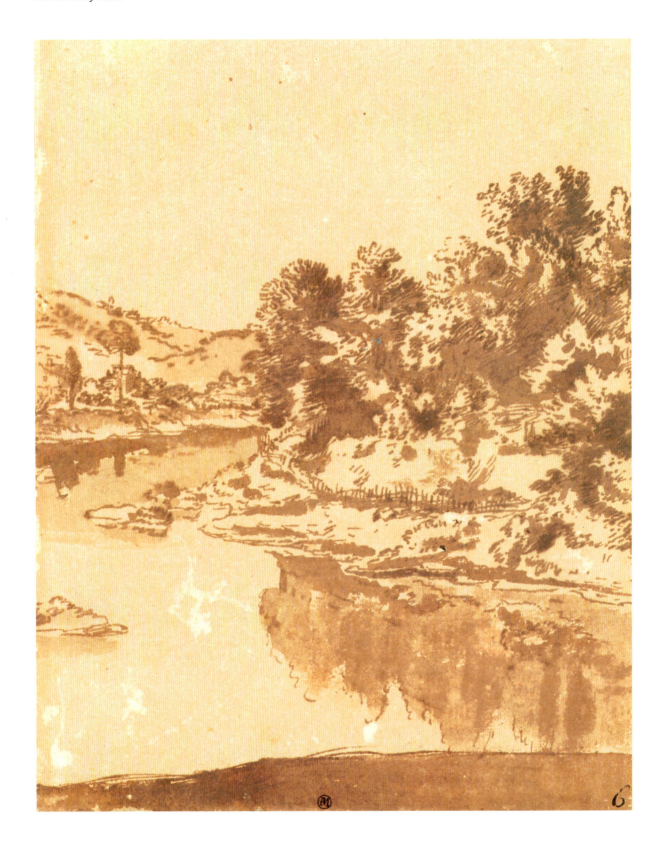

A View of the Tiber

Pen and bistre wash on paper tinted pale sepia;
20 x 14 cm. (*CR* 276)

Musée Fabre, Montpellier

A study from nature, which Blunt identified as portraying a stretch of the Tiber Valley just above the Ponte Molle,[1] the Montpellier drawing has often been linked with the background of the Berlin *Landscape with St Matthew and the Angel* [No. 5] – though the sites are not identical. The drawing is usually dated to the 1630s and is typical of a number of spontaneous nature studies executed by Poussin on the sketching expeditions into the Roman campagna which Sandrart and Félibien note that he undertook during these years. With delicate strokes of the pen overlaid with graduated touches of wash, the artist brilliantly captures the shimmering play of light over the trees and river-bank and frames the scene below with the more unmodulated tones of the reflections in the water and the foreground shore.

The Montpellier drawing has a distinguished history. In the early nineteenth century, it was owned by the painter, François-Xavier Fabre (1766–1837), who bequeathed it to the museum which bears his name. Earlier than this, it formed part of the collection of Jean-Pierre Mariette, who owned a number of Poussin's finest landscape drawings, among them the *Five Trees* [fig. 19]. In 1741, Mariette wrote the earliest appreciation of Poussin's qualities as a draughtsman, which includes the following account of his studies from nature:[2]

'... he followed for his landscapes a method different from the one which he adopted for figure painting. The absolute need to study the scene on the spot led him to make a large number of very careful landscape drawings from nature. Not only did he on these occasions observe the forms with reverent care, but he also paid special attention to unusual effects of light, which he then incorporated into his paintings with great success. On the basis of these studies, he composed in his studio those noble landscapes which make the spectator feel that he has been transported to ancient Greece, to those enchanted valleys described by the poets.'

1. Anthony Blunt, *The Drawings of Poussin*, New Haven and London, 1979, p. 55.
2. Quoted from the above, p. 2. (P.-J. Mariette, *Description sommaire des desseins des grands maistres ... du cabinet de feu M. Crozat*, Paris, 1741, p. 114.)

Landscape with the Tower of Caesar

Venturi 32

Oil on paper, mounted on canvas; 19 x 30 cm.

Musée Granet-Palais de Malte, Aix-en-Provence,
Dépôt de l'Etat

Cézanne's earliest landscapes date from around 1860. During the next ten years he produced fewer than two dozen works in this vein, the majority of them portraying scenes of rural nature undisturbed by humanity. *Landscape with the Tower of Caesar* is one of the first of these and probably dates from Cézanne's student days, *c.* 1860–61. In its delicacy and restraint it suggests a brief phase of quiet contemplation before nature which predates Cézanne's discovery of the more assertive art of Courbet and Pissarro, who were to provide him with his first recognisable landscape style.

The scene depicted is located several kilometres from Aix, in the direction of the Mont Sainte-Victoire, where a group of hills flank a gentle vale beyond which rises the so-called Tower of Caesar. Cézanne probably painted this tranquil site directly from nature. Executed on paper, which has been mounted on canvas, it recalls the landscape *études* of Corot and Granet, who often adopted a similar procedure and who would also appear to be the most obvious stylistic influences upon this very early work. With its limpid clarity, subtle gradations of tone and hue, and broad but meticulous handling, the *Landscape with the Tower of Caesar* is reminiscent of the art of both of these masters and affords tantalising evidence of Cézanne's apprenticeship in the Poussinesque tradition of the nineteenth century, as exemplified by Corot and Granet. Although the large collection of Granet's works which the painter bequeathed to the museum at Aix in 1849 was only on public view after

1862, it has been plausibly suggested that Cézanne may have been introduced to it earlier by Joseph Gibert, curator of the museum and Cézanne's first drawing master.[1]

For all its modesty and tentativeness, the picture reveals a remarkable poise and discretion which already foretell the future Cézanne. Enclosed to either side by the diagonally aligned contours of a sequence of receding hills, the design is focused upon a single cottage and cypress, which mark its exact centre. In the sloping roof of the house, Cézanne uncovers further diagonals to mirror the lines of the converging hills, as though reiterating in this combination of cottage and tree the principal axes of the entire composition.

Corot and Granet rarely subjected themselves to such limited means. But for Cézanne – even in his cautious beginnings – finding order in nature was all. Ten years later, a similar disposition of pictorial elements, three-fold in design, would re-emerge in the artist's first great landscape painting, *The Railway Cutting* [fig. 29], where as Lawrence Gowing has observed 'the formal strophe and antistrophe of modern painting established themselves for the first time'.[2]

1. Denis Coutagne, *Cézanne au Musée d'Aix*, Aix-en-Provence, 1984, pp. 210 f.
2. Lawrence Gowing, 'The Early Work of Paul Cézanne', *Cézanne, The Early Years 1859–1872*, Royal Academy of Arts, London, 1988, p. 15.

Landscape

Venturi 37

Oil on canvas; 26.7 x 35 cm.

Vassar College Art Gallery,
Poughkeepsie, New York

In the years around 1865 Cézanne executed a number of landscapes with sweeping strokes of the brush or palette knife in a bold and impetuous manner. Small in size and experimental in handling, these works might be dismissed as the unassuming exercises of youth but for the passionate intensity of their vision.

The Vassar landscape is typical of these pictures in its modest dimensions, forceful brushwork, and dramatic contrasts of tone and hue. In a letter to Zola of 1866, concerning his earliest attempts to paint figures in a landscape, Cézanne confessed that he was initially struck by the contrasts in nature when working before it. 'But you know all pictures painted inside, in the studio, will never be as good as those done outside', observed the artist, 'When out-of-door scenes are represented, the contrasts between the figures and the ground is astounding and the landscape is magnificent. I see some superb things and I shall have to make up my mind only to do things out-of-doors'.[1]

In the Vassar canvas, which dates from *c.* 1865, Cézanne reduces the forms of the landscape to simplified masses surging with energy and emotion, as though determined to synthesise his impressions before nature in a powerful and economical manner. Thick, buttery strokes of paint reduce the swelling forms of the trees and terrain to alternating areas of green and ochre which interlock to create a somewhat brusquely ordered scene. Far from contemplating the landscape before him Cézanne appears to do battle with it in these turbulent early works. In the words of Kurt Badt, 'he had not yet mastered the problem

of how to place his ego at a distance from its surroundings'.[2]

The impassioned style of these landscapes is mirrored in the following lines from a poem Cézanne sent to his friend Numa Coste in 1863, which reveals the extent of his romantic identification with nature during these years:[3]

The tree shaken by the fury of the winds
Stirs its stripped branches in the air
An immense cadaver that the mistral swings.

The immediacy of Cézanne's landscapes of this period cannot conceal the fact that they are also very timeless scenes. Though their vehement handling may owe something to both Courbet and Pissarro, whom Cézanne had met in 1861, their synthetic approach to nature already sets Cézanne apart from his contemporaries and reveals the greater universality of his vision. In the most characteristic of his early landscapes, Cézanne avoids the topographical concerns of his generation and seldom concentrates upon the identifying features or inhabitants of a scene. Instead, he favours unpopulated views of average nature which appear so unburdened of pictorial fact that they are rarely identifiable and bear no more specific title than simply *Landscape*.

1. *Letters*, pp. 112 f.
2. Kurt Badt, *The Art of Cézanne*, trans. Sheila Ann Ogilvie, Berkeley and Los Angeles, 1965, p. 263.
3. *Letters*, p. 366.

The Avenue at the Jas de Bouffan

Venturi 47

Oil on canvas; 38 x 46 cm.

The Tate Gallery, London

In 1859 Cézanne's father bought the Jas de Bouffan, an estate on the outskirts of Aix consisting of a fine, eighteenth-century manor house and farm set in 37 acres of land. During the next forty years, the Jas de Bouffan served as the family residence and a frequent subject of Cézanne's art. Its avenue of chestnut trees furnished the motif for a series of paintings, drawings, and watercolours of *c.* 1865–88, two of which are exhibited here [Nos. 49 and 53]. The earliest of these are a canvas of 1865–67 (V.38) and a watercolour [fig. 41] of 1867–70, the delicacy and discursiveness of

Fig. 41. Cézanne, *The Avenue at the Jas de Bouffan*, *c.* 1867–70. Watercolour
(Present whereabouts unknown)

which contrast with the strict formality of the Tate picture.

The scene is constructed out of a sequence of parallels dominated by the vertical trunks of the trees and the horizontal divisions of the land. Linking these is a third series of diagonal accents formed by the bank of vegetation at the lower right, the receding pathway, and the overhanging foliage. This rigid scheme is reinforced by the repeated tones of green, ochre, and black which build up the composition. In intensity and saturation, these remain undiminished into the distance, asserting the surface unity of the construction as though in defiance of the recessional nature of the scene.

The date of the Tate picture has given rise to much discussion.[1] Although its rich colours, strong tonal contrasts, and thick surface texture relate to Cézanne's style of *c.* 1869–70, its emphatic construction bears certain similarities to works of the mid-1870s, painted immediately after Cézanne's most Impressionist phase.[2] (Cézanne is not recorded in Aix between 1871 and 1874, making it unlikely that the picture was painted during the intervening years.) A comparison with the artist's first masterpiece of landscape painting, *The Railway Cutting* of *c.* 1869–70 [fig. 29], suggests that there is nothing in the Tate Gallery picture which was beyond Cézanne's powers at this stage of his career. Both works possess a classic formality and an emphatic colour harmony which threaten to usurp attention from their subjects. These traits concur with the assertive style of Cézanne's pre-Impressionist years and find obvious parallels in his still-lifes and figure paintings of around 1870, among them the *Still-life with a black Clock* and the *Overture to Tannhäuser*.

The Tate Gallery canvas is among Cézanne's first paintings of a receding road lined with trees – one of the favourite motifs of his art. Corot and Pissarro also portrayed this theme in a series of airy and spacious scenes of an almost wistful beauty, which reveal their concern with the most fragile and fleeting aspects of nature. In contrast, Cézanne's *Avenue at the Jas de Bouffan*, with its severe, claustrophobic construction and its rigorous integration of space and surface, recalls the formal principles of Poussin's *Landscape with a Roman Road* [No. 21].

1. For a summary of views on this question, see Ronald Alley, *Catalogue of the Tate Gallery Collection of Modern Art*, London, 1981, pp. 103 f.
2. Cf. V. 158–60, 164.

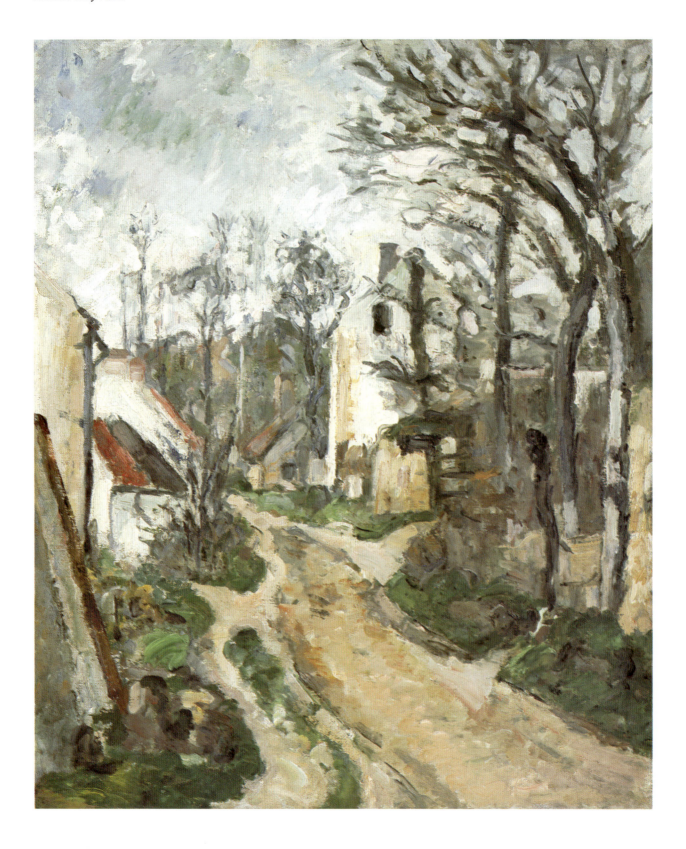

The Road at Auvers

Venturi 147

Oil on canvas; 55 x 46 cm.

National Gallery of Canada, Ottawa
Musée des beaux-arts du Canada, Ottawa

In 1872 Cézanne moved to the town of Pontoise, outside Paris, to work with Pissarro, whose influence was to have a decisive effect upon his development, eventually leading him to abandon the dramatic landscape style of his earliest years in favour of one which was increasingly attentive to the nuances of light and colour he observed in nature. In the autumn of that year, Cézanne moved to the nearby village of Auvers and took up residence near Dr Paul Gachet, a noted amateur and enthusiastic printmaker, who was one of the first champions and collectors of the Impressionists. Cézanne remained at Auvers until the summer of 1874, making a number of etchings using Dr Gachet's printing press and painting the road lined with houses and trees which led through the village. The *Road at Auvers* is one of seven such scenes produced during this period, the majority of them winter landscapes executed in a muted range of browns, ochres and greys. These reveal Cézanne's sensitivity to the most delicate gradations of hue together with the more varied and restrained handling he adopted during his Impressionist years.

The Ottawa canvas returns to the theme of a receding road of the Tate Gallery's *Avenue at the Jas de Bouffan*, but in a wholly different spirit. Rather than asserting his authority upon the landscape, Cézanne here submits to its waywardness and irregularity, its overcast sky and dull, northern hues – in short, its very mundanity. Focusing upon the meandering road leading to a centrally placed house – a motif which recurs in a small picture of this same period in the Musée d'Orsay (V.134) – Cézanne frames the scene with the sloping roofs at the lower left and the trees at the upper right. Adding to the naturalism of the effect is the spontaneity of the brushwork, its freedom and unpredictability mirroring nature's own caprice. No less remarkable is the restricted colour harmony out of which Cézanne builds the scene, as though refusing to admit contrasts or emphasis in this unprepossessing subject. Only the sparing accents of red and green and the pure whites of the buildings relieve the somewhat drab impression. And only the prominent façade of the central house, with its darkened window and chimney, presses forward towards the foreground trees, as though summoning the whole to order.

This device recurs in Cézanne's finest treatment of this theme, the *House of Dr Gachet* of *c.*1873 in the

Fig. 42. Cézanne, *The House of Dr Gachet, c.*1873 (Musée d'Orsay, Paris)

Musée d'Orsay [fig. 42], where house and tree are set firmly in the centre of the picture, creating a more compact composition, and the prominent windows and chimneys of the surrounding buildings are furtively echoed in a square-shaped 'cloud' at the upper right. In works such as this, Cézanne appears to coax an order and harmony from nature while still remaining attentive to its surface appearance, as though momentarily enjoying the best of both worlds. Small wonder that within months of Cézanne's settling in the North, Pissarro wrote proudly to the painter Guillemet: 'Our friend, Cézanne, raises our expectations ... If, as I hope, he stays some time in Auvers, where he is going to live, he will astonish a lot of artists who were too hasty in condemning him'.[1]

1. Quoted in John Rewald, *Cézanne, A biography*, London, 1986, p. 95.

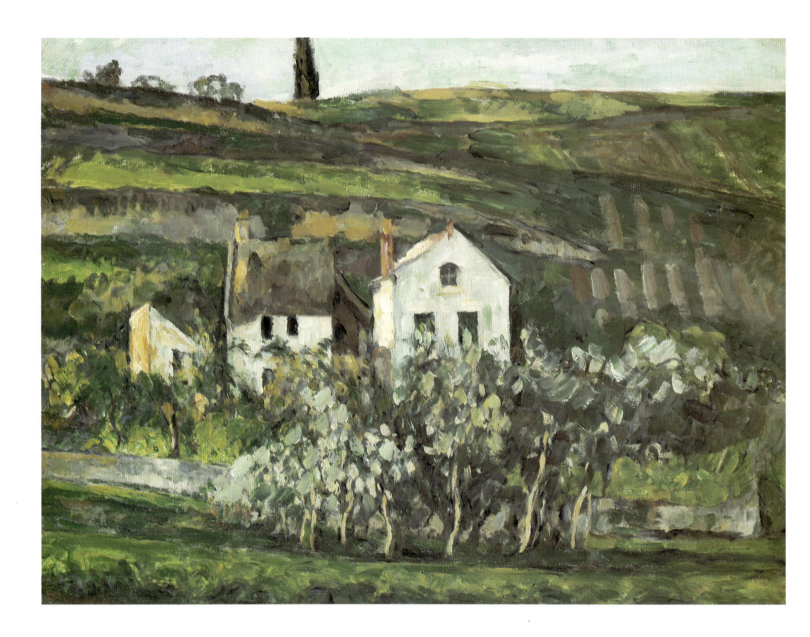

Small Houses at Auvers

Venturi 156

Oil on canvas; 40 x 54 cm.
Signed, lower left.

Fogg Art Museum, Harvard University,
Cambridge, Massachusetts,
Bequest of Annie Swan Coburn

Cézanne was repeatedly drawn to the motif of a group of houses set into a hillside and surmounted by a narrow band of sky [Nos. 29 and 33]. This permitted him to explore the relations of form and colour between the buildings and their surroundings across the entire picture surface. *Small Houses at Auvers* is among his earliest works on this theme and was presumably painted in 1873–74. Its vibrant light and colour suggest that it is a summer scene and contrast with the more muted and wintry colour harmonies of the *Road at Auvers*. Its handling is also considerably bolder than that of the preceding picture, particularly at the right, where Cézanne has worked the greens of the hills into the tops of the trees and introduced a sequence of parallel strokes which serve further to link foreground with distance. In their strength and regularity these add emphasis to this portion of the picture, echoing the hues of the rocky ridges at the left and counterbalancing the weight of the buildings below them.

The picture is characteristic of Cézanne's Auvers landscapes in its spontaneous handling and varied brushwork, as in the unassuming nature of its motif. Out of this, however, Cézanne wrests a unity and richness of colouring, together with a sequence of formal correspondences, which anticipate the achievement of his *Houses in Provence* of a decade later [No. 33]. Framed above and below by a strip of sky and a narrow road, Cézanne's houses glow against the myriad hues of the hillside like jewels in a surround. One, left of centre, bears a roof-top coloured in the mottled hues of the surrounding rocks. At the exact centre, the receding wall of the largest house, painted in the purest white, comes forward to stabilise the composition. Finally, the windows and chimneys of the two most prominent houses mirror the erect stance of a solitary tree at the upper left, in quiet collusion.

According to Venturi, the motif of the Fogg canvas is taken from the side of the Val-Harmé, a site which also forms the subject of a landscape of 1879–82 by the artist (V. 318).

Small Houses at Auvers is first recorded in the collection of Victor Chocquet, early champion of the Impressionists and the first important collector of Cézanne's pictures.[1] Chocquet met Cézanne in 1875 and, two years later, exhibited much of his collection at the third Impressionist exhibition, where he was regularly to be seen, extolling the merits of the new painters. 'He was particularly indefatigable on the subject of Cézanne, whom he placed on the very highest level', recounts Théodore Duret, '... Many were amused at Chocquet's enthusiasm, which they considered something like a gentle insanity ...'[2] Among those who shared his enthusiasm for the artist as early as 1877 were Georges Rivière[3] and Zola. In a short article on the exhibition the latter praised Cézanne as 'certainly the greatest colourist of the group' and added: 'There are, in the exhibition, some Provençal landscapes of his that have a splendid character. The canvases of this painter, so strong and so deeply felt, may cause the bourgeois to smile, but they nevertheless contain the makings of a great artist ...'[4]

1. Cf. John Rewald, 'Chocquet and Cézanne', *Studies in Impressionism*, ed. Irene Gordon and Frances Weitzenhoffer, London, 1985, pp. 121 ff.

2. Quoted in John Rewald, *Cézanne, A biography*, London, 1986, p. 113.

3. *Ibid.*, pp. 112 f.

4. *Ibid.*, p. 113.

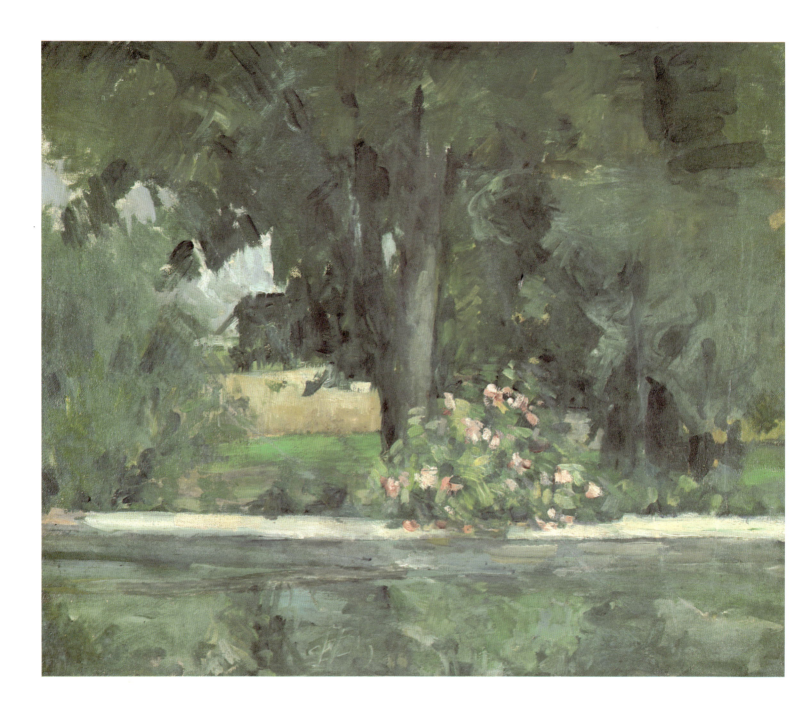

The Pool at the Jas de Bouffan

Venturi 160

Oil on canvas; 46 x 55 cm.

Sheffield City Art Galleries

In 1874 Cézanne left Auvers and returned to Paris, where he exhibited three pictures at the first Impressionist exhibition, among them the celebrated *House of the Hanged Man* in the Musée d'Orsay. During the next four years he worked in both Paris and the Midi, returning briefly to Pontoise and Auvers in 1877. Although relations with his family, and particularly with his father, were strained as a result of his liaison with Hortense Fiquet, who bore him a son in 1872, he returned to the Jas de Bouffan to paint a handful of works during these years. One of the most audacious of them is the *Pool at the Jas de Bouffan*, which probably dates from 1875–77. Only Cézanne could confront the enchanting spectacle of a tree shading a secluded pathway, reflected in a tranquil pool, and reduce it to a simple pictorial equation of vertical versus horizontal, seen in the strictest symmetry. Monet would have put us wholly at ease before such a subject. But Cézanne immediately summons us to attention.

The Sheffield canvas is painted in a broad and summary manner, the brushstrokes varying in both length and direction and, in the flowering shrub at the base of the tree, taking on a delicacy reminiscent of Cézanne's Impressionist years. As though to hold all of this freedom in check, Cézanne limits his colour range and harnesses it to a design of startling simplicity, bisecting the canvas with the trunk of the tree, framing it below with the rigid lines of the pathway and pool, and connecting these two axes with the diagonal contours of the foliage, which fan out to form the sides of a triangle set within the rectangle of the frame. It is as if geometry has been summoned to discipline nature. The early landscapes of Mondrian cannot be far away.

Cézanne repeated this device in an oil (V. 164) and a watercolour [Rewald 155; fig. 43], painted when the trees before his family home had shed their leaves and could serve even more effectively to reveal the

Fig. 43. Cézanne, *The Pool at the Jas de Bouffan*, *c.*1881–83. Watercolour
(Oskar Reinhart, Collection, Winterthur)

skeletal symmetry of the scene. Both works exhibit a determination to penetrate to the essential features of the landscape which lends to much of Cézanne's art an elemental simplicity. 'In Cézanne a pictorial world seems to have been created with the primary elements of vision', observed Fritz Novotny of this aspect of the master's achievement, 'and it is in his painting that this occurred for the first time, not in impressionism, in which, however near it may come with its great creations to Cézanne's form of construction, many non-painteresque elements nonetheless contribute to the effect of the picture. Representations of the elementals, it is true, are continually found in the development of art ... – but never have they been revealed so openly in the constituents of reality as in the painting of Cézanne, and never, except in his work, without being brought into relationship to some realm of thought, either generally religious or subjective, transcending reality'.[1]

1. F. Novotny, *Cézanne*, London, 1961, p. 13.

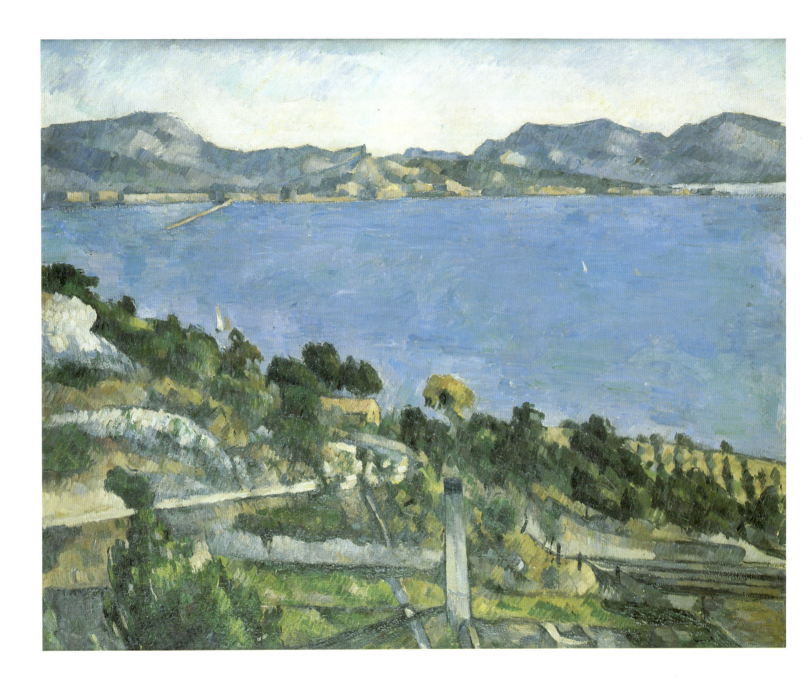

L'Estaque, View of the Gulf of Marseilles

Venturi 428

Oil on canvas; 59.5 x 73 cm.
Signed, lower right.

Musée d'Orsay, Paris, legs Gustave Caillebotte

Cézanne first visited the Mediterranean village of L'Estaque, outside Marseilles, in 1870. He returned there six years later, staying in a house owned by his mother, and was immediately struck by the splendour of the view from this seaside town situated on the shores of the Gulf of Marseilles, 30 km south of Aix, and bounded on the opposite side by a row of distant hills. 'It's like a playing-card', exclaimed the artist in a letter to Pissarro of July 1876, 'red roofs over the blue sea ... The olive and pine trees always keep their leaves. The sun here is so tremendous that it seems to me as if the objects were silhouetted not only in black and white, but in blue, red, brown, and violet. I may be mistaken, but this seems to me to be the opposite of modelling. How happy our gentle landscapists of Auvers would be here ...'[1]

During the next ten or twelve years, Cézanne painted more than a dozen landscapes of this commanding view, three of which are included in the present exhibition [Nos. 35, 36 and 45]. The earliest of these (V. 168) does not adopt the high vantage-point which the artist eventually favoured for this most diverse and panoramic of all his landscape subjects. These features are apparent, however, in the Musée d'Orsay's version of this theme, which probably dates from 1878–79 and exhibits a notable advance in technique over the *Pool at the Jas de Bouffan* of two or three years earlier. Gone are the myriad, multi-directional strokes of the earlier canvas; and, in their place, Cézanne has adopted a more orderly and systematic technique, building up the forms of the land through a series of parallel diagonal strokes and contrasting these with the blended and horizontally aligned paint-work of the calm, blue sea.

A comparison with a photograph of the same motif [fig. 44] reveals the extent to which Cézanne has brought the distant hills forward to crown the view, their warm ochre tones echoing those of the land below. In the centre foreground a prominent smoke-stack rises towards a solitary red tree silhouetted against the sea; and, as though in response to this, the hills beyond don the hues of this tree. Roads and rocky ridges traverse the land in a series of intersecting diagonals answered by the line of a distant jetty and by the edge of the land on the opposite shore. Immersed

Fig. 44. The Gulf of Marseilles seen from l'Estaque

in the grandeur and animation of the spot, Cézanne even includes the forms of two sailing-boats on the water, executed wtih the merest flick of the brush – a rare indulgence from an artist normally unconcerned with transitory effects.

On 19 December 1878, Cézanne wrote to Zola from L'Estaque: 'As you say, there are some beautiful views here. The difficulty is to reproduce them, this isn't exactly my line. I began to see nature rather late, though this does not prevent it being full of interest for me'.[2] Faced with the Musée d'Orsay's serene view of L'Estaque, which probably dates from the period of this letter, one is struck more by Cézanne's 'interest' in the scene than by his chronic self-doubts.

The picture was one of only two works by the artist accepted by the Louvre from among the five Cézannes included in the Caillebotte Bequest of 1896. Even then, it was hung safely out of the public's view, a fact lamented by Gustave Geffroy, who, in an article of 1897, praised the picture as 'a magnificent southern marine by Cézanne, perched, one does not know truly why, on the ceiling'.[3]

1. *Letters*, p. 146.

2. *Ibid.*, pp. 173 f.

3. Quoted in *Cézanne dans les musées nationaux*, Orangerie des Tuileries, Paris, 1974, p. 72.

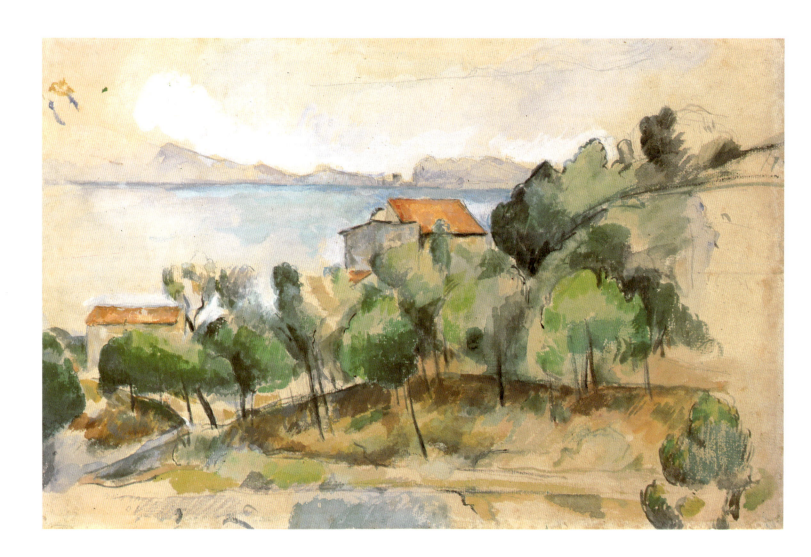

The Bay at L'Estaque

Rewald 117

Pencil, watercolour and gouache on buff paper;
29.1 x 45.5 cm.

Kunsthaus, Zürich

Although Cézanne had made landscape watercolours from the start of his career, only in the late 1870s did he turn regularly to working in this medium before nature. There may be several reasons for this. In his painted landscapes of the early and mid-1870s Cézanne applied his pigment in small, dense strokes of colour, creating a thick and crusty surface texture to record his sensations before nature. Since this effect could not be accommodated to the more fluid medium of watercolour, the artist appears to have largely abandoned it during these formative years of his career in order to consolidate his painting technique. Once he had evolved the orderly 'constructive' stroke of his paintings of the end of the 1870s, however, Cézanne appears to have felt freer to pursue the more spontaneous medium of watercolour. In this he created an ever-increasing number of works during his remaining years. Though many of these treat the same motifs as his paintings, rarely may they be regarded as preparatory to his larger canvases. Rather, Cézanne pursued a parallel development in watercolour, exploring its technical possibilities with a freedom and felicity unattainable in the more substantial medium of oil.

'Cézanne's genius found its purest expression in water-colour painting', observed Kurt Badt, 'and what made this possible was partly the characteristics of the paints themselves and partly the technique of using them which he developed. The fact that all shades of water-colour paints were transparent, letting the light of the white ground gleam through their own darkness, enabled him to produce with them the most perfect example of those sweeping and rhythmical harmonies and that clear, continuous modulation at which he aimed in all his pictures'.[1]

In the *Bay at L'Estaque* of 1878–82 Cézanne has applied carefully graduated touches of watercolour and gouache (opaque watercolour) over a light, preparatory pencil drawing. In their density and precision these still reflect the comparatively laboured style of Cézanne's painted landscapes of these years. Through the transparency of watercolour, however, Cézanne captures effects in nature which are denied to him in oil – above all, its insubstantiality and its shimmering light and atmosphere.

The Zürich watercolour portrays the same motif as a painting (V.408) and drawing (Chappuis 783) of these years, both of which show the scene from a higher vantage-point, which affords an even more expansive view of the surrounding bay. The result is a steeper and more dramatic composition which lacks the poise and harmony of the work exhibited here.

1. Kurt Badt, *The Art of Cézanne*, trans. Sheila Ann Ogilvie, Berkeley and Los Angeles, 1965, p. 37.

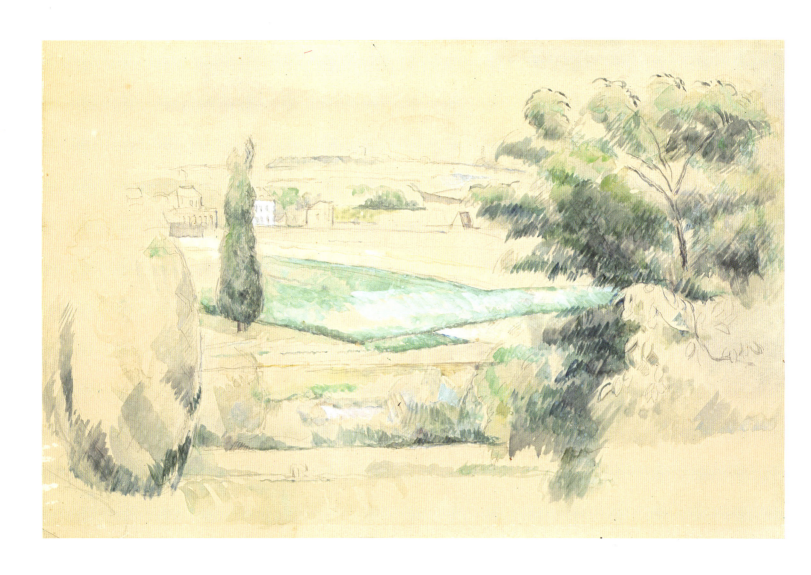

Landscape

Rewald 79

Pencil and watercolour on white paper;
29 x 46 cm.

Lent by Mr Eric Estorick

In a group of landscapes of the end of the 1870s, Cézanne first explored the theme of a sweeping vista framed by trees, one of the most avowedly classical motifs of his art.[1] Though the artist had already adopted this scheme in a rare imaginary landscape, the *Harvest* of 1875–77 [fig.6], only with the consolidation of his technique in *c.*1879–82 does he appear to have consciously sought such alignments in nature. In one of these, executed in watercolour [fig.

Fig. 45. Cézanne, *Trees framing a View of a Town,*
*c.*1881. Watercolour
(Present whereabouts unknown)

45], the expansive view of a village and fields is framed by trees whose overhanging branches meet in the centre of the sheet, a device which anticipates the Phillips Collection's *La Montagne Sainte-Victoire* of 1885–87 [No.41].

The present landscape of 1879–80 shows a less rigorous application of these same principles and probably depicts a motif in northern France. With rhythmic strokes of the brush Cézanne portrays a spacious view of fields and houses framed in the foreground by clumps of trees. In the more fully worked-up foliage at the right, the artist employs the parallel diagonal strokes familiar from his oils of these years. In its serenity and composure, this watercolour invites comparison with Poussin's most classically conceived landscape drawings. Added to these, however, are a delicacy and airiness which are entirely Cézanne's own. Transposing his sensations before nature in watercolour, Cézanne often concerned himself with its most evanescent features.

1. In addition to the two watercolours cited here, see V. 165, 316.

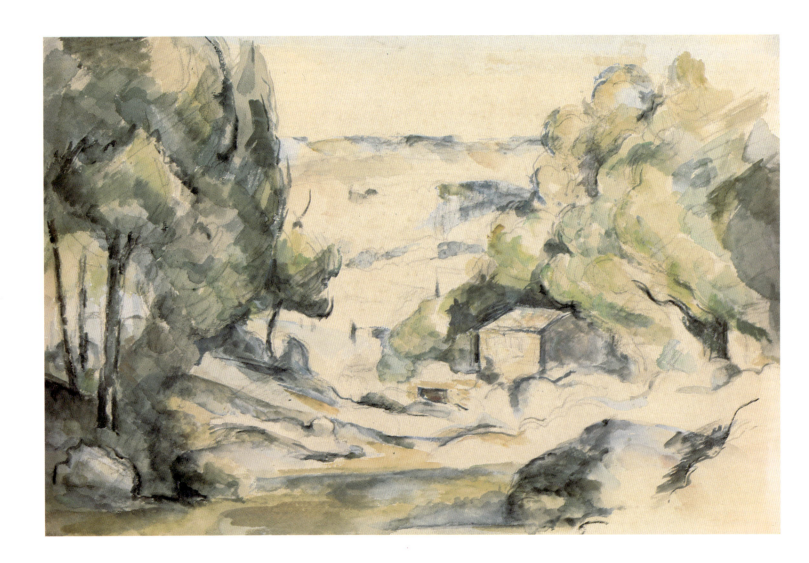

Landscape in Provence

Rewald 115

Pencil, watercolour and gouache on white paper;
34.6 x 49.9 cm.

Kunsthaus, Zürich

The balanced construction of this watercolour of *c.*1880 cannot conceal Cézanne's evident joy when creating it. Over a cursory pencil sketch, the artist has applied exuberant touches of wash which vividly convey his expansive mood before this scene of rolling hills and billowing trees. In the middle of the design, a small rectangle of red provides a focus for the composition. Surrounding it are clumps of trees framing a distant ridge of hills. The former are painted in a subtly modulated range of greens, blacks, and blues applied with an almost carefree abandon which appears barely contained by Cézanne's summary pencil strokes. Here the artist seems to rejoice in the deftness and freedom of the watercolour medium – and in his own increased mastery of it.

For all their apparent modesty, Cézanne's watercolours were regarded by the artist himself as independent creations, no less worthy of public attention than his paintings. Thus, in addition to the fourteen canvases Cézanne chose to show in the third Impressionist exhibition of 1877, there were three watercolours. Two of these were landscapes of the late 1860s, which the artist entitled 'impression d'après nature', as though to declare his solidarity with the new movement, which had earned its name from Monet's canvas of 1874, *Impression – soleil levant* (formerly Musée Marmottan, Paris). Probably loaned by Victor Chocquet, these works drew no response from the critics, who rarely missed an opportunity to condemn the artist during these years. But, if they regarded them as unworthy of comment, Cézanne evidently considered them fitting counterparts to his more ambitious creations in painting; and posterity has endorsed this view.

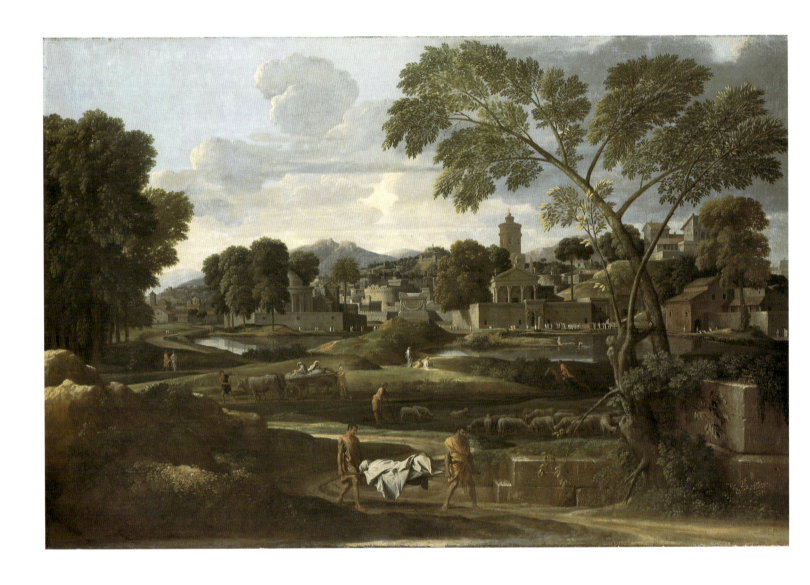

18

**Landscape with the Body of Phocion
carried out of Athens**

Oil on canvas; 114 x 175 cm.

The Earl of Plymouth, Oakly Park, Shropshire
(on loan to the National Museum of Wales, Cardiff)

Painted in 1648 for the Lyons merchant, Cerisier, Poussin's two landscapes illustrating the story of Phocion have long been regarded as cornerstones of the classical landscape tradition and among the supreme achievements of the artist's maturity.

The theme is from Plutarch's *Lives* (XVIII). Phocion (402–318 BC), a noble Athenian general and leader of his people, was condemned to death by his enemies in the city and forced to drink hemlock. As a further indignity, his body was refused burial within the city walls and carried to the nearby town of Megara, where it was cremated. His widow then secretly gathered his ashes and transported them back to Athens where

they were accorded an honourable burial once the tide of political opinion had changed. This episode forms the subject of the pendant composition [No. 19].

Poussin's choice of theme, which had never before been treated in painting, reflects his staunch creative independence and his profoundly stoical outlook upon life. The theme of the tragic fate which may befall even the most honourable of men had already formed the subject of one of the artist's earliest masterpieces, the *Death of Germanicus* of 1627–28, and likewise appears elsewhere in his art. It is possible that the story of Phocion appealed to the artist because of its close parallels with events in France in the late 1640s, where the civil unrest which was to lead to the outbreak of the Fronde in 1649 was already apparent. On 19 September 1649 Poussin wrote to Chantelou deploring the 'stupidity and inconstancy of the people' in their enthusiastic reception of the court, when it returned to Paris after the Peace of Rueil in August of that year.[1] Earlier in 1649 he lamented the bad news he had recently received from England (the execution of Charles I), Naples (the revolt of Masaniello), and Poland (the revolt of the Cossacks), and added, with characteristic detachment: 'It is a great pleasure to live in a century in which such great events take place, provided that one can take shelter in some little corner and watch the play in comfort'.[2] In this Poussin appears to advocate that life of contemplation and withdrawal which he himself followed and which contrasted with the active, public life, subject to 'the inconstancy of the people', which Phocion himself had chosen.

The landscape in which Poussin has set the burial of Phocion is one of unparalleled splendour, which at once seems to celebrate the virtues of his hero and to serve as an ironic contrast to his unhappy fate. Directly above Phocion's body rises the tomb of a rich Athenian – one such as Phocion himself deserved, and one probably earned by material wealth rather than genuine virtue. At the upper right, a procession of figures approaches the Temple of Jupiter, an annual event celebrated by the Athenians on 19 March, the day of Phocion's execution. According to Plutarch 'all those who were still capable of humanity and whose better feelings had not been swept away by rage or jealousy felt that it was sacrilege not to postpone the execution for a single day and thus preserve the city from the pollution incurred by carrying out a public execution while a festival was being celebrated'. In keeping with this festive tone, the landscape is brimming with figures engaged in a variety of activities, all of them indifferent to the tragic fate that has befallen Phocion.

In devising the setting Poussin applied the rigorous principles of composition of his most Raphaelesque figure paintings of these years to the creation of a landscape. Like the *Baptism* or *Ordination* [figs. 22, 23] from the Chantelou *Sacraments*, the protagonists are cen-trally placed and the design contains firm framing elements and a parallel recession back into space. Adding to the clarity and coherence of the construction is the rhythmic disposition of buildings and trees in the background and the carefully distributed light accents. Certain of the buildings in the distance have been identified, the circular temple in the grove at the left with Palladio's reconstruction of the Temples of Vesta in Rome and Tivoli and the circular fortress to the right of it with the Castel Sant'Angelo, including its post-classical additions.

The *Landscape with the Body of Phocion carried out of Athens* forms the subject of an imaginary dialogue between Poussin and the ancient Greek painter, Parrhasius, composed by Fénelon around 1695, in which the French master enumerates the wealth of episodes and incidents included in the picture and describes their appropriateness to the action. 'Have you avoided confusion?', enquires Parrhasius, at one point in the conversation. 'I have avoided both confusion and symmetry', replies Poussin, 'I made a number of irregular buildings; they nevertheless make an agreeable group, where everything takes its most natural place. All is comprehended and distinguished at once; all unites and makes a whole; so there is apparent confusion, but real order when looked into'.[3] Poussin's proverbial modesty may account for the 'apparent confusion' which Fénelon prompts him to attribute to the Phocion picture. But the 'real order' of the scene is beyond dispute. In its richness of interest and complexity of construction, the *Landscape with the Body of Phocion carried out of Athens* is among the most intellectually demanding – and formally satisfying – landscapes ever painted.

Scarcely less impressive is the solemn gravity of the picture's mood. This aspect of the work particularly appealed to Delacroix, despite the fact that he could not have known the original. 'What could be more striking', wrote the nineteenth-century French master in his great essay on Poussin, 'than this sombre vault of ancient trees under which advance the two poor slaves bearing the body of the virtuous Phocion, while the view proceeds in the distance towards the pleasant countryside surrounding Athens, his ungrateful fatherland!'[4]

A drawing for the principal figure group is in the Louvre;[5] and a copy of the painting, acquired as an original, was purchased by the same museum in 1920.

1. *Correspondance*, p. 406.

2. *Ibid.*, p. 395.

3. Quoted from Maria Graham, *Memoirs of the life of Nicholas Poussin*, London, 1820, pp. 163 f. (Originally published in Abbé de Monville, *La Vie de Pierre Mignard*, Paris, 1730.)

4. Eugène Delacroix, *Essai sur Poussin*, Geneva, 1966 (orig. 1853), p. 107.

5. Anthony Blunt, 'Newly Identified Drawings by Poussin and his Followers', *Master Drawings*, XII, 3, 1974, p. 241.

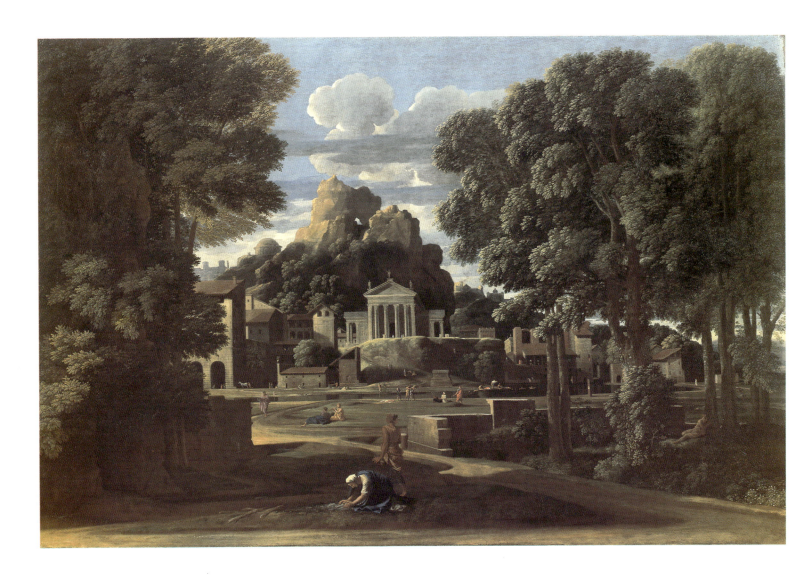

19

**Landscape with the Gathering
of the Ashes of Phocion**

Oil on canvas; 116 x 178.5 cm.

Board of Trustees of the National Museums
and Galleries on Merseyside (Walker Art Gallery)

The second of the two *Phocion* landscapes differs in
type, as in theme, from the *Landscape with the Body of
Phocion carried out of Athens*. In the first scene Poussin
contrasts the heroic action of the slaves with the
public ignominy which has resulted in Phocion's
execution, symbolised by the monumental cityscape
which forms the setting of the picture and at once
recalls the hero's dignity – and eventual disgrace. In

the pendant Poussin commemorates instead the private devotion of his wife and a maidservant as they gather Phocion's ashes on the outskirts of Megara, a clandestine act which is mirrored in the more enclosed and mysterious nature of the scene. Protected from the town by a grove of trees, whose dense shadows fall across the foreground of the picture, as though serving as an accomplice to the action, Phocion's widow performs her task in a pose which conveys both her trepidation and despair. Gazing warily around, as if fearful of detection, is her faithful maidservant; while, hidden in the shadows at the right, a man spies upon the women. His presence reinforces the surreptitious nature of the deed and serves to remind us of its attendant dangers. In the middle distance, Poussin includes a wealth of figures engaged in everyday pursuits who seem oblivious to the momentous events which surround them. Bathing, reading, or engaged in an archery competition, they go about their daily lives indifferent to Phocion's fate. The world does not pause over the downfall of one man, suggests Poussin in this and other works of these years.

According to the early sources, ancient Megara was built upon two rocks. Poussin introduces these above the central temple, where they serve both to set the scene and to contribute to the mood of ominousness which pervades the Liverpool picture. Even to the naked eye it is apparent that these rocks have been painted over a layer of cloud and that the portion of sky visible behind them was added at a later stage in the execution. The temple itself is derived from a reconstruction by Palladio of a temple at Trevi and adds to the convincingly antique character of the setting.

The painting is one of the most concentrated of all Poussin's compositions, with the entire picture surface equally accentuated to a degree which is rare even for this artist. To achieve this Poussin has contrasted the horizontal accents which typically prevail in landscape with an equal number of counterbalancing verticals to create an intricately faceted composition. Though the spatial recession is measured by a sequence of gradually diminishing figures, the surface design is equally emphasised through the uniform clarity of the handling, the framing of the background cityscape by the foreground trees, and the intense colour and light which pervade the picture. The whole forms a supreme demonstration of intellectual coordination and control. Small wonder that, upon seeing the Phocion landscapes in Paris in 1665, Bernini pointed to his forehead and exclaimed: 'Signor Poussin is an artist who works from here.'[1]

The Liverpool landscape is one of a handful of works by the artist of 1648–50 in which an interlocking sequence of geometric shapes consistently stresses the two-dimensional harmony of the construction in an almost abstract manner. In this respect it looks forward not only to the formal devices of Cézanne but to those of the Cubists, and even of Mondrian. Poussin may have been led to adopt this severe method of pictorial composition by the prolonged experience of painting the Chantelou *Sacraments*, six of which include architectural backgrounds which provide a geometric support for the actions of the figures. Conceived in a shallow, frieze-like manner, these works anticipate the austerity and finality of such masterpieces of the end of the 1640s as the *Holy Family on the Steps*, the Chantelou *Self-Portrait* [fig. 1], and the two Phocion landscapes.

In a letter to Chantelou of June 1648, Poussin posited a further link between the *Seven Sacraments* and the works which followed them in his career. Having devoted the *Sacraments* to the general theme of the life of virtue and wisdom which might shield mankind from the wayward workings of Fortune, the artist observed that he would now like to devise another series of works treating the general theme of the tricks which Fortune may play upon unsuspecting humanity, and especially upon those men who had chosen to lead an active life, subject to the whims of both nature and society. Although this desire never resulted in a series of closely related pictures comparable to the *Sacraments*, the broad theme outlined in Poussin's letter forms the subject of many of his landscapes of 1648–51.[2] For the notion of the tragic fate which may befall unsuspecting humanity underlies not only the two *Phocion* pictures, but the *Landscape with a Man killed by a Snake* [fig. 38] of 1648, the *Landscape with Orpheus and Eurydice* (Louvre) of 1650, and the *Landscape with Pyramus and Thisbe* (Frankfurt) of the following year.

The *Phocion* pictures were engraved by Baudet in 1684 and were among Poussin's most frequently copied landscape paintings. A fine account of the *Landscape with the Gathering of the Ashes of Phocion* appeared in the *Magasin pittoresque* in May 1848 – a periodical from which Cézanne often drew – praising Poussin's ability to conceive of landscape in so grand and dignified a manner.[3] In an equally memorable account of the picture in the *Atheneum* of October 1881, S. P. Lambros extolled instead its solemnity and pathos. 'The horror of the shadows and the brooding light which pervade this superb painting', he observed, 'are like threatenings of thunder ominous of the anger of the gods'.[4] In keeping with the deepest import of his theme, Poussin imbued both Phocion landscapes with an air of tragedy – and nobility.

1. Paul Fréart de Chantelou, *Diary of the Cavaliere Bernini's Visit to France*, ed. Anthony Blunt, Princeton, 1985, p. 111.

2. R. Verdi, 'Poussin and the "Tricks of Fortune",' *The Burlington Magazine*, CXXIV, 956, November 1982, pp. 681 ff.

3. 'Phocion. Tableaux de Poussin', *Magasin pittoresque*, XVI, 1848, pp. 145 f.

4. S. P. Lambros, 'The Private Collections of England No. LXIII – Knowsley Hall, Prescott', *The Atheneum*, 1 October 1881, No. 2814, pp. 439 ff.

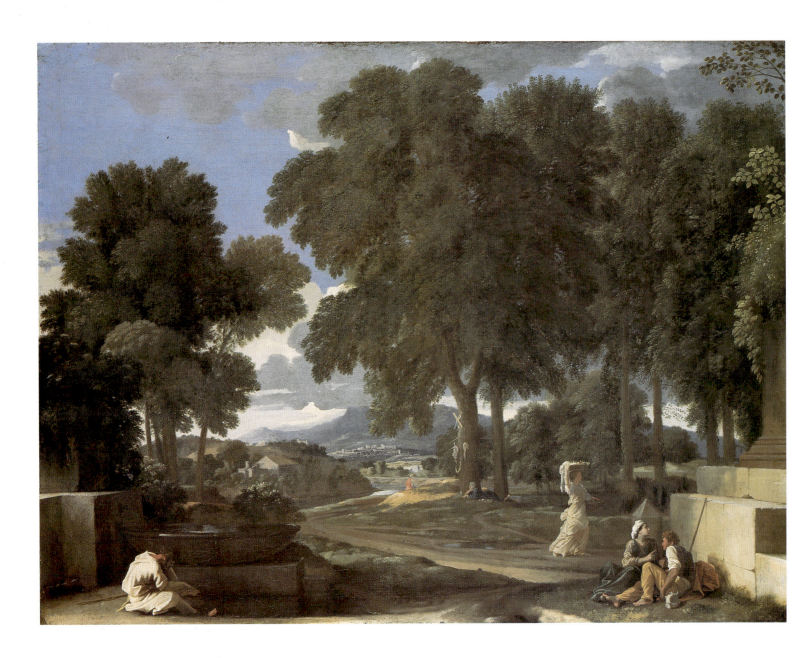

Landscape with a Man washing his Feet at a Fountain

Oil on canvas; 74.5 x 100 cm.

Trustees of the National Gallery, London

Although this picture is not mentioned by any of the early sources, there is good reason to believe that it was painted as a pendant to the *Landscape with a Roman Road* [No. 21], which Félibien dates to 1648. In addition to their similarities in size and type, the two pictures formed part of a series of four landscapes by Poussin engraved by Etienne Baudet in 1684, the other two of which were the Phocion pair.[1] Erroneously known as *Phocion* in the early nineteenth century, the National Gallery picture was bequeathed to the nation by Sir George Beaumont in 1828 and has long been among Poussin's most admired landscapes, with John Constable even declaring it 'the most affecting picture I almost ever stood before'.[2]

Poussin would appear to be concerned with no specific literary subject in the London and Dulwich canvases but only with the activities of ordinary man set into a landscape which, in the London canvas, appears rural and uncultivated and, in the Dulwich picture, has been subjected to the civilizing hand of man, symbolised by the Roman Road. In addition, the motifs of a man washing his feet and another drawing water from a fountain, which occupy similar positions in both works, may be intended to allude to the cleansing and sustaining powers of water – a theme which is a favourite one with Poussin and may also be found in his landscapes with *Diogenes* and *Hagar and the Angel* [Nos. 22 and 55]. Apart from these connections, the two works do not possess the close links normally associated with pendants – e.g. complementary compositions and times of day, together with a shared horizon line. Eschewing these more decorative aspects of the traditional pendant relationship, Poussin appears to have conceived them as independent compositions which need not be hung together. Indeed, so self-sufficient are both works that it is far from easy to determine which way around they were intended to go.

Despite its modest dimensions and unassuming subject, the *Landscape with a Man washing his Feet at a Fountain* is conceived along the same principles as Poussin's grandest landscape compositions of the end of the 1640s. Framed by groups of masonry and trees, the scene proceeds towards the horizon through a winding road peopled with figures whose gradually diminishing size marks the extent of the view. Though the composition appears weighted towards the right,

Poussin balances it by the lightly clad and tensely animated figure of the man washing his feet on the opposite side and asserts the overall symmetry of the construction in the centre middle distance, where the combination of the three primary colours plus the white of the roadside shrine stresses the central axis of the composition.

Although the authenticity of the National Gallery picture has been disputed, its sensitive handling and brilliant colour leave little doubt that it is an original. Particularly striking are the delicately nuanced greens of the trees and the pure and intense hues of the sky and mountain range, which reaffirm the two-dimensional harmony of the composition at the most recessional point in the scheme. Though Poussin's avoidance of a more naturalistic play of light in this picture earned Ruskin's condemnation, the latter still conceded the work to be 'one of the finest landscapes that ancient art has produced – the work of a really great and intellectual mind'.[3]

Other artists and critics have paid the picture more unequivocal praise. A painted copy of it was made in Rome by James Barry in 1767 (National Gallery of Ireland) and another, in watercolour, by Edward Dayes in 1783 (City Museum and Art Gallery, Birmingham). But it was left to John Constable, who saw the picture at the Royal Academy in 1821, to pay it the most memorable tribute:[4]

'... there is a noble N. Poussin at the Academy, a solemn, deep, still summer's noon with large umbrageous trees, and a man washing his feet at a fountain near them. Through the breaks in the trees are mountains, and the clouds collecting about them with the most enchanting effects possible. It cannot be too much to say that this landscape is full of religious and moral feeling.'

1. For the suggestion that the National Gallery picture may have been commissioned by Pointel and did not form a pair with the *Roman Road*, see Jacques Thuillier and Claude Mignot, 'Collectionneur et Peintre au XVIIᵉ: Pointel et Poussin', *Revue de l'Art*, No. 39, 1978, p. 49.

2. C. R. Leslie, *Memoirs of the Life of John Constable*, ed. Jonathan Mayne, London, 1951, p. 297.

3. John Ruskin, *Modern Painters*, London, 1900 (3rd ed. in small form), Vol. I, p. 153.

4. Leslie, *op. cit.*, p. 84.

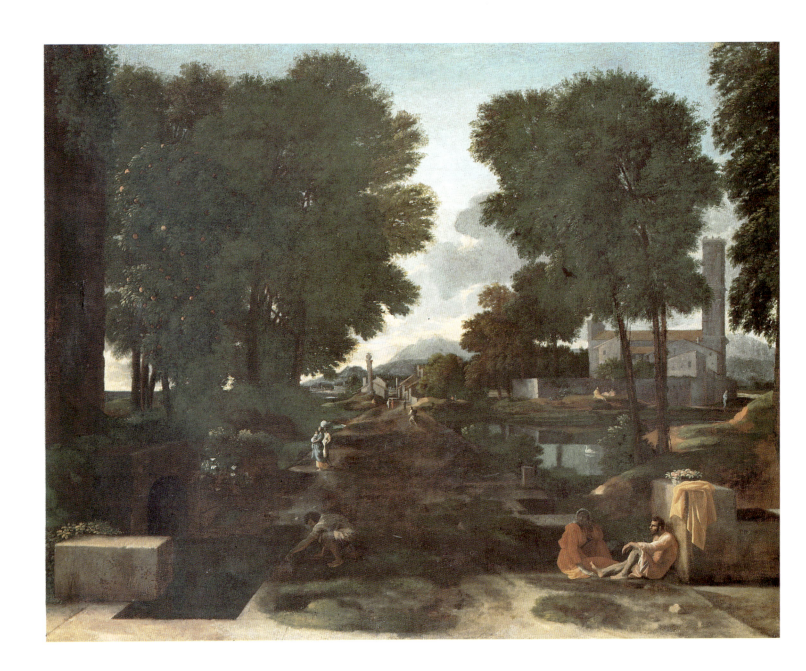

Landscape with a Roman Road

Oil on canvas; 79.3 x 100 cm.

By permission of
the Governors of Dulwich Picture Gallery

The *Landscape with a Roman Road* was recorded in the collection of the Chevalier de Lorraine in 1685 by Félibien, Poussin's most informative early biographer, who dated the picture to 1648 but made no mention of its presumed pendant [No. 20]. It is possible that the two canvases had already been separated by this time; for, whereas the copy by James Barry mentioned in the preceding entry suggests that the National Gallery picture was still in Rome in 1767, the Dulwich canvas was already in Paris when Félibien was writing. The different conditions of the two works likewise suggest that they have long been separated. While the *Landscape with a Man washing his Feet at a Fountain* is generally well preserved, the Dulwich picture is damaged and seriously abraded and lacks much of the subtlety of tone and modelling of the National Gallery landscape. These weaknesses have led some critics to conclude that the Dulwich picture is a copy of a lost original. In the present state of the painting, it is impossible to ascertain what its original quality may have been; but what can be said with certainty is that it is the finest surviving version of one of Poussin's noblest landscape compositions.

X-rays of the picture reveal three figures that correspond closely with the left-hand group of females in Poussin's *Moses trampling on Pharaoh's Crown* of c. 1646–48 in the Louvre. The canvas was then turned on its side and reused for the Dulwich landscape – an unprecedented act for Poussin at this late stage of his career. Although the artist may have resorted to this in order to salvage part of a canvas which had been damaged at the right, it is possible that both paintings are copies and that, having first decided to paint the *Moses*, the copyist changed his mind, cut down the canvas, and proceeded to copy the Dulwich picture instead.

The motif of the *Landscape with a Roman Road* is among the most daring of Poussin's career as a landscape painter and would appear to be the artist's own invention. Though perspectively receding architectural scenes are common in earlier art – and had been used by Poussin himself in his *Plague at Ashdod* of 1630–31 (Louvre) – the Dulwich picture would appear to represent an unprecedented attempt within the classical landscape tradition to adapt this device to a portrayal of nature.[1] Poussin avoids the potential divisiveness of this scheme by a careful balancing of masses to either side of the road and by an alignment of masonry, buildings, figures, and trees which proceeds towards the horizon in a zigzag fashion, linking both sides of the composition. Adding further to the unity of the design are the carefully distributed accents of light, which alternate along the sides of the road, aiding the progression back into space while at the same time connecting both halves of the picture. The result is a tour de force of compositional unity and equilibrium which overrides the potential difficulties of the theme to attain that quality which Wordsworth found so admirable in Poussin's landscapes – their 'wholeness'. 'We have known him enlarge', wrote Hazlitt of the great poet,[2] 'with a noble intelligence and enthusiasm on Nicolas Poussin's fine landscape-compositions, pointing out the unity of design that pervades them, the superintending mind, the imaginative principle that brings all to bear on the same end; and declaring that he would not give a rush for any landscape that did not express the time of day, the climate, the period of the world it was meant to illustrate, or had not this character of *wholeness* in it.'

In his fine essay on the Dulwich Gallery, Hazlitt expressed his own admiration for Poussin's *Roman Road*. 'The genius of Antiquity might wander here and feel itself at home', he observed, 'The large leaves are wet and heavy with dew, and the eye dwells "under the shade of melancholy boughs".'[3]

More unexpected praise for the picture came from Turner, who normally favoured Poussin's wilder and more romantic landscapes. Commending the Dulwich picture in 1811 as 'a powerful specimen of Historic landscapes',[4] Turner proceeded to base his own *Château de St. Michel, Bonneville* (Yale Center for British Art, New Haven) of 1812 on Poussin's striking composition.

1. The only earlier example known to me is a copper roundel of a *Country Road by a House* attributed to Goffredo Wals (Fitzwilliam Museum, Cambridge), which lacks the compositional intricacy of the Dulwich picture.

2. *The Complete Works of William Hazlitt*, ed. P. P. Howe, London and Toronto, 1934, Vol. XI, p. 93.

3. William Hazlitt, *Criticisms on Art: and sketches of the picture galleries of England*, London, 1856 (2nd ed.), Vol. I, p. 34.

4. Jerrold Ziff, 'Turner and Poussin', *The Burlington Magazine*, CV, 724, July 1963, p. 315.

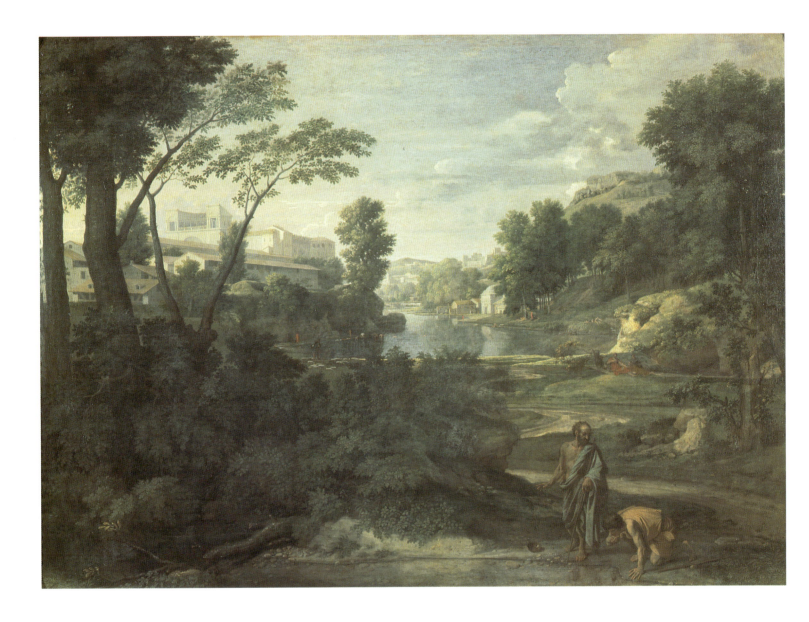

Fig. 46. Jean-Victor Bertin, *Diogenes*, 1805
(Engraving after a lost painting)

Fig. 47. Poussin, *The Belvedere*. Drawing
(Musée Condé, Chantilly)

Landscape with Diogenes

Oil on canvas; 160 x 221 cm.

Musée du Louvre, Paris

This is the only landscape by Poussin included in the present exhibition that Cézanne could have known in the original. In his day it was the only French painting to hang in the Salon Carré of the Louvre – that Pantheon traditionally reserved for the gems of the collection, including the *Mona Lisa*. According to Théophile Gautier,[1] Poussin's picture warranted this distinction through a nobility of style which made it a model of historical landscape painting.

The Louvre canvas was painted in 1648 for the Genoese banker Lumague,[2] who, so far as we know, commissioned no other paintings from Poussin. The subject is from Diogenes Laertius[3] and portrays the Cynic philosopher, Diogenes, who, having reduced his worldly possessions to a cloak and a drinking bowl, casts aside the latter at the sight of a youth drinking from his hand alone, whose action convinces him that this possession is unnecessary to his chosen mode of natural existence.

Poussin mirrors Diogenes's return to a state of nature in one of the most spacious and luxuriant landscapes of his entire career. Rather than the lucid and rigorous interplay of natural and architectural elements of, for example, the *Phocion* pictures [Nos. 18 and 19], the artist here creates a scene of verdant, untrammelled growth which befits a theme that celebrates the renouncing of the constraints of civilization upon mankind. Reinforcing this impression are the broad and textured application of paint and the intoxicating range of greens which pervade the scene. Poussin even seems to allude to the natural state of existence of his figures in the colours that clothe them. These are blue and yellow, which combine to make green, the dominant hue of the rest of the picture and of nature itself.

When compared with the artist's other documented landscapes of 1648, the *Diogenes* testifies to the range and variety of Poussin's landscape art at this moment in his career and reveals a pantheistic love of nature one would hardly suspect from the creator of the more rationally conceived *Phocion* pair. Not surprisingly, the freshness and naturalness of the Louvre landscape, with its rich colour and subtle atmospheric effects, earned especial praise from nineteenth-century artists and critics, who regularly cited the *Diogenes* as proof that Poussin had scrupulously studied nature – a practice which succeeded in rendering even his most idealised scenes essentially true.[4] Among its many admirers at this time was J. M. W. Turner, who praised it as a 'charming and grand composition' with 'the foreground large as to parts and beautifully pencil'd and the figures happyly introduced'.[5] Numerous copies of the picture – and an extended critical discourse on it[6] – testify further to the work's popularity with nineteenth-century artists and critics, as does a version of this same theme of 1805 by Jean-Victor Bertin [fig.46], teacher of Corot, and an artist also apparently admired by Cézanne.[7]

A drawing for the Belvedere of the Vatican shown at the upper left of Poussin's picture is at Chantilly (*CR* 280; fig.47). Though done from nature, it possesses a classical balance and symmetry characteristic of Poussin's composed landscapes or of any number of Cézanne's most well-ordered views.

The magisterial portrayal of nature which forms the true subject of the Louvre landscape cannot disguise the fact that the action depicted in it was also one close to Poussin's heart. Sharing Diogenes's own tendencies towards modesty and self-abnegation, Poussin is once reputed to have shown Cardinal Massimi to the door of his house, carrying a candle to light the way. When the cardinal expressed his pity that the artist had no servants to perform this task for him, Poussin retorted: 'And I pity your Eminence for having so many'.[8]

1. Théophile Gautier, *Guide de l'Amateur au Musée du Louvre*, Paris, 1882, p. 64.

2. On the Lumague family and the putative identity of Poussin's patron, see: Saburo Kimura, 'Etudes sur *Diogène jetant son écuelle* de Nicolas Poussin', *Mediterraneus*, v., 1982, pp. 51 ff.

3. Diogenes Laertius, *Lives of Eminent Philosophers*, trans. R. D. Hicks, II, London and Cambridge, Mass. (Loeb Classical Library), 1925, p. 37.

4. Further to the critical appraisal of the *Diogenes* in the nineteenth century, see Verdi, *Poussin's Critical Fortunes ...*, pp. 274, 285 ff.

5. Alexander Joseph Finberg, *A complete Inventory of the Drawings of the Turner Bequest*, London, 1909, Vol. I, p. 183.

6. Pierre-Louis Duplat, 'Dissertation sur le tableau de Nicolas Poussin connu sous le nom du "Diogène",' *Annales de la Société Libre des Beaux-Arts*, XVII, 1847–50, pp. 44 ff.

7. *Supra*, p. 57.

8. G. P. Bellori, *Le Vite de'pittori, scultori et architetti moderni ...* Rome, 1672, p. 441. As Anthony Blunt observed (*Nicolas Poussin*, London and New York, 1967, Vol. I, p. 171.), this echoes another episode from the life of Diogenes, who, when informed that his only slave had run away, replied: 'My slave has run away? Say rather that I have become free'.

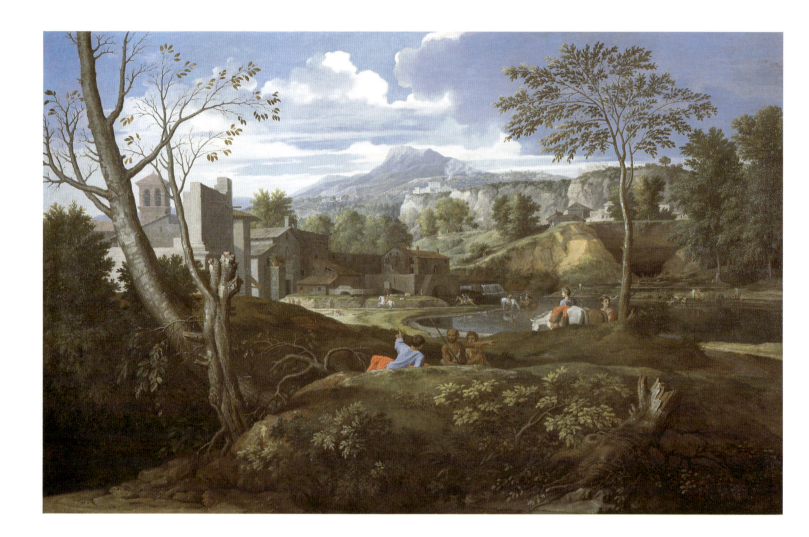

Landscape with Buildings

Oil on canvas; 120 x 187 cm.

Museo del Prado, Madrid

Unmentioned by any of the early writers on Poussin, the *Landscape with Buildings* is first recorded in the collection of Philip V of Spain at La Granja in 1746. With the exception of Doris Wild,[1] who attributes it to Gaspard Dughet, the picture is widely regarded as a major work of Poussin's maturity and dated *c.* 1650–51. Like the *Calm* landscape of 1651 [No. 24], the Prado picture portrays a broad and expansive setting, pervaded by a mood of meditative calm, and reveals a heightened sensitivity on Poussin's part to the most diverse phenomena of nature. The absence of a specific literary theme further distinguishes these two works as among the artist's most naturalistic landscape paintings. In both, observation and intellect appear to be held in perfect equilibrium, anticipating the achievements of those nineteenth-century painters – from Valenciennes and Corot to Cézanne – who strove to unite the principles of classical landscape composition with the direct perception of nature.

The *Landscape with Buildings* depicts a rugged and uncultivated landscape showing the outskirts of a town at the edge of a lake and bounded by a distant range of mountains and hills. In the foreground, an outcrop of land encloses the composition and serves to enhance its tranquil nature. Animating the landscape are a series of anonymous figures – horsemen, travellers, bathers, and conversing figures – who reflect the mood of peace and contentment which pervades the scene. In the centre foreground two travellers asking the way are redirected by a seated youth clad in blue and red. The outstretched arms of the youth and old man, pointing in opposite directions, provide a focus for the attention and an inducement to the viewer to explore the broad terrain which stretches beyond them, so rich in human interest and natural variety.

Rarely in his landscape art of any phase does Poussin appear more engrossed in the peculiarities of individual forms in nature than in the Prado canvas, with its blasted tree-stumps, dense undergrowth, and bare and wind-lashed trees. In his painstaking description of these elements Poussin endows the view with a vitality and veracity which all but conceal the equally methodical control he has exercised over all aspects of the composition.

The design is of the strictest symmetry, with the foreground group of travellers and the distant mountain peak crowned by clouds marking the exact centre of the composition. To either side, framing trees delimit the scene, progressing from the foreground left to the right middle distance and, thence, to the buildings and hills beyond, in an alternating sequence across the picture which both balances the composition and charts the progression back into space. Adding to the rationality of the construction are the rhythmically distributed accents of light and colour, particularly the blues, reds, and whites of the figures and horses, which appear in different combinations throughout the scene, linking foreground with distance while avoiding obvious repetitions.

In its rural seclusion and selective naturalism, the Prado picture calls to mind the more lyrical landscape art of Gaspard Dughet, who often portrays anonymous travellers resting or conversing in wooded and hilly surroundings. An example of this is Gaspard's fine chalk drawing of a *Landscape in Tivoli with a blazing Castle* in the National Gallery of Scotland, which is a preparatory study for a painting at Dresden [fig. 48].

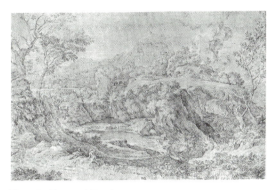

Fig. 48. Gaspard Dughet,
Landscape in Tivoli with a blazing Castle. Drawing
(National Galleries of Scotland)

With his keen love of the countryside and his ability to evoke the mood and atmosphere of the Roman campagna, Dughet surpassed his more illustrious brother-in-law in the tastes of eighteenth-century collectors, especially in Britain. Poussin's *Landscape with Buildings*, with its unprepossessing theme and bucolic mood, mirrors this aspect of Gaspard's art. Since the chronology of the latter's development is notoriously uncertain, it would be unwise to say which way the influence went. The Prado canvas is either the type of Poussin landscape from which Gaspard learnt most or a rare incursion by Poussin himself into that realm of nature imagery – gentle and undemonstrative – chiefly associated with the art of his brother-in-law.

1. Doris Wild, Review of Georges Wildenstein's *Les graveurs de Poussin au XVIIᵉ siècle*, Kunstchronik, XI, 1958, p. 168.

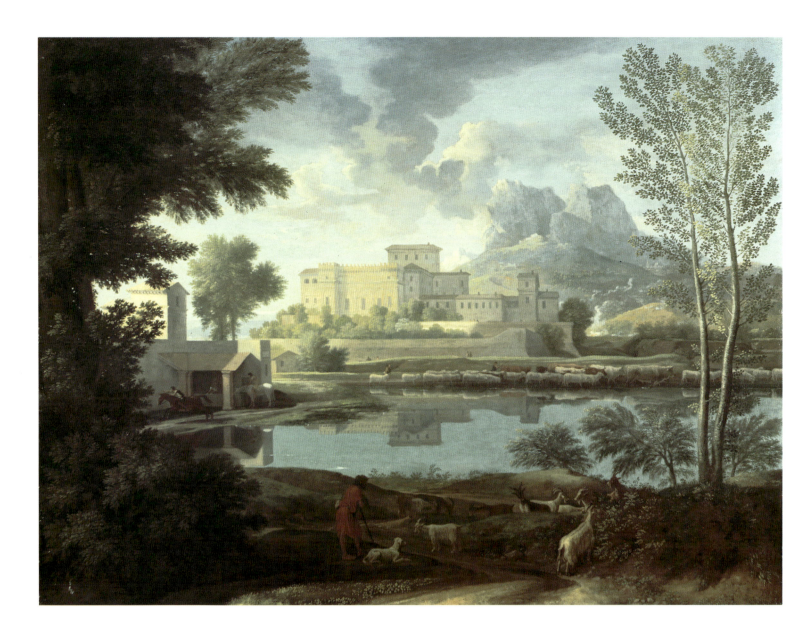

Landscape with a Calm

Oil on canvas; 97 x 131.5 cm.

Sudeley Castle Trustees

Félibien records that Poussin painted two companion landscapes for the Parisian banker, Pointel, in 1651 depicting a *Storm* and a *Calm*. Though the former was engraved in 1679, the original versions of both of these pictures were believed to be lost until the mid-1970s, when Clovis Whitfield identified the present canvas as the missing *Calm*, previously attributed to Poussin's brother-in-law, Gaspard Dughet.[1] Coincidentally, the original of the *Storm* [fig. 25] emerged in the collection of a dealer in Rome, likewise attributed to Gaspard. It has subsequently been re-assigned to Poussin himself and purchased by the Musée des Beaux-Arts, Rouen.[2] The re-emergence of both of these pictures is the most important Poussin discovery of recent years and serves further to document his output as a landscape painter during its most prolific phase.

Poussin chose to illustrate no literary theme in these two landscapes but simply to portray the contrasting effects upon mankind of benevolent and malevolent nature. Thus, if the *Storm* depicts the terrified reactions of humanity to nature's wrath, the *Calm* portrays a scene of utter tranquillity, in which man exists in harmony with his surroundings. In the foreground, a peaceful goatherd tends his flock. Beyond him stretches a landscape of limpid clarity, which centres upon a view of the Belvedere of the Vatican, also visible at the upper left of the *Landscape with Diogenes* [No. 22]. This is painted with a purity and intensity of colour, and a sensitivity to the most subtle gradations of light, that make the *Calm* appear one of Poussin's most naturalistically rendered scenes. In its acutely observed atmospheric effects it foreshadows the open-air studies of Corot and makes it easy to understand why nineteenth-century viewers believed Poussin's *Calm* to depict an actual site, the Lake of Bolsena.[3]

Adding to the pristine quality of the work is its outstanding state of preservation. Unusually for Poussin, the picture is painted over a light ground, which enhances its vibrant luminosity. In contrast, the *Storm* employs the dark underpainting traditionally favoured by the artist, which now shows through.

No less remarkable than the colour and handling of the *Calm* are the poise and clarity of its design, which is as finely calibrated as any of Poussin's more ambitious landscapes of these years. The composition is carefully divided into alternating areas of land, water, buildings, and sky. In the centre middle distance, a line of buildings appears wreathed by the intense blues of the motionless lake and tranquil sky – a rarified effect which justifies Whitfield's description of this picture as 'Nicolas's *Enchanted Castle*'.[4] To either side, groups of trees discretely frame the composition, the slender poplars at the right unfurling their lacy foliage against the sky to reflect the fragile beauty of the scene.

Poussin's decision to portray two contrasting states of nature in the *Storm* and *Calm* may reflect his well-known theory of the modes, outlined in a letter to Chantelou of 1647.[5] In this, Poussin noted that different subjects demanded different treatment in painting and that the artist should vary his style to accord with the prevailing mood or emotion of his theme. Poussin's adherence to this doctrine is apparent in the diverse nature of the landscapes he created between 1648–51, which move from the nobility of the *Phocion* pair to the luxuriance of the *Diogenes* and the almost 'plein air' effects of the *Calm*.

A drawing at Turin, exhibited here [No. 28], includes a group of buildings similar to those which appear at the left of the present picture.

The back of the original canvas of the *Calm* bears the inscription *N.P. + F.R.* (*Nicolas Poussin + Fecit Romae*), the cross either indicating that Poussin painted the picture in Holy Year (1650) or that the inscription was added after the artist's death.

The lyricism and delicacy of Poussin's *Calm* inspired a number of landscapes by Jan Frans van Bloemen (Orizzonte) in the mid-eighteenth century.[6] These reflect something of the picture's bucolic tone – if not of its transfixing stillness or immaculate beauty.

1. Clovis Whitfield, 'Nicolas Poussin's *Orage* and *Temps Calme*', *The Burlington Magazine*, CXIX, 886, January 1977, pp. 4 ff.

2. Anthony Blunt, 'Landscape by Gaspard, Figures by Nicolas', *The Burlington Magazine*, September 1975, pp. 607 ff.; Jacques Thuillier, 'Poussin et le paysage tragique, "L'Orage Pointel" au musée des Beaux-Arts de Rouen', *Revue du Louvre*, 26, 1976, N. 5/6, pp. 345 ff. Blunt later changed his mind and assigned the entire picture to Nicolas.

3. Whitfield, *op. cit.*, pp. 7 ff.

4. *Ibid*, p. 4 (a reference to Claude's *Landscape with Psyche outside the Palace of Cupid*, otherwise known as *The Enchanted Castle*, of 1664 in the National Gallery, London).

5. *Correspondance*, pp. 370 ff.

6. Cf. Andrea Busiri Vici, *Jan Frans van Bloemen. Orizzonte e l'origine del paesaggio romano settecentesco*, Rome, 1974, Nos. 213, 218, 326.

Classical Landscape with Figures

Black chalk and bistre wash; 14.8 x 38.7 cm. (*CR* 279)

The Hermitage, Leningrad

The sweeping recession and carefully balanced composition of this drawing reflect the grandeur of Poussin's art of the 1640s, the date traditionally assigned to this sheet. In its general layout the Hermitage drawing most obviously recalls the *Landscape with St John on Patmos* of 1640 in Chicago [fig. 9], though the style would appear to be somewhat later than this and invites comparison with the Turin *Town with a Basilica in the Distance* [No. 28] and certain of the drawings for the Chantelou *Sacraments*. With broad, modulated strokes of wash, Poussin defines the deep space of the scene and creates an air of tranquillity and repose characteristic of the most austere and heroic phase of his art.

View of the Aventine

Bistre wash, faint black chalk underdrawing;
13.4 x 31.2 cm. (*CR* 277)

Gabinetto Disegni e Stampe degli Uffizi, Florence

One of the most striking and concentrated of Poussin's nature studies, the Uffizi drawing portrays a view of the Aventine seen from the north bank of the Tiber, with the buildings of the Priory of Malta on the skyline. A faint black chalk drawing on the *verso* appears to depict a view of the Palatine.

The drawing is datable to the mid-1640s and bears evident similarities with the landscape backgrounds of the *Baptism* and *Ordination* scenes from the Chantelou *Sacraments* [figs. 22, 23] in its rhythmic integration of natural and architectural elements, its strict planarity, and its repeated parallelisms. Choosing a viewpoint which was itself balanced and harmonious, Poussin has reduced the motif to two framing horizontal axes, formed by the line of the buildings and the bank of the river and linked by the diagonal of an ascending hill lined with trees. Enhancing the abstract unity of the composition are the bold touches of wash throughout, which brilliantly capture the intense sunlight playing over the scene and strengthen the overall surface harmony of the construction. In its rigorous alignment of all aspects of the motif and its commanding frontality, the *View of the Aventine* invites comparison with Cézanne's *Château de Médan* of *c*.1880 or his views of Gardanne of 1885–86 [Nos. 29, 50 and fig. 50]. In works such as these, the determination of both artists to wrest an abstract order from a scene in nature appears at its most uncompromising.

Not surprisingly, this facet of Poussin's genius first attracted critical attention among artists and critics of Cézanne's generation. Foremost among them was Félix Bracquemond, who wrote of the abstract appeal of Poussin's drawings in 1885:[1]

'In his drawings, intended to prepare and condense the artistic matter that he would use for his pictures, he, more than any other painter, provides an example of the search for the contrast between light and dark shading, *quite irrespective of any representation*. In other words, conceiving a work only in terms of its essence, its *luminosity*, he retains only the essential minimum of the forms that he will eventually present in their entirety in the definitive work. He sees them as so much light and shade, without imposing precise limits on their extent and direction, these lights and shades forming the basis of his pictorial composition, free from any secondary considerations.

'Even more in his drawings than in his paintings, Poussin demonstrates the kind of analysis to which he subjects form and colour, by the total subordination of the secondary to the principal which he establishes between the light that displays and defines and the light that (merely) provides colour. That is how he demonstrates to us the secret of that incomparable feeling for the whole that characterises his genius. Beyond every natural representation there always seems to lie a poetical, even a literary concept. In a word, his drawings alone … would suffice to place him in the front rank of decorative artists.'

1. Félix Bracquemond, *Du dessin et de la couleur*, Paris, 1885, pp. 208 f.

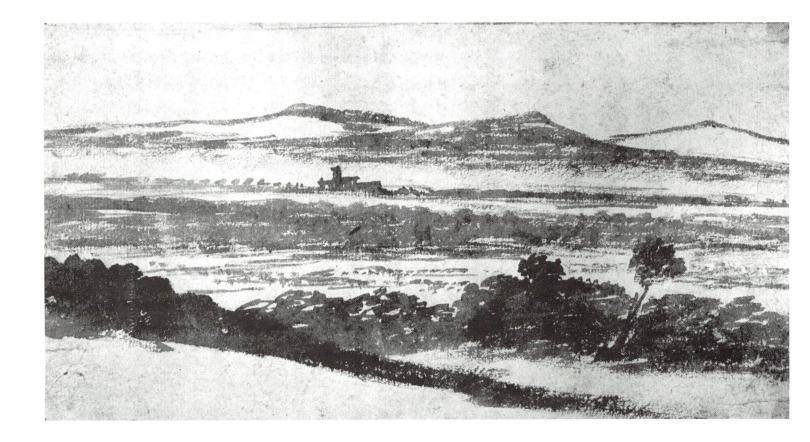

View of the Tiber Valley

Pen and bistre wash; 13.3 x 25.9 cm. (*CR* 455)

The Rt Hon. the Viscount Coke, Holkham Hall,
Norfolk

Formerly attributed to Claude, this drawing is now ascribed to Poussin and dated to the 1640s. In its striated sequence of washes, building up the broad contours of the land and receding hills, it is reminiscent of the atmospheric landscape backgrounds of the *Landscape with a Boy drinking from a Stream*, the *Landscape with St Matthew and the Angel*, and the *Landscape with the Body of Phocion carried out of Athens* [Nos. 1, 5 and 18].

Few studies from nature by Poussin are more economical in means or harmonious in construction than the Holkham drawing. Three broad bands of wash, gradually lightening in tone, serve to define the extent of the view. Reducing the entire motif to horizontal and diagonal accents, Poussin imbues it with an order and rationality comparable to that of certain of Cézanne's mature watercolours of the Mont Sainte-Victoire [No. 52].

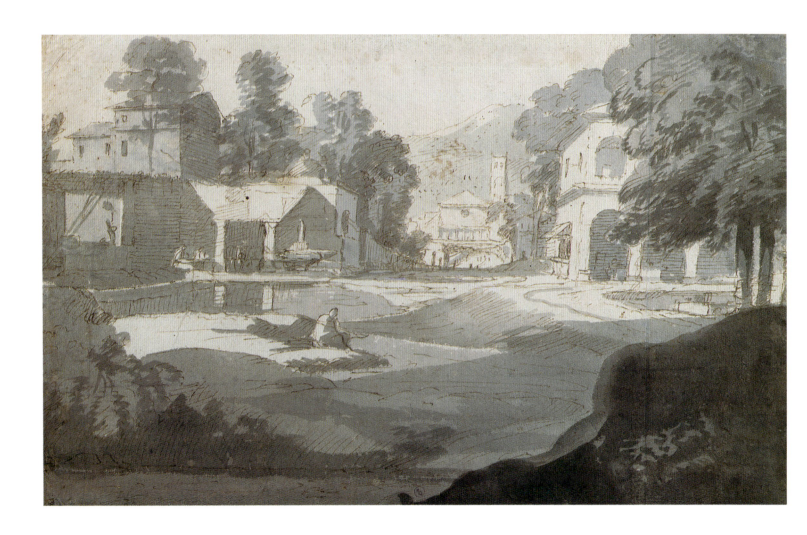

A Town with a Basilica in the Distance

Pen and brown ink, grey-sepia wash; 25 x 40.5 cm.
(*CR* 285)

Biblioteca Reale, Turin

Like the *Classical Landscape with Figures* [No. 25], the Turin drawing is an imaginary composition datable to the 1640s and (as might be expected at this phase of the artist's career) rigorously symmetrical in construction. With certain modifications, the same composition appears on a large drawing at Düsseldorf (*CR* 287) and was eventually incorporated by Poussin into the background of his *Christ healing the blind Men* of 1650 in the Louvre. Extensive pentimenti to the buildings at the left and right of the Turin drawing indicate that this was the artist's earliest version of this composition. In its carefully bounded construction and its deep, receding space, marked by an orderly arrangement of buildings and trees, it recalls the compositional principles of certain of Poussin's grandest landscape paintings of the late 1640s, among them the *Landscape with the Gathering of the Ashes of Phocion* and the *Diogenes* [Nos. 19 and 22].

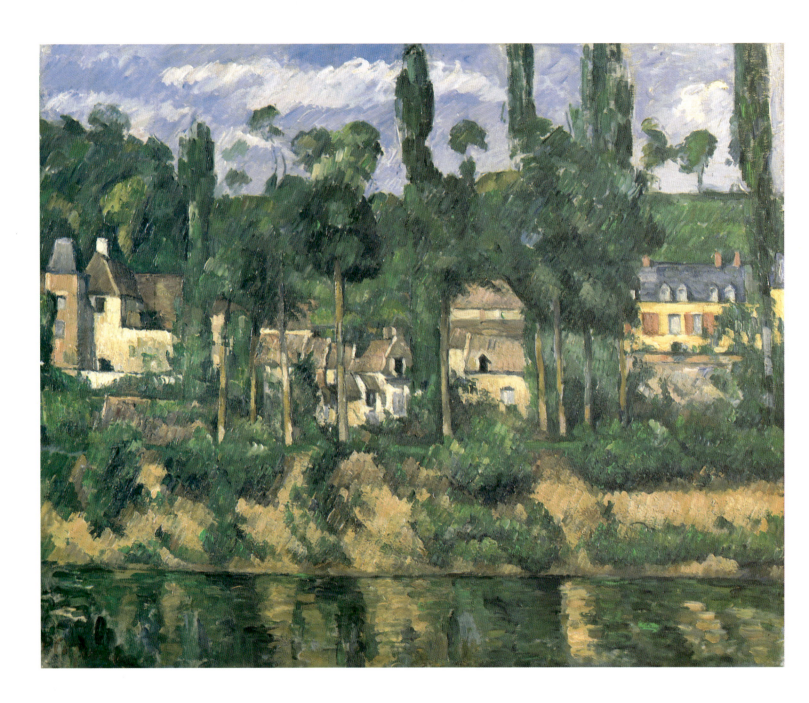

Le Château de Médan

Venturi 325

Oil on canvas; 59 x 72 cm.
Signed, lower left.

The Burrell Collection,
Glasgow Art Gallery and Museum

In 1878 Zola purchased a large house on the banks of the Seine at Médan, outside Paris, where he proceeded to work on his *Rougon-Macquart* series of novels. Cézanne visited him there every year between 1879 and 1882 and again in 1885. On 19 June 1880, he wrote to the novelist, announcing his arrival: 'if you are not alarmed at the length of time I risk taking, I shall allow myself to bring a small canvas with me to paint a motif, always providing that you see in this nothing disturbing'.[1] The Glasgow picture is Cézanne's only surviving portrayal of this site and was painted from an island on the Seine with Zola's house off to the right. At the left is the Château de Médan, with its blue roof and red dormer windows. Preceded by a number of drawings [No. 30] and a fine watercolour [No. 31], the picture is one of the most successfully resolved works of Cézanne's middle years and counted among its earliest admirers Paul Gauguin, in whose collection it is first recorded, along with four or five other canvases by the artist.[2]

Few canvases by Cézanne are as insistently logical as the Glasgow picture, in which all of nature is perceived as essentially rectilinear. Horizontally banded into five nearly equal areas of river, bank, buildings, hills, and sky, it is subdivided vertically by a rhythmic screen of trees which is itself rigorously symmetrical. At the centre the darkened windows of two adjacent houses frame a single tree and provide a fulcrum for the composition. But the stability of this scheme is far from lifeless. Densely binding all the forms of the landscape is a weft of diagonal brushstrokes which enliven the emphatic vertical and horizontal divisions of the scene, clothing nature's geometry in its ceaseless animation. In its lustre and uniformity Cézanne's paint-work attains a breathtaking richness and resolution, justifying the apparent pains he took over this composition, the earliest of his landscapes for which so many preparatory studies survive.

Le Château de Médan may be compared with the *Small Houses at Auvers* of 1873–74 [No. 12], which treats a similar theme of trees and buildings set into a hillside. If the earlier canvas reveals Cézanne's immersion in the charm and vivacity of nature, the commanding Glasgow painting celebrates instead its strength and austerity.

These qualities derive in part from a favourite device of Cézanne's landscape art, which is employed in its purest form in the Glasgow picture – that of separating the motif from the viewer by a prominent barrier. In the *Château de Médan* Cézanne surveys the landscape from across the river. With the object of his attention located in the middle distance of the picture and placed frontally and symmetrically within the confines of the frame, Cézanne endows the landscape with a confrontational quality which heightens the severity of the impression and distinguishes his approach to landscape from that of his Impressionist contemporaries. In the works of Monet or Pissarro, the observer is often insinuated into the landscape through a projecting road or stretch of land which continues beyond the confines of the frame, providing ready access to the scene. Even when Cézanne portrays a receding road, however, he tends to include a band of empty space at the bottom of the picture, which isolates the motif from the viewer. One may contemplate such a vision of nature much as the artist himself did when painting it; but one may never inhabit it. Cézanne's landscapes transcend desire or possession.

1. *Letters*, p. 189.
2. Cf. Merete Bodelsen, 'Gauguin's Cézannes', *The Burlington Magazine*, CIV, 710, May 1962, pp. 204 ff.

Landscape at Médan

Chappuis 787

Pencil on grey laid paper; 26.4 x 30 cm.

Oeffentliche Kunstsammlung Basel, Kunstmuseum

Though the relationship between Cézanne's drawings and watercolours and his more ambitious paintings varies throughout his career, this pencil study and the watercolour of the same motif exhibited here [No.31] are preparatory studies for the *Château de Médan* of *c.*1880 [No.29], one of the artist's most carefully deliberated compositions of these years. Another pencil study for the picture exists (Chappuis 786), testifying further to the evident pains Cézanne took over the Glasgow canvas.

The Basel drawing is a study for the area to the left of centre in the finished picture. With its compact design and methodical alignment of vertical and horizontal accents it may be seen to contain the germ of the entire composition and already announces its austere and lofty tone. As Lawrence Gowing has observed: 'this same balance of alignments ... was profoundly linked with the seriousness of art before Cézanne and after him'.[1] It may be seen in Poussin's *View of the Aventine* [No.26] and finds its purest expression in Mondrian's near-abstract studies from nature of *c.*1909–10.

1. Lawrence Gowing, *Paul Cézanne: The Basel Sketchbooks*, Museum of Modern Art, New York, 1988, p. 30.

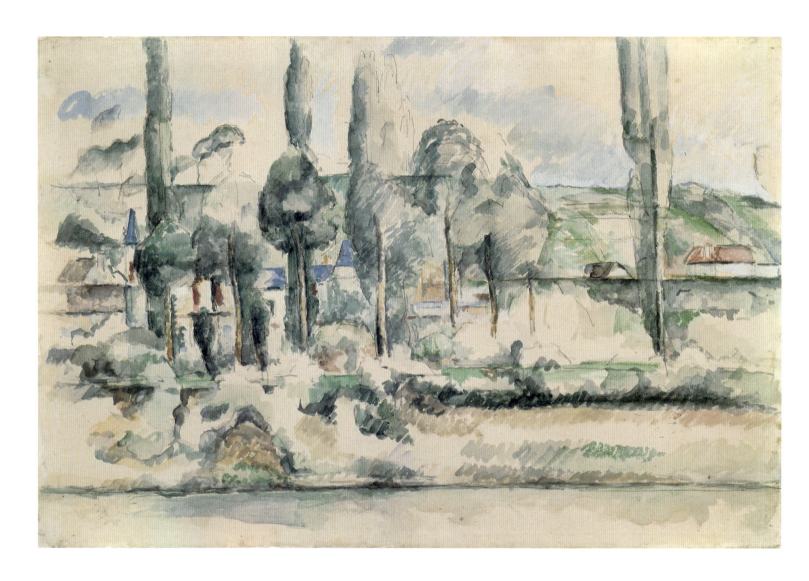

Le Château de Médan

Rewald 89

Pencil, watercolour and gouache on white paper;
31.3 x 47.2 cm.

Kunsthaus, Zürich

A preparatory study for the painting in Glasgow [No. 29], in which the motif is viewed from a position further to the right. Cézanne altered his vantage-point in the completed canvas in order to include the group of buildings at the extreme right, which provide a more effective balance to the brightly coloured Château de Médan on the opposite side of the picture.

Lawrence Gowing has observed of the Zürich watercolour:[1]

'When he went to Médan in 1880 with a view of the village from the river in mind, he used watercolour to explore the site for qualities quite different from the effects of light and the topographical picturesqueness that had concerned Monet in similar subjects at Vétheuil ... He sorted out the parts of the subject, the shapes of actual things and their conjunctions, and identified them with colours as if with labels. The tree trunks were associated with the sandy soil they sprang from and coloured the same ochre yellow. The slate roofs were coloured ultramarine as if they belonged to the same element as the sky; the tiled roofs were linked by way of red shutters with colour-washed walls and thus eventually with the same ochre bank at the nodal point which drew the threads together.

'There is no particular light or atmosphere. Even the space, stepped back in successive zones to the distant hill, had no influence on the system of colour. The same emerald green was chosen to label and relate the river-bank path and the field on the skyline. Like the other colours, its whole function is on the surface of the paper. There is no illusion; Cézanne seems almost to have overridden the congenial character of the place. Yet he had been at pains to represent just this scene. It involved writing to Zola, who was to be his host, to warn him[2] and having himself ferried to an island on the Seine. There was evidently a virtue in this single viewpoint, looking between tall trees across the horizontals of the river-side landscape. At this time the typical scenery of the Île de France, with a high skyline of rolling hills characteristically crossed by rows of poplars, seems to have provided Cézanne with physical unities to replace the atmospheric unity of Impressionism. The watercolour was a stage in the exchange of atmosphere for structure, and when Cézanne moved a little to the left to paint the oil picture now in Glasgow the process was completed. The village where his old friend lived appeared as if wedged in a rectangular grid, a structure of correspondences extending from side to side and from top to bottom of the canvas, with the aid of reflections in the unruffled water. Condensed and intensified areas of colour pressed together on the surface as if inlaid.'

1. *Watercolour and Pencil Drawings by Cézanne*, an exhibition organised by Northern Arts and the Arts Council of Great Britain, Laing Art Gallery, Newcastle upon Tyne, and Hayward Gallery, London, 1973, pp. 8 f.

2. See No. 29.

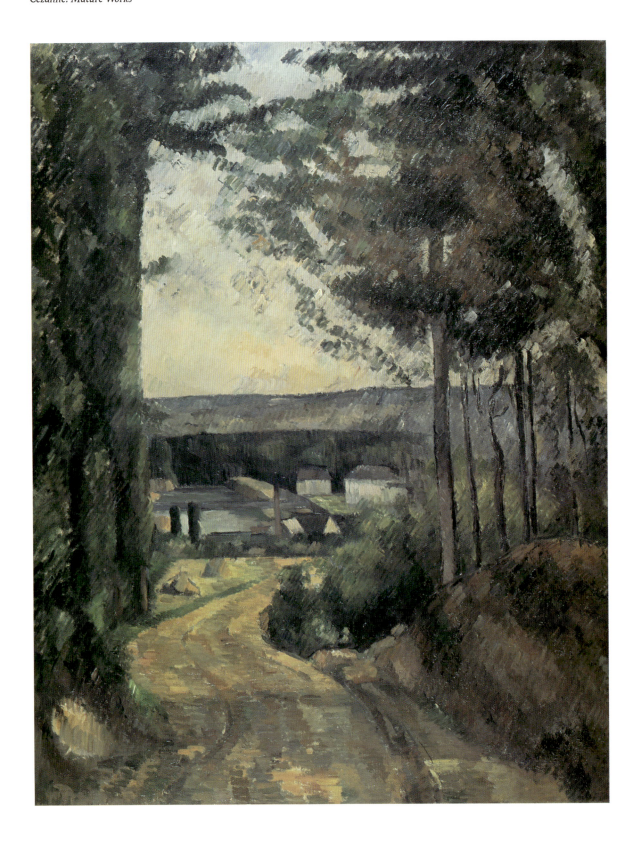

Road with Trees and Pond

Venturi 327

Oil on canvas; 81 x 60 cm.

Rijksmuseum Kröller-Müller, Otterlo

Around 1800 Cézanne's art underwent a remarkable consolidation. The composition of his pictures became stricter and firmer, the contours of his forms more decisive, and his method of applying paint more systematic, with uniform, striated strokes of the brush building up the scene and enhancing the material richness of his pictures. With this came an ever-increasing concern with the two-dimensional harmony of the composition, seen at its most extreme in the Otterlo *Road with Trees and Pond*, a landscape which is so abstractly designed and rigorously balanced that it would retain its decorative unity even if hung upside down.

The picture is one of the most consciously classical works of Cézanne's career, with its framing trees, receding road, and stratified spatial construction calling to mind Poussin's methods of composition in the *Landscape with a Roman Road* [No. 21]. Even more than his great predecessor, however, Cézanne subjects the forms of the natural world to the laws of geometry. Though the scene contains little architecture, it is pervaded by perpendicular lines, the erect trunks of the trees and the horizontals of the land creating a grid-like composition comparable to that of the *Château de Médan*.

A closer look at the landscape reveals the extent to which Cézanne has stripped away everything from the scene that could not find its equivalent somewhere else in the picture. The line of shadow across the road echoes the horizontals of the distant land, a smoke-stack in the middle distance mirrors the large tree-trunk at the right, and a bank of foliage along the left margin of the picture is reduced to a single, rising vertical, improbably conforming to the rectilinearity of the whole. Even the diagonal of the road at the right finds its counterpart in the contours of the trees above it, whose brownish hues mirror the tones of the rocky mass below. Though the effect may appear somewhat wilful, its equilibrium and repose represent a notable advance over Cézanne's two earlier paintings of a receding road exhibited here [Nos. 10 and 11] and herald a new phase of his art.

The Otterlo picture has been variously dated between 1879–82 and 1885–90, an unusual measure of disagreement for any of the artist's works. This probably arises from the apparent discrepancy between the picture's technique and its degree of resolution, which conforms to that of Cézanne's most classically conceived designs of the end of the 1880s. The style of the picture is certainly that of *c.* 1880, with its diagonal brushstrokes, thick paint texture, and abrupt tonal contrasts. The highly wrought composition would likewise appear to be of this phase, its very deliberateness attesting to its comparative immaturity and linking it with the *Château de Médan*. Like *Hills with Houses and Trees* [No. 47] of the same years, both works remind us that Cézanne had first to be wilfully classical before he could become unselfconsciously so.

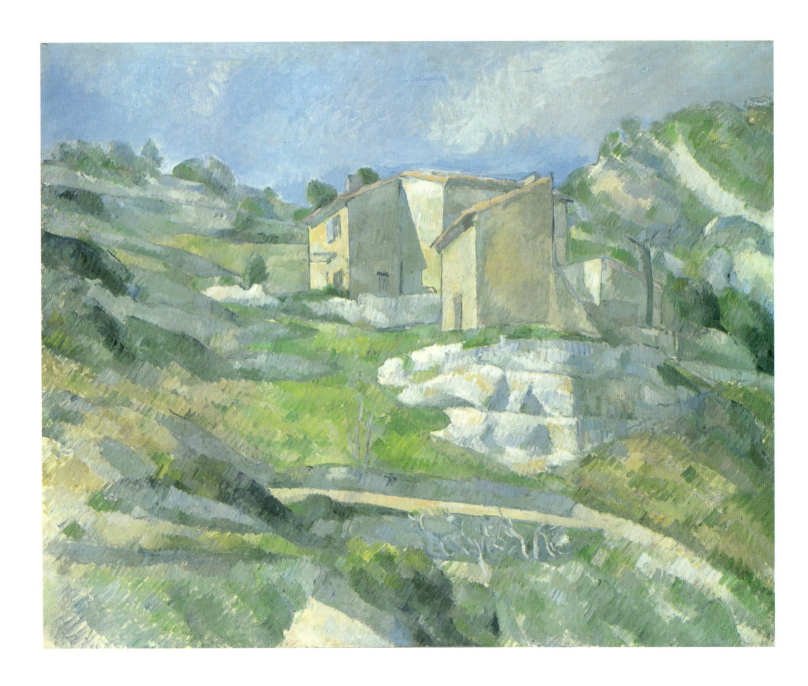

Houses in Provence

Venturi 397

Oil on canvas; 65 x 81 cm.

The National Gallery of Art, Washington, D.C.

'Cézanne's difficulties are those of the first word', wrote Merleau-Ponty in an illuminating study of the artist which stresses his desire to penetrate to the essential reality of his subjects, 'beneath the imposed order of humanity'.[1] In a letter to Bernard of 23 October 1905 Cézanne himself confessed this: 'we must render the image of what we see, forgetting everything that existed before us'.[2] *Houses in Provence* bears witness to this search for an elemental vision of nature. Here everything in the landscape – houses, rocks, trees, and hillside – appears of a common substance and comparable solidity and man's implicit hierarchies are abandoned in favour of an exploration of the intrinsic beauty of nature.

The motif itself is scarcely more prepossessing than that of the earlier *Small Houses of Auvers* [No. 12] – a group of houses nestled in a rocky hillside baked by the Provençal sun. Out of this Cézanne has created a composition which links the colours and shapes of the buildings with those of the terrain to a prismatic effect. Ochres and blues pervade the scene, binding the façades of the houses to the steep, faceted contours of the land. The result is a work of crystalline clarity which restores to nature something of its original splendour.

In his classic study of the art of Cézanne, Roger Fry includes a memorable account of the creative position Cézanne appears to adopt in the *Houses in Provence*. 'We may describe the process by which such a picture is arrived at in some way as this', observes Fry, '– the actual objects presented to the artist's vision are first deprived of all those specific characters by which we ordinarily apprehend their concrete existence – they are reduced to pure elements of space and volume. In this abstract world these elements are perfectly co-ordinated and organized by the artist's sensual intelligence, they attain logical consistency. These abstractions are then brought back into the concrete world of real things, not by giving back their specific peculiarities, but by expressing them in an incessantly varying and shifting texture. They retain their abstract intelligibility, their amenity to the human mind, and regain that reality of actual things which is absent from all abstractions'.[3]

The Washington picture is datable to 1882–85 through its densely textured and prevailingly diagonal brushwork and its comparatively limited range of hues. In the felicity of its construction and the unforced nature of its unity, it appears later in date than the more carefully deliberated *Château de Médan* and *Road with Trees and Pond* [Nos. 29 and 32] of *c.* 1880 and ranks among the masterpieces of Cézanne's early maturity.

1. Maurice Merleau-Ponty, *Sense and Non-Sense*, trans. H. L. and P. A. Dreyfus, Evanston, Illinois, 1961, pp. 9 ff.

2. *Letters*, p. 316.

3. Roger Fry, *Cézanne, A study of his development*, London, 1932 (2nd ed.), pp. 58 f.

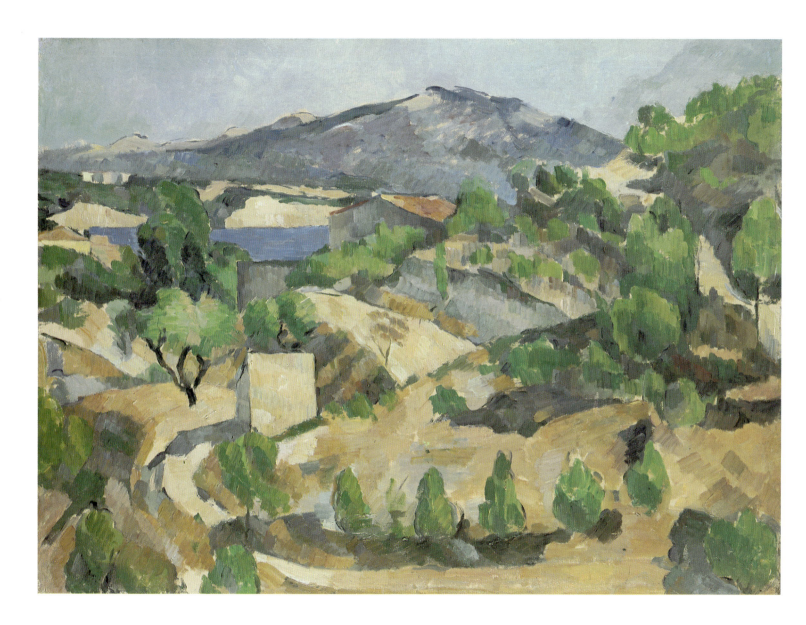

Mountains in Provence

Venturi 490

Oil on paper, mounted on canvas; 54 x 73 cm.

National Museum of Wales, Cardiff

The Cardiff landscape has one of the most illustrious histories of any of Cézanne's pictures. Its earliest owner was Gauguin, who first encountered Cézanne in the early 1880s and eventually came to own six of the artist's pictures[1] and to reflect the influence of Cézanne's style in a number of his own works of 1889–90 – a compliment which was not reciprocated by the master of Aix. In 1885 Gauguin executed a fan after the Cardiff picture, the original of which his wife sold between 1891 and 1894.

The picture was exhibited at the Montross Gallery, New York, in 1916, where it earned the praise of W. H. Wright, one of the most astute critics of Cézanne of his generation, who observed that 'it possessed that quality of linear depth which gives it synthetic movement. Cézanne, when sitting before nature, tried to penetrate to the motivating rhythm of his subject, irrespective of preconceived ideas as to what the rhythm should be'.[2]

Two years later, the picture was purchased by the Davies sisters of Wales, the earliest collectors of Cézanne in Britain; and, in 1922, it became the first work by the artist to be shown in a public gallery in this country, when it was placed on loan to the Tate Gallery. Only in the following year did Samuel Courtauld purchase the first of an outstanding group of works by Cézanne which he eventually bequeathed to the nation, now distributed between the National Gallery and the Courtauld Institute Galleries.

No less intriguing than the Cardiff picture's history is the manner of its creation. *Mountains in Provence* is painted on a commercially prepared paper, which the artist presumably pinned to a board on his easel and which was laid down onto canvas at a later date. Since the paper Cézanne employed was normally intended for rapid outdoor sketching, the artist may have been prompted to work very quickly in this instance. This may account for certain uncharacteristic features of the work – above all, the thick, unmodulated areas of paint and their resulting flatness and simplification.

These reduce many portions of the landscape to areas of pure colour which make it easy to see why the picture attracted Gauguin's attention but not easy to place the work within Cézanne's development.

Mountains in Provence has been variously dated between 1878–79 and 1883–84. If its summary technique suggests the earlier date, its bold and constructive organization indicates the latter, as does the absence of Cézanne's characteristically striated brushwork of the years 1879–82. Equally unusual for the artist is the choice of motif, which is panoramic but not really spacious and in which the distant mountain forms the culminating point of a somewhat intractable sequence of ascending curves, created by the coiling contours of the land. These led the artist to reduce the whole motif to a single, abstract pattern of interlocking curves punctuated by buildings and trees and arranged in such a way that the scene possesses an unusual degree of homogeneity. At the bottom centre an orderly row of six trees establishes the sequence of rhythmic curves which traverse the picture and eventually culminate in the blue mountain beyond. Standing immediately below it is a red-roofed house, which echoes the contours of the mountain, and a patch of blue sea, painted with a purity and intensity of hue which refutes all notions of aerial perspective. In the exact centre of the picture stands a solitary brown tree, as though to vary the rhythm at a crucial point in the composition and suggest those even greater variations in the scene before him which Cézanne might have added had he been painting by more conventional means. As it stands, the picture combines the brevity of statement of the artist's watercolours with the uniform handling of his oils and remains a fascinating hybrid in Cézanne's career.

1. Merete Bodelsen, 'Gauguin's Cézannes', *The Burlington Magazine*, CIV, 710, May 1962, pp. 204 ff.

2. Quoted in John Rewald, *Cézanne and America, Dealers, Collectors, Artists, and Critics, 1891–1921*, London, 1989, p. 299.

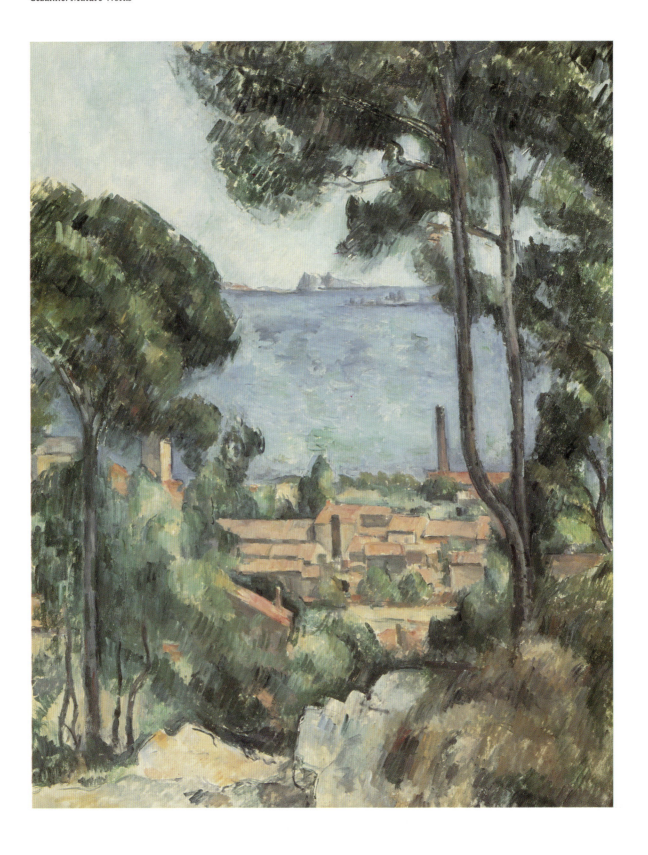

L'Estaque

Venturi 406

Oil on canvas; 71 x 57.7 cm.

Private Collection
(on loan to the Fitzwilliam Museum, Cambridge)

The stately dignity of this picture owes much to the fact that it is Cézanne's only portrayal of this subject on an upright canvas. As in *Road with Trees and Pond* [No. 32] the artist has employed this format to create an image of remarkable concentration and simplicity.

The composition is framed by two groups of trees, whose slender verticality and deftly painted foliage enhance the picture's elegance and lyricism. Between them rises a view of the land, sea, and sky of L'Estaque, divided into three broad zones and bounded by clear horizontals, which add to the serenity of the impression. At the transition between land and sea, the trunk of a tree at the right changes direction, as though to acknowledge this juncture in the composition. Further linking the trees with the land below are the buildings at the left, painted in a light ochre which presses forward and comes to rest beneath the crown of the tree on this side of the composition. At the right, a smoke-stack, silhouetted against the sea, aligns itself with the foreground trees and likewise seems to loom forward. These oscillations in space ultimately bring the sea itself to rest on the surface of the picture, establishing the decorative harmony of the composition. Painted in a pure, intense blue, it rises to a distant ridge of mountains ringed with the blue foliage of the foreground trees.

L'Estaque dates from 1882–85 and is executed in a mixed techique which still employs the diagonally hatched strokes of the immediately preceding years in the foliage and rocks. Elsewhere, Cézanne applies firmer and more blended strokes which follow the contours of the forms and contribute to the prevailing stillness and solidity of the composition.

In a letter to Zola of 24 May 1883, written from L'Estaque, Cézanne observed: 'I am still busy painting – I have here some beautiful views but they do not quite make *motifs*. – Nevertheless, climbing the hills as the sun goes down one has a glorious view of Marseille in the background and the islands, all enveloped towards evening to very decorative effect'.[1]

In his distinction between a view and a motif, Cézanne reminds us of how carefully he deliberated over his choice of a landscape subject. By the artist's own admission, a view might be beautiful without necessarily qualifying as a motif. As *L'Estaque* demonstrates, the latter was a scene in nature which was itself intrinsically balanced and harmonious and already contained the germ of a composition. Once discovered, such sites may have aroused in the artist a

sense of their potential for formal integration even before he picked up a brush.

That Cézanne deliberated tirelessly over his choice of motifs is apparent from one eye-witness who observed him repeatedly rearranging still-life objects in his studio until he was satisfied that they comprised a composition.[2] In portraiture and figure painting Cézanne enjoyed a similar freedom to devise his designs before painting them. Only in landscape was he forced to choose his compositions rather than make them. When one remembers that those compositions were generally more complex than his works in other forms, the importance of Cézanne's choice of a landscape subject appears momentous and becomes a fundamental part of the creative act.[3]

1. *Letters*, p. 209.
2. John Rewald, *Cézanne, A biography*, London, 1986, p. 228.
3. The broad compositional similarities between *L'Estaque* and one of Cézanne's earliest composed landscapes, the *Landscape with a Fisherman* [fig. 49] of c. 1860–62, attest to his instinctively classical response to nature in his maturity.

Fig. 49. Cézanne, *Landscape with a Fisherman*, c. 1860–62 (Formerly Jas de Bouffan, Aix-en-Provence)

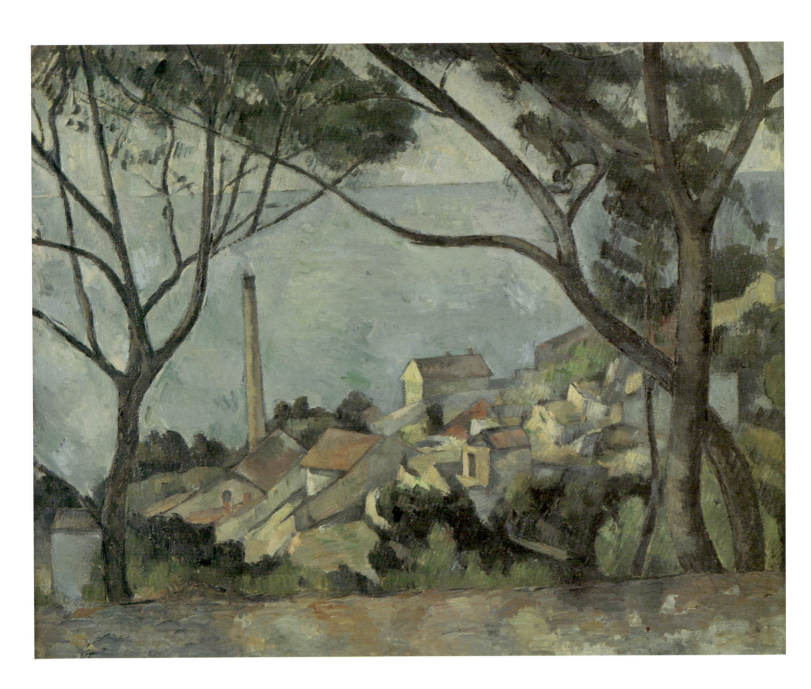

The Sea at L'Estaque

Venturi 425

Oil on canvas; 73 x 92 cm.

Musée Picasso, Paris

In his recollections of Cézanne, first published in 1921, Joachim Gasquet recalls a conversation with the artist concerning the challenge which painting from nature posed for him. 'You see, a motif is this ...', exclaimed Cézanne,[1] '(He put his hands together ... drew them apart, the ten fingers open, then slowly, very slowly brought them together again, clasped them, squeezed them tightly, meshing them.) "That's what one should try to achieve ... If one hand is held too high or too low, it won't work. Not a single link should be too slack, leaving a hole through which the emotion, the light, the truth can escape. You must understand that I work on the whole canvas, on everything at once. With one impulse, with undivided faith, I approach all the scattered bits and pieces. Everything we see falls apart, vanishes, doesn't it? Nature is always the same, but nothing in her that appears to us, lasts. Our art must render the thrill of her permanence along with her elements, the appearance of all her changes. It must give us a taste of her eternity."'

Few works by the artist demonstrate better the resolution of nature's opposing tensions which Cézanne constantly sought before the motif than *The Sea at L'Estaque* of 1882–85. Like the upright canvas of a similar view exhibited here [No. 35], this is one of the artist's most carefully calibrated compositions. But, whereas the former possesses a soaring lyricism, the picture in the Musée Picasso has a tensile strength, epitomised by the interlocking branches of the framing trees and reinforced by the dense and uniform paint surface, which locks all elements of the landscape into place, affording 'us a taste of [nature's] eternity'.

The composition centres upon a group of buildings rigidly framed to all sides by road, sky, and trees. Prominent among them is a single building bearing a bright yellow façade which is silhouetted against the sea in the exact centre of the picture. To the left a tall smoke-stack rises assertively, as though striving to reach the framing trees. Its dramatic isolation serves to counterbalance the diagonal build-up of the land on the right of the scene and strengthens the cohesion between foreground and distance.

But the most remarkable liaisons within the landscape occur between the disparate framing elements. At the bottom, the sharp edge of the road cuts across the base of the trees, providing an internal frame for the composition which complements the horizon line above. Also linking the distant sea and sky with the foreground are the interweaving branches of the trees, which intersect to the left of centre exactly at the juncture between sea and sky, binding all elements in the landscape into a taut unity reminiscent of Cézanne's clenched fingers. Fanning out like fret-work across the top of the picture, these branches appear in places to *contain* the sea, which is painted so flatly at the left that it comes to rest on the surface of the picture. In the strength and stability of these relationships Cézanne evokes all that is most indestructible – and indivisible – in nature. Nor can one fail to notice that the classical harmony of the *Sea at L'Estaque* owes much to Poussin's favourite device of framing the landscape with trees whose branches span the upper reaches of the picture. In this respect, the canvas in the Musée Picasso may be seen as Cézanne's *Phocion*.

The picture is one of four works by the artist formerly owned by Picasso, whose admiration and indebtedness to Cézanne forms a seminal chapter in the history of early twentieth-century painting. 'He was my one and only master!', exclaimed Picasso of Cézanne in 1943, 'Don't you think I looked at his pictures? I spent years studying them ... Cézanne! It was the same with all of us – he was like our father. It was he who protected us ...'[2]

1. Quoted from *Cézanne, The Late Work*, ed. William Rubin, Museum of Modern Art, New York, 1977, pp. 405 f. (Orig. Joachim Gasquet, *Cézanne*, Paris, 1921, p. 130.)
2. Gyula H. Brassaï, *Picasso and Co.*, New York, 1966, p. 79.

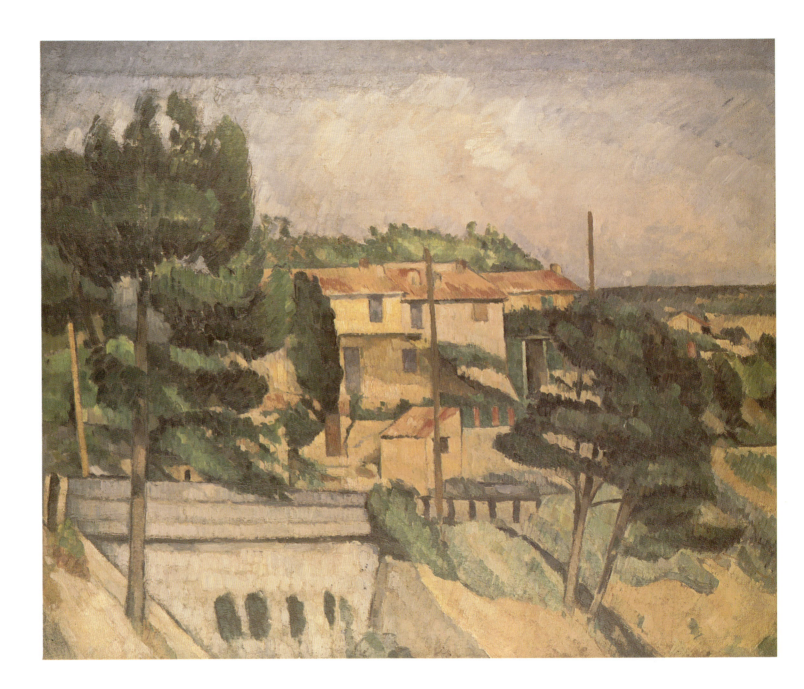

The Viaduct at L'Estaque

Venturi 402

Oil on canvas; 54 x 65.5 cm.

Ateneumin Taidemuseo, The Art Museum
of the Ateneum, Helsinki, Coll. Antell

With few exceptions Cézanne's early landscapes consist of either rural scenes or architectural views. The latter are often studies of roof-tops which may have been inspired by similar works by François-Marius Granet, the landscape painter from Aix who bequeathed his collection to the museum in the town. By the 1870s, however, Cézanne had begun to recognise the advantages of combining architecture with the forms of the natural world to lend stability to his landscapes. The *Viaduct at L'Estaque*, which dates from 1882–85, demonstrates the use he made of this device in his maturity.

Focusing upon a group of houses set above the viaduct at L'Estaque, Cézanne reduces all elements of the scene to a series of vertical and horizontal accents which endow it with an almost forbidding austerity. Here everything is about alignment. The composition is divided by the assertive verticals of the foreground trees and two telegraph poles. These intersect with the rigid horizontals of the viaduct and buildings to create a network of perpendicular accents across the picture. Enlivening this scheme are the connecting diagonals of the roof-tops and terrain and the directional brushstrokes of the foliage and sky. At the foreground left the darkened sluice gates of the viaduct provide the inspiration for a series of rhythmic accents which reappear throughout and find their clearest statement in the blue windows and door of the house in the exact centre of the picture. To frame the composition, and provide yet another firm horizontal, Cézanne has added a 3 cm. strip of canvas at the top, painted in a clear blue.

The rigour and rationality of this picture, with its tightly interlocking arrangement of natural and architectural forms, calls to mind such landscape drawings by Poussin as the *View of the Aventine* [No. 26]. In both, the scene is reduced to a faceted sequence of geometrical shapes which appear to impose the laws of architecture upon the multifarious forms of the natural world.

In Cézanne's own career, the Helsinki canvas anticipates the series of views of the town of Gard-anne, south of Aix, which he executed in 1885–86. Dominated by the cubic forms of the buildings of the town rising above the surrounding hills, these are among Cézanne's most austere and architectonic landscapes. In the greatest of them, now in the Barnes Foundation, Merion, Pennsylvania [fig. 50], the forms

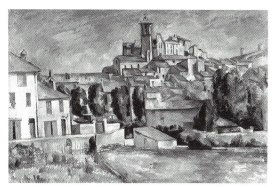

Fig. 50. Cézanne, *View of Gardanne*, 1885–86 (Barnes Foundation, Merion, Pennsylvania)

of the trees are themselves made to conform to the shapes of the buildings, creating a majestic impression of gravity and order which compares with the great series of views of the Mont Sainte-Victoire and the Gulf of Marseilles upon which Cézanne embarked during these same years [Nos. 38,41,45 and figs. 10,12, 16,31].

The epic grandeur of Cézanne's views of Gardanne find their echo in his letters of this period. On 11 May 1886, he wrote to Chocquet from this town: 'As for the rest, I have nothing to complain about. Always the sky, the boundless things of nature, attract me and give me the chance to look with pleasure ... To conclude, I must tell you that I am still occupied with my painting and that there are treasures to be taken away from this country, which has not yet found an interpreter equal to the abundance of riches which it displays'.[1]

1. *Letters*, p. 225.

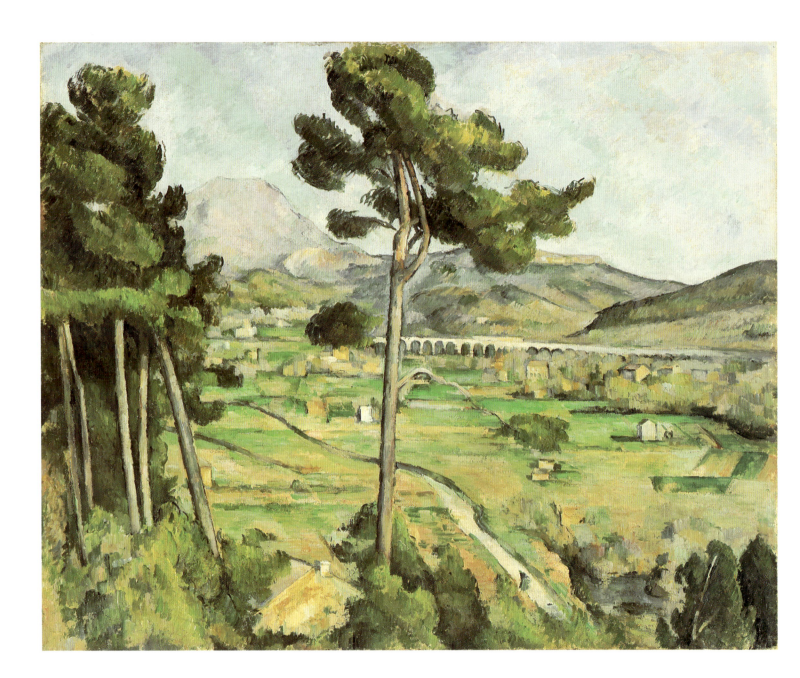

La Montagne Sainte-Victoire

Venturi 452

Oil on canvas; 65 x 81 cm.

The Metropolitan Museum of Art,
Bequest of Mrs H. O. Havemeyer, 1929,
The H. O. Havemeyer Collection

Although Cézanne's earliest views of the Mont Sainte-Victoire date from the 1870s, only in the following decade did he repeatedly turn his attentions to portraying this landmark of the countryside around his native Aix. In a magnificent series of canvases of the 1880s, Cézanne depicted the broad face of the mountain visible from the south-west of the town, where it rises above the valley of the River Arc, whose most prominent feature is a railway viaduct leading south. This viewpoint permitted the artist to relate the animated landscape of the valley, with its winding roads and scattered buildings, to the serene face of the mountain beyond. In certain of these scenes Cézanne portrayed the Mont Sainte-Victoire from an unimpeded view. In others, it appears framed or encircled by foreground trees. But, in his most daring depictions of this motif, it is contrasted with a solitary central tree, which mediates between all points in the composition – left and right, near and far – as though holding them in its sway.

Cézanne painted two versions of this scene in the years around 1885–87, the larger and more highly finished of which is the picture exhibited here.[1] Preceding them are two drawings and a watercolour [cf. Nos. 39 and 40], all of which are chiefly concerned with the broad division of masses within this complex scene. These preliminary works testify to the careful consideration Cézanne gave to this finely equilibrated composition. Justifying his efforts is the celebrated canvas of this subject in the Metropolitan Museum, one of Cézanne's most poised and serene landscape paintings.

Flanked by the expansive silhouette of the Mont Sainte-Victoire and its surrounding hills, surmounting the valley below, the composition is focused upon a solitary pine whose tufted crown echoes the shape of the mountain itself and serves to connect the most distant features of the scene. Midway between them, the line of the viaduct intersects the trunk of the tree, linking the three main spatial points in the composition. At the point of contact between viaduct and tree, a single branch rises upwards, lightening in hue and arching in shape, as though in response to the colour and form of the viaduct itself. Descending towards the right, it parallels the line of the road which traverses the valley, subjecting even this recessional diagonal to an alternative role in strengthening the two-dimensional harmony of the composition. If the tilt of the central tree adds a potential imbalance to the scheme, its ability to reconcile the most disparate features of the landscape establishes the unity and stability of the scene. The result is an image of nature held in dynamic equilibrium – one which appears both eternal and ever-changing.

In its smooth, firm handling and decisive organization, the picture is one of the most resolved and complete of all Cézanne's landscapes. Yet it is also among his subtlest works in this form. Though broadly symmetrical in design, its symmetry appears concealed by the unorthodox balancing of the group of trees at the left with the rising hills on the opposite side of the picture. Throughout the composition, Cézanne uncovers further correspondences between the most diverse features of the landscape. To the left of the central tree the line of the viaduct forms the 'branch' of a tuft of foliage suspended above the valley. Directly below it, the façade of a house takes on the form and colour of a chimney in the centre foreground. And, discretely framing the whole composition below is a line of vegetation and buildings which rises and falls across the lower border of the picture in a contour which repeats that of the trees, mountain, and hills silhouetted against the sky.

The abiding unity and intense luminosity of the Metropolitan Museum's picture testifies to a deep love of his native countryside which Cézanne derived from his youthful exploits in the landscape around Aix. In a letter to Zola of 9 April 1858, Cézanne affirmed his devotion to it in a description which calls to mind the motif of the New York picture. 'Do you remember the pine tree which, planted on the bank of the Arc, bowed its shaggy head above the steep slope extending at its feet?', enquired the artist, 'This pine, which protected our bodies with its foliage from the blaze of the sun, ah! may the gods preserve it from the fatal strokes of the wood-cutter's axe.'[2]

1. Cf. V. 453.
2. *Letters*, pp. 17 f.

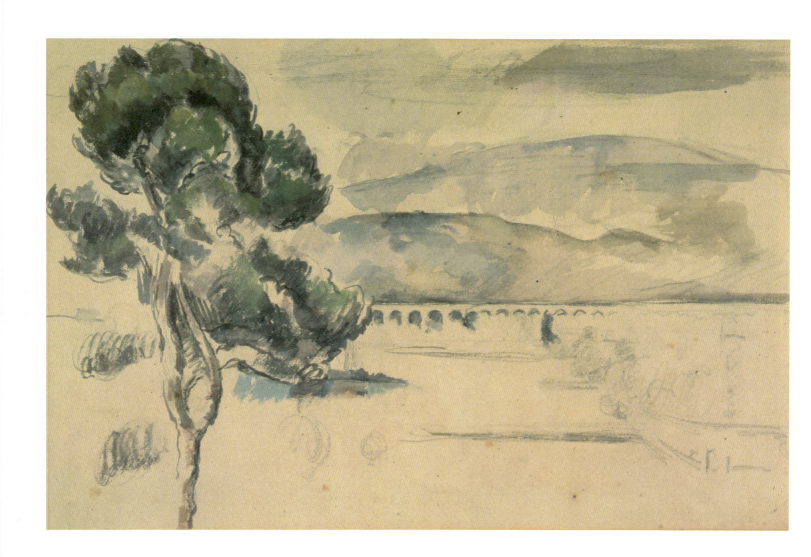

Pine before the Valley of the Arc

Rewald 239

Pencil and watercolour on buff paper; 29.6 x 47 cm.

Vienna, Graphische Sammlung Albertina

This magnificent watercolour is closely related to three paintings of this subject, among them the Metropolitan Museum's canvas of 1885–87, exhibited here [No. 38].[1] Cézanne also made a rapid thumbnail sketch of the composition of the New York picture in a sketchbook formerly in the Block Collection (Chappuis 905), which is chiefly concerned with the broad distribution of masses within the scene. Another study for this picture is No. 39 in the present exhibition.

John Rewald has observed of this group of works:[2]

'In all these works Cézanne made admirable use of the decorative qualities of the isolated pine tree, which here has become the sole, off-centre feature of the composition, vaguely reminiscent of Oriental brush drawings. The background landscape serves merely as a foil for the convoluted shape of the tree. But whereas in the other works Sainte-Victoire could be perceived in the distance, here Cézanne selected this motif in such a way that no other rising form interferes with the Baroque conformation of the tree.'

1. The other two are V. 453 and 488.
2. Rewald, p. 142.

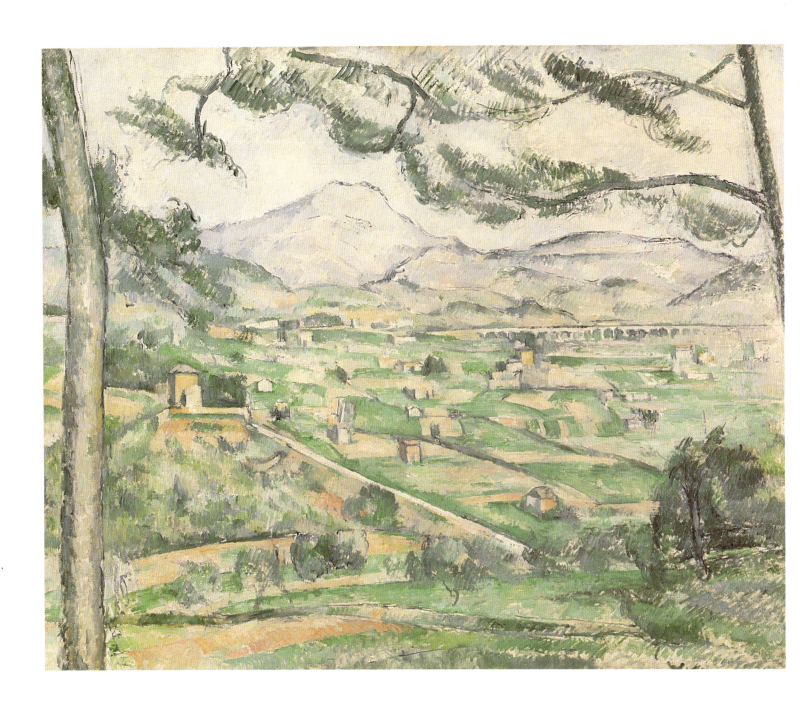

La Montagne Sainte-Victoire

Venturi 455

Oil on canvas; 59.6 x 72.5 cm.

The Phillips Collection, Washington, D.C.

With the great canvas of this same subject in the Courtauld Institute [fig. 12] and a related watercolour [No. 42], the *Montagne Sainte-Victoire* in the Phillips Collection is one of the most decoratively conceived of Cézanne's works. In its feathery branches unfurling across the sky to frame the distant mountain, it provides the exception to the rule that Cézanne remained the one great painter of his generation impervious to the influence of Japanese art. Moreover, it affords unmistakable evidence that the artist did on occasion resort to the pictorial devices and methods of Poussin in order to lend harmony to his compositions; for coincidence alone cannot account for the inevitable relationship which here exists between mountain and tree. Reason instead must have willed it.

The picture shows a panoramic view of the valley of the Arc bounded by the Mont Sainte-Victoire; and, like other works of these years, was probably painted from an elevated viewpoint to the south-west of Aix, presumably from a hill at Bellevue, the estate which Cézanne's brother-in-law, Maxime Conil, had purchased in 1881 and which the artist often visited and painted [Nos. 46 and 59] during these years.

Painted with cursive strokes of the brush, which leave much of the canvas bare, it possesses a tender lyricism and fragility which contrast with the commanding splendour of the Courtauld version of the same subject, where the massive peak of the mountain sits squarely in the centre of the picture, heroically crowning the view. In the Phillips painting (and the Chicago watercolour) Cézanne has shifted his gaze slightly to the left to reveal the trunk of the tree on the upper right and to place the mountain itself left of centre, where it provides a less dramatic focus for the composition. Below it, the panoramic landscape of the valley, with its roads, buildings, and viaduct, enhances the vivacity of the scene, vividly conveying Cézanne's deep joy at the most reassuring aspects of nature.

Comparisons with photographs of the motif [fig. 51] reveal that the artist has brought the mountain forward, increasing its size in order to compensate for the sweeping expanse of the valley and ensure the surface unity of the composition. This is reinforced by the device of painting the undulating branches of the trees in the identical hues as the contour of the mountain beyond. But it is also less demonstratively shown at the upper left of the picture, where a tuft of foliage, overlapping with the mountain, imperceptibly

Fig. 51. Mont Sainte-Victoire with the Valley of the Arc

'slips' into providing the contour lines of the distant hills. Enhancing the harmony of the whole are the deft handling and radiant colour, which is remarkable for its subtly varied range of greens. These add an airiness and lyricism to the scene, which contrast with the more heavily worked Courtauld picture, which is considerably less atmospheric. Through both works there shines, however, the remarkable impersonality of the artist's vision. Though Cézanne's emotional engagement with the landscape is beyond dispute, the contrasting moods of these two pictures ultimately seem wrested from nature itself, rather than imposed upon it by the artist. In this regard they remind one of Clive Bell's well-known statement on the artist: 'Cézanne has made a generation of artists feel that compared with its significance as an end in itself all else about a landscape is negligible'.[1]

The picture was purchased by Duncan Phillips in 1925 and proved to be the first of an outstanding series of works by Cézanne which he gradually acquired for the collection which bears his name. In a sensitive appreciation of his *Montagne Sainte-Victoire*, Phillips observed: 'Cézanne has pondered every touch – no wasted motions, no hastily improvised devices. His composition was built from top to bottom and from end to end and when it was finished the relations of one thing to another seemed inevitable, as if determined from the beginning of the world. Cézanne's cosmos within a frame is so compact and complete that there is nothing more to say'.[2]

1. Clive Bell, 'The Debt to Cézanne', *Art*, London, 1928, p. 209.

2. *Cézanne, An Exhibition in Honor of the Fiftieth Anniversary of The Phillips Collection*, Washington, D.C., 1971, p. 33.

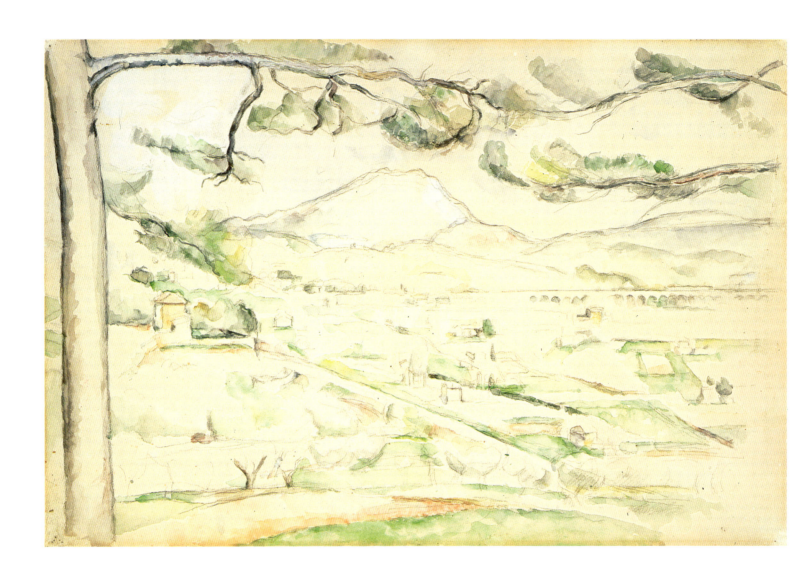

The Valley of the Arc

Rewald 241

Pencil and watercolour on white paper; 34.7 x 53.1 cm.

The Art Institute of Chicago

In an informative catalogue entry on the Chicago watercolour, John Rewald has observed:[1]

'In all likelihood, Cézanne executed this watercolour before tackling the oils of the same subject (Venturi Nos. 454 and 455). As a matter of fact, it would seem that he really began with a fairly minute drawing to which he subsequently applied color, a method he used less and less in later years, after he had evolved the peculiar technique of thin, large, superimposed washes out of whose cohesion the image emerged. Here the process is still much simpler and more traditional: the pencil has put into place the essential features, to which the brush has added a few accents of discreet tints here and there, generally leaving areas of white paper to enhance their interplay. As a result, one might actually speak of a drawing heightened with color.

'The upper part of the picture is animated by the arabesque of pine branches, a decorative and almost "scenic" device seldom used by Cézanne, and one that might be ascribed to Japanese influences, were it not that Cézanne had scarcely any contact with Oriental art. But precisely because he generally did not employ ornamental designs, one is tempted to presume that this watercolor enabled him to judge the effect such elements would produce. The artist seems to have been pleased with the result, since these branches appear again in two paintings of the same motif. Of these the one in the Phillips Collection in Washington (Venturi No. 455; [No. 41 in the present exhibition]) comes closest to the composition of this watercolor (with the addition of a few accents in the foreground). There is a separate pencil study for the branches (Chappuis No. 893). Although the freedom of Cézanne's later and more typical watercolors is lacking here, the care with which he worked on this pictorial view and its relation to some of his major paintings of the eighties confer on this sheet an undeniable importance.'

1. Rewald, p. 142.

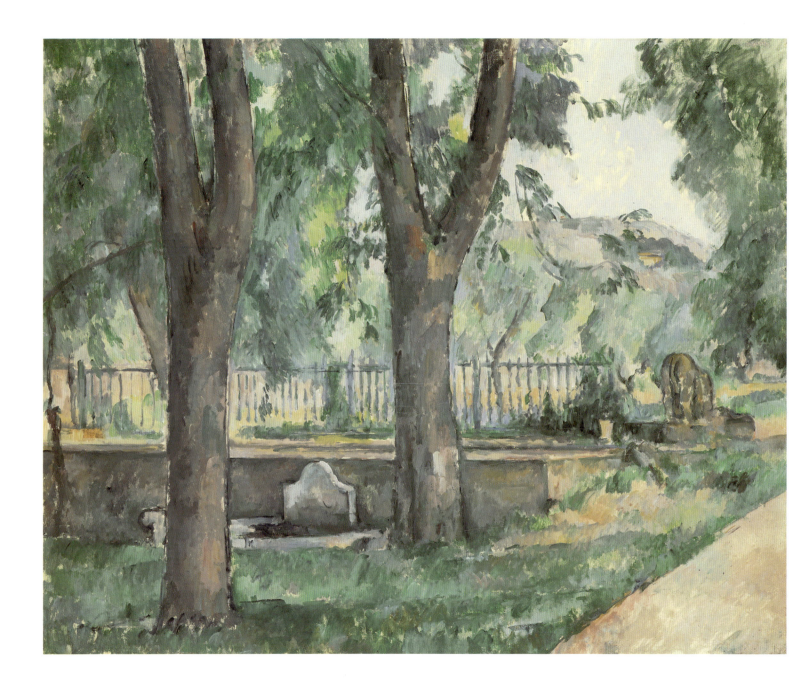

Near the Pool at the Jas de Bouffan

Venturi 648

Oil on canvas; 65 x 81 cm.

Lent by The Metropolitan Museum of Art,
Bequest of Stephen C. Clark, 1960

Cézanne painted and drew more views of the Jas de Bouffan during the second half of the 1880s than at any other point in his career. A number of factors, both personal and artistic, may account for this. In 1886 the artist reached a turning point in his life which led him to spend more of his time at Aix. In the early spring of that year Zola's *L'Œuvre* appeared, marking the end of Cézanne's friendship with the great writer and his increased withdrawal from the artistic life of Paris. Shortly after this, on 28 April, Cézanne married Hortense Fiquet at Aix; and in October of the same year, his father died, aged 88, leaving the artist with a substantial fortune. During the next years, Cézanne often spent long periods at the Jas de Bouffan, tending his aged mother and painting the family house and its surroundings. More than a dozen canvases of the Jas de Bouffan date from this period, among them the picture of 1888–90 exhibited here.

The grounds of the Jas de Bouffan, with its avenue of chestnut trees and its square pool ornamented with stone dolphins and lions, provided Cézanne with an ideal subject at this most classical phase of his career. Not only was the site close at hand but it was ordered, architectural, and severely rectilinear. These features are apparent in the Metropolitan Museum's canvas, with its stately trees intersecting the horizontal lines of the fence and pool to create a lucidly balanced composition. In the measured intervals which separate all elements of the scene, as also in its poise and equilibrium, the picture cannot fail to bring Poussin's methods of landscape composition to mind. With its integrated arrangement of trees, masonry, and statuary, it is as though one is glimpsing a corner of Poussin's *Roman Road* [No. 21], made over again 'according to nature'.

Few canvases demonstrate more readily the dynamic equilibrium which Cézanne sought in nature. The composition is centred upon a single tree, whose forked branches provide the focus of the design. To

either side of this, the brushstrokes of the foliage and background hills follow a diagonal gradient which converges upon the central trunk, as though drawn magnetically to it. At the point of division in the branches themselves, Cézanne adds isolated touches of red, green, and ochre to the bark of the tree, which stress this crucial point in the design. To either side, balance is attained through fundamentally different means. At the left, the dark and solid form of another tree, painted in deeper hues, appears silhouetted against the strict horizontals of the fence and pool, framing and stabilising this portion of the picture. On the right, however, balance is achieved not by recti-linear accents but by the assertive diagonal of a receding road surmounted by a stone lion and a group of framing trees. Adding to the more dynamic impression created on this side of the composition are the light, flickering brushwork and the more vivacious colour contrasts. Light blues, greens, and yellows prevail here, counterbalancing the strong structural accents at the left through their animated changes of hue. The result is a harmony of opposites – a composition centred upon a motif which is commanding in both colour and structure and is framed to either side by elements in which one or the other of these predominates.

Characteristic of this phase in Cézanne's career is the combination of authority and felicity with which the artist imbues his picture. Like the Metropolitan Museum's great *Montagne Sainte-Victoire* [No. 38] of this same period, the composition possesses a discrete, concealed symmetry which unites left and right, near and far, in a finely balanced whole. Individual elements appear at once clear and self-contained and firmly integrated with the overall design of the picture. Enhancing the impression of unity and repose is the incisive contouring of the forms and the carefully regulated brushwork, which clothes the stable structure of the composition in the variegated hues of nature.

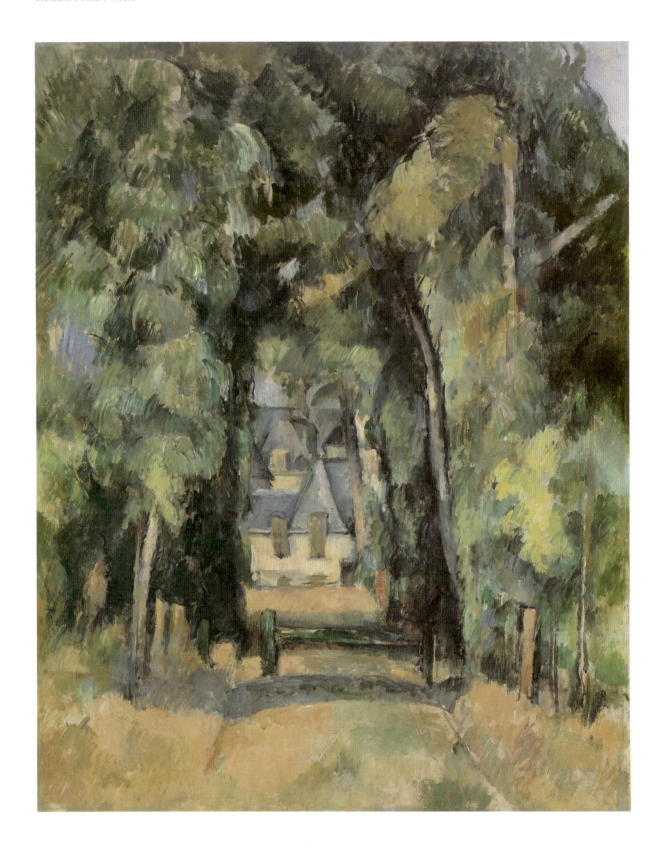

Avenue at Chantilly

Venturi 627

Oil on canvas; 81 x 65 cm.

The Toledo Museum of Art;
Gift of Mr and Mrs William E. Levis

In 1888 Cézanne spent five months working in the town of Chantilly, outside Paris, and along the banks of the Marne. During this period he executed three canvases of a tree-lined avenue in the town, together with several watercolours of the same motif.[1] One of these pictures, recently bequeathed to the National Gallery from the Chester Beatty Collection (V.626), is a delicately handled work, painted in a range of light greens and ochres which perfectly capture the effect of dappled light playing through the trees. The more heavily painted Toledo canvas exhibited here affords a more imposing view of this same subject and is one of Cézanne's finest treatments of the theme of a receding road lined by trees.

Plainly visible in the distance is a group of houses whose gabled blue roofs, viewed through an opening in the trees, establish the centre of the composition. In the triangular shape of the most prominent of these Cézanne uncovered the architectural counterpart to the leaning trunks of the trees, creating an arrangement of the strictest symmetry which is enlivened throughout by the artist's ceaseless variations of colour. In criss-crossing strokes of blue, red, yellow, ochre, and green, Cézanne evokes the lushness and animation of the spot. This dazzling range of hues, with its intense luminosity, may be compared with the more limited light and colour of the *Road with Trees and Pond* of c.1880 [No.32] as an index of the greater subtlety of Cézanne's art of the late 1880s.

The vibrant colours of the Toledo picture are not the only means Cézanne employs to unify this scene. He also establishes a continuous tension between space and surface through formal correspondences between distant elements in the landscape. Thus, the grey-brown windows of the buildings are restated in the markers to either side of the bench in the foreground of the composition. This in turn creates a prominent horizontal shadow which echoes the lines of the buildings, effectively bringing them forward. Adding to the tautness of the construction is the blank area at the bottom of the picture, where the artist has suppressed the receding lines of the road. This reduces all elements of the scene to vertical and horizontal accents which delineate space while still aligning themselves with the edges of the frame.

Like Poussin before him, Cézanne employed this method of reconciling space and surface throughout his career. Only at the end of his life, however, did the artist outline this theory in writing in a letter to Emile Bernard of 15 April 1904. 'Lines parallel to the horizon give breadth', observed Cézanne, '... lines perpendicular to this horizon give depth. But nature for us men is more depth than surface, whence the need to introduce into our light vibrations, represented by the reds and yellows, a sufficient amount of blueness to give the feel of air'.[2]

Cézanne's remarks outline a method of creating space without the use of converging diagonals, a favourite device of illusionistic painters and one which affords the viewer with easy access into the scene. Instead, Cézanne's method of engendering space strengthens the two-dimensional harmony of the composition and stresses the aesthetic autonomy of the picture. 'Art is a harmony which runs parallel with nature', declared Cézanne in 1897.[3]

1. V.626–28; Rewald 308–09.
2. *Letters*, p. 301.
3. *Ibid.*, p. 261.

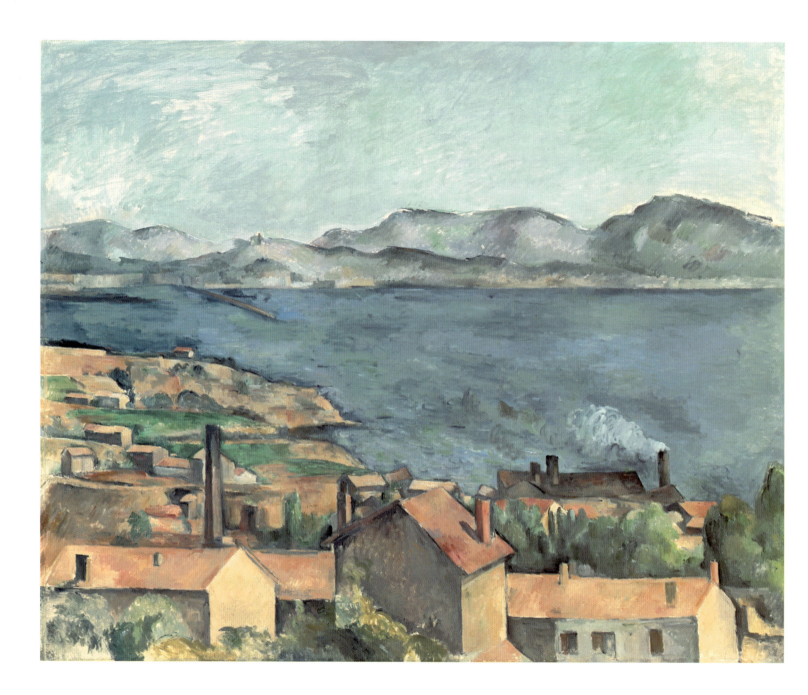

The Gulf of Marseilles, seen from L'Estaque

Venturi 493

Oil on canvas; 80.8 x 99.8 cm.

The Art Institute of Chicago

Arguably the grandest of all Cézanne's views of the Gulf of Marseilles, the Chicago canvas dates from 1886–90. A slightly smaller version of the same scene in the Metropolitan Museum (V.429) omits the prominent façades of the buildings in the foreground, which lend such gravity and authority to the present picture.

In his important study of Cézanne, Meyer Schapiro has written of the Chicago canvas:[1]

'The painting lives through the power of great contrasts: the luminous, richly broken field of reds, oranges, and greens against the blue sea; the modeled wavy mountains, convex, against the filmy, substanceless sky ... An ever-active touch, responding to the lie or swerve or rise of objects, unites this extended world from point to point. Nothing is perfectly still; the dark water has its pulsations and nuanced mood, and the pure sky, a delicate quivering of ethereal tones.

'Below, a great block of a building breaks the alignment of the buildings beside it and the banding of earth, sky, and distant mountains. Parallel to the ascending shoreline, it looks to the puff of smoke and the highest mountain and induces an undrawn diagonal between them across the sea. But mountain and smoke are parallel to the major roof-lines of this building – these are directed like the slope of the shore and re-enforced by the unique cast shadow of the chimney. Following these lines, each of another color, we come upon the finesse of the far-off jetty pointing to the puff of smoke along the same inclined axis, and below this jetty we discover the little red house on the shore and the high chimney – a mysterious unstressed grouping of isolated elements which take their places in the harmony of the whole. The chimney is an object for wondering contemplation, so beautifully wedded it is, in its multiple character, to the forms and colors of the whole – rising from light warm to dark cool, re-enacting the contrast of earth and sea, ending at a level where an inlet dovetails the line of water and land, opposing and uniting the strong horizontals of roofs and ground, and focusing the play of scattered verticals by its culminating form.

'A marvellous peace and strength emanate from this work – the true feeling of the Mediterranean, the joy of an ancient nature which man has known how to sustain through the simplicity of his own constructions.'

The grandeur and resolution of this heroic canvas suggest that it was Cézanne's culminating view of this panoramic scene. So far as we know, the artist never worked at L'Estaque after the 1880s, for reasons which he stated in a letter of 1 September 1902 to his goddaughter, Paule Conil:[2]

'I remember perfectly well the Establon and the once so picturesque banks of l'Estaque. Unfortunately what we call progress is nothing but the invasion of bipeds who do not rest until they have transformed everything into hideous *quais* with gas lamps – and, what is still worse – with electric illumination. What times we live in!'

1. Meyer Schapiro, *Cézanne*, New York, 1963, p. 62.
2. *Letters*, p. 292.

The Pigeon Tower at Bellevue

Venturi 650

Oil on canvas; 65 x 81 cm.

The Cleveland Museum of Art, Cleveland, Ohio

During the years 1888–92, Cézanne painted a number of views of his brother-in-law's house at Bellevue, with its prominent pigeon tower. In 1889 he was joined there by Renoir, who rented the house from Conil and spent several months painting in the vicinity. Although Cézanne executed a number of canvases showing the back of Conil's estate, masked by vegetation, his most highly structured views of this motif are painted from the same vantage-point as Renoir chose for his only canvas of this subject [fig. 52]. These show the prominent façade of the pigeon tower at the left, adjoining the house, and surrounded by clumps of trees – a view which is still visible in a photograph of the motif [fig. 53]. In the foreground, an area of barren land provides a broad plateau for the composition. When seen from this angle, the forms of the buildings and trees, rising between unbroken areas of land and sky, provided Cézanne with one of his most compact and regimented subjects.

Cézanne produced two nearly identical canvases of this theme in the years around 1890,[1] the larger and more tautly designed of which is the picture exhibited here. The composition is centred on the cylindrically shaped pigeon tower, which the artist has extended upwards and to the left in order to increase its prominence. This is framed at the sides by trees and organized in a stratified construction of the utmost clarity. At the bottom, broad bands of ochre and green isolate the motif from the viewer; while above, it appears silhouetted against an unbroken expanse of sky. Within this rigorous scheme, Cézanne uncovers further formal correspondences between different elements of the landscape. Taking his cue from the tiered and scalloped shape of the pigeon tower, he introduces similar contours into the forms of the trees, reducing them throughout to compact, regular shapes, which mirror the forms of the buildings. Adding to the balance and harmony of the picture are the decisive contrasts of tone and hue. At the juncture between the pigeon tower and the trees, in the exact centre of the composition, appear the most dramatic tonal contrasts. Surrounding them are pure, unbroken expanses of local colour – blues, greens, ochres, and the near-white of the pigeon tower itself – which add to the serenity of the impression. Rarely in Cézanne's mature art did he so ruthlessly reduce a landscape to its essential forms and colours as in this spartan scene – one in which abstract considerations seem completely to override the vagaries of nature. As D. H. Lawrence observed in 1929, 'sometimes Cézanne builds up a landscape essentially out of omissions'.[2]

Fig. 52. Renoir, *The Pigeon Tower at Bellevue*, 1889 (Present whereabouts unknown)

Fig. 53. The Pigeon Tower at Bellevue

1. Cf. V. 653.
2. *Phoenix I: The Posthumous Papers of D. H. Lawrence*, ed. Edward McDonald, New York, 1972, p. 581.

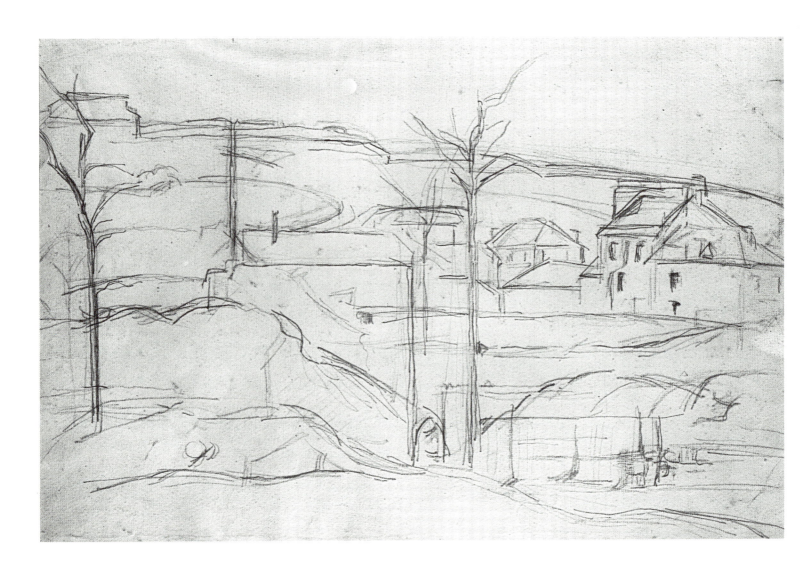

Hills with Houses and Trees

Chappuis 798

Pencil on laid paper; 31.3 x 47.3 cm.

Oeffentliche Kunstsammlung Basel, Kunstmuseum

One of the most revealing of Cézanne's landscape drawings, *Hills with Houses and Trees* of 1880–83 has been described by Lawrence Gowing as follows:[1]

'... among the sheets at Basel there is another drawing that concerned the further investigation of vertical and horizontal at another village in the Île de France. The subject now concerns (like more than one of the pictures of the time) the way downhill to the village clustering in a valley and up the slope on the other side to the skyline. The first pencilings were hardly more controlled or calculated than the sketch at Auvers [fig. 54]; indeed, the initial style appears to have been indistinguishable. Then the significance occurred to him of the straight winter trees beside the road into the village, and a little distance either side. These slender verticals crossed the horizontals of houses and garden walls and meeting the skyline branched and intersected it, reaching up into the sky. The subject that now concerned him was straightness. The houses were redrawn more decisively; architectural character became apparent; triangular gables set up systems of parallel diagonals. The horizontals crossed the sheet at well-calculated spatial intervals but the verticals of trees and posts were not quite beyond doubt. Then it appears that Cézanne found an

Fig. 54. Cézanne, *Landscape with Houses and Trees*, *c.* 1874. Drawing (Kunstmuseum, Basel)

appropriate straight-edge in his pocket, perhaps a card or a fold of paper; he added a ruled vertical to the still-sketchy uprights of some of the trees, sometimes supplying a straighter edge, more often a sharper reinforcement.'

1. Lawrence Gowing, *Paul Cézanne: The Basel Sketchbooks*, Museum of Modern Art, New York, 1988, p. 31.

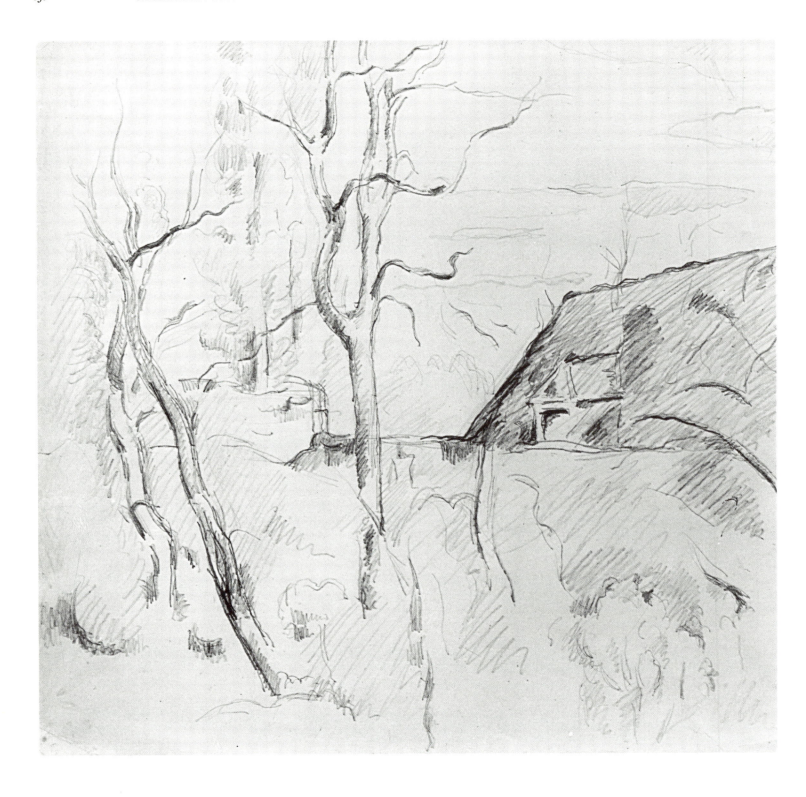

Trees and Roof

Chappuis 878

Pencil; 32.6 x 34.5 cm.

Museum Boymans-van Beuningen, Rotterdam

This impressive drawing has been dated between 1879 and 1883. A drawing of two trees on the verso dates from 1885–87.

As in the Sheffield *Pool at the Jas de Bouffan* [No. 13] or the São Paulo *Great Pine* [No. 59], Cézanne here sets himself the challenge of exploring the dynamism of nature within the confines of an essentially symmetrical and rigorously balanced composition. Bisecting the sheet with the form of a single, forked tree, which rises assertively to the top of the design, he complements this strict vertical with strikingly contrasted motifs to either side. At the right the geometric shape of a roof seen behind a wall provides a substantial stabilising device which endows this side of the composition with a monumental solidity. On the left, however, Cézanne portrays a group of steeply sloping trees growing upon a knoll, whose vigorously curving trunks and branches add a dynamic vitality to the scene. The whole affords another example of Cézanne's desire to portray those two opposing forces he sensed throughout nature – 'the thrill of her permanence' and 'the appearance of all her changes'.[1]

1. Joachim Gasquet, *Cézanne*, Paris, 1921, p. 130.

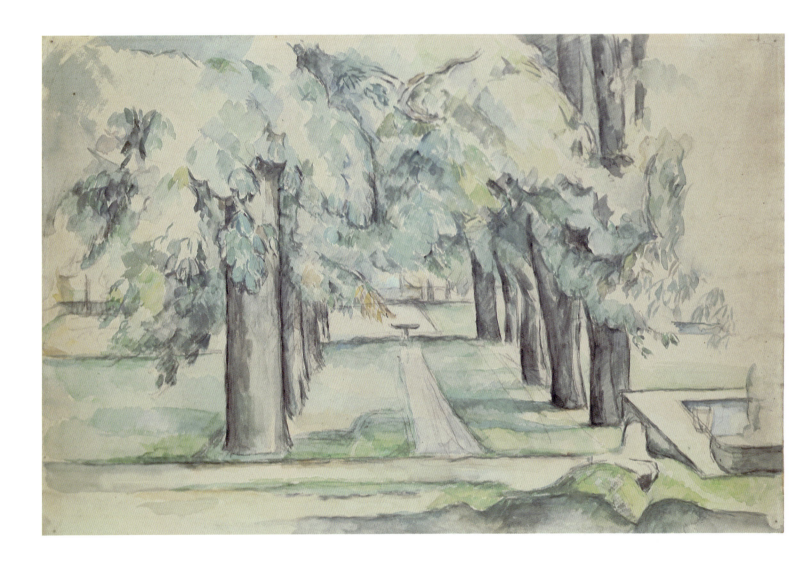

The Avenue at the Jas de Bouffan

Rewald 113

Pencil and watercolour on white paper;
30 x 47 cm.

Graphische Sammlung im Städelschen Kunstinstitut,
Frankfurt-am-Main

Cézanne's earliest watercolour of the avenue of chestnut trees at the Jas de Bouffan dates from 1867–70 [fig.41], the period of the Tate Gallery canvas of the same subject exhibited here [No. 10]. In both of these the artist preferred to observe the scene from an oblique angle in order to create a more dynamic impression. Only in this stately watercolour of 1878–80 does Cézanne confront it head-on and lay bare its inherent logic and symmetry. Focusing upon the clearly defined contours of the trees and land, the artist portrays a scene in which vertical and horizontal accents regulate the composition and the more freely applied touches of the overhanging foliage serve to animate it. At the lower right, the edge of the pool of the Jas de Bouffan, also visible in the Metropolitan Museum's canvas of this subject [No. 43], provides an architectural counterpart to the prevailing geometry of nature.

Though Cézanne was to paint only one more view of this motif (V.649), he did return to it in a later drawing [No. 53]. Moreover, as his series of paintings and watercolours of a tree-lined avenue at Chantilly of 1888 makes clear [No. 44; cf. V. 626, 628; Rewald 308–9], the motif itself preoccupied the artist during the middle years of his career. Whether in the grounds of his family estate at Aix or in the comparative unfamiliarity of the North, Cézanne was repeatedly drawn to the lucid and orderly scene of trees lining a receding road, as though recognising in it a basic equation of nature.

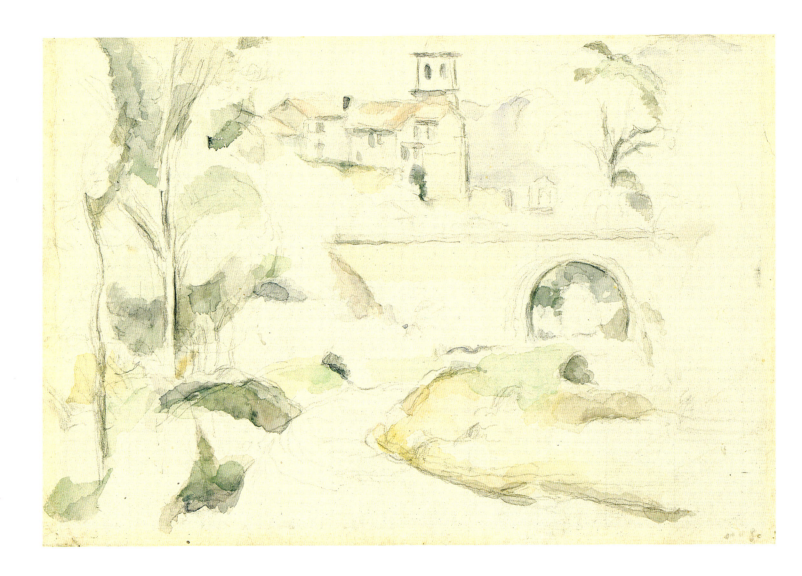

Gardanne, The Old Bridge

Rewald 248

Pencil and watercolour on white paper;
20.6 x 31.1 cm.

The Museum of Modern Art, New York

Gardanne, The Old Bridge is datable to 1885–86, the only period Cézanne is recorded as working in this picturesque town, 17 km. south of Aix. Like his seven oils of this subject,[1] it possesses a geometric severity which presages the austerely architectonic landscapes of the Cubist painters and reveals Cézanne's determination to uncover an abstract logic and order from a confusing scene in nature.

Erle Loran, who identified and published a photograph of the motif of this watercolour in the 1920s [fig. 55] has written of it:[2]

'The water color reproduced here is not an important work of art, but, when compared with the

Fig. 55. The Bridge at Gardanne

photograph of the original scene on the outskirts of Gardanne, it does clearly reveal Cézanne's method of organizing space. (a) The foreground has been compressed in size and flattened by a sharper turn in the road. The large trees on the left have been reduced enormously in scale, but of course due allowance should be made for growth since the time Cézanne's painting was made.

'(b) The background buildings and railroad bridge, which in the photograph of the motif are tiny in size, have been radically enlarged in Cézanne's painting to become the most important forms in the entire picture. (c) Thus, scientific perspective is again completely ignored, if not actually reversed, in the process of organizing deep space and relating it to the flatness of the picture plane. In less technical terms, Cézanne was primarily interested in the bridge and church. He made them large because they were psychologically the most important forms in his subject; and furthermore, the tall trees on the left could only be balanced by enlarging the forms on the right.'

1. V. 430–33, 435–37.
2. Erle Loran, *Cézanne's Composition*, Berkeley, Los Angeles and London, 3rd ed., 1963, p. 48.

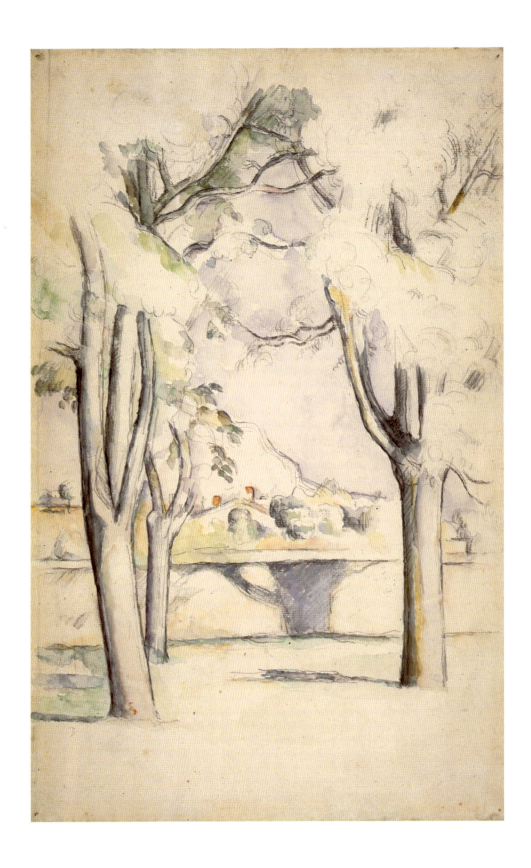

**La Montagne Sainte-Victoire
seen from the Wall of the Jas de Bouffan**

Rewald 263

Pencil and watercolour on white paper;
45.5 x 30 cm.

National Gallery of Art, Washington, D.C.,
Collection of Mr and Mrs Paul Mellon

Like the Chicago watercolour of the Valley of the Arc [No. 42], this is essentially a coloured drawing in which Cézanne deliberately denies himself the freedom and spontaneity possible in watercolour in order to create a more monumental impression. It would be difficult to imagine a more carefully considered or consciously classical composition than that of the Washington watercolour, which dates from 1885–88, the period of Cézanne's grandest paintings of the Mont Sainte-Victoire. Solemnly framed to either side by the large chestnut trees which adorned the Cézanne family estate, the composition is bounded in the middle distance by a horizontal wall beyond which rises the silhouette of the Mont Sainte-Victoire, here rendered so lightly that it appears as another branch of the foreground trees. To the centre right an area of blue shadow on the wall links foreground with distance and serves further to unite the contour of the mountain with the overhanging foliage. At the upper centre, areas of green pigment discretely reaffirm the symmetry of this harmonious design, one of the most tranquil and meditative of Cézanne's watercolours.

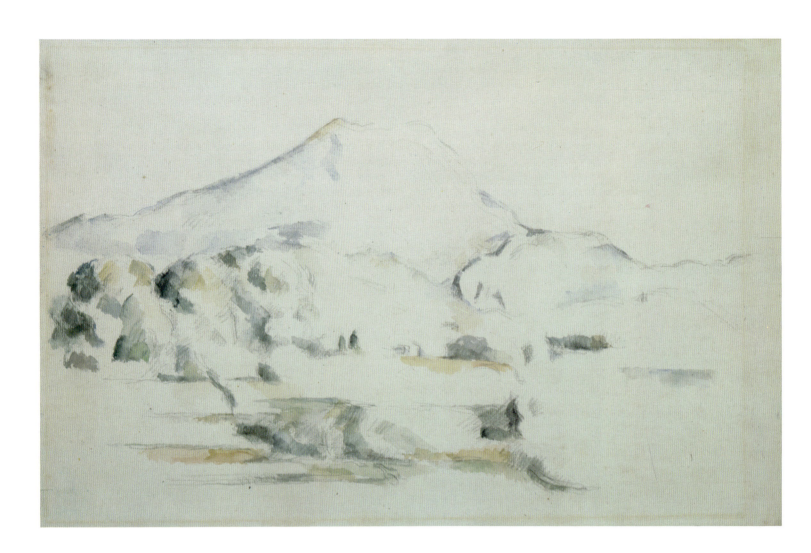

La Montagne Sainte-Victoire

Rewald 279

Pencil and watercolour on white paper;
32.8 x 50.5 cm.

Courtauld Institute Galleries, University of London

The Courtauld Institute watercolour is closely related to one of Cézanne's mightiest views of the Mont Sainte-Victoire of the second half of the 1880s, the canvas now in the Barnes Foundation, Merion, Pennsylvania [fig. 31]. Both works were painted from about 1 km. south-west of the Jas de Bouffan. This position affords the most balanced view of the mountain, which in both the Barnes painting and the London watercolour is set squarely in the centre of the scene and seen from an unimpeded view which emphasizes its massive shape and impregnable strength.

In the Barnes canvas Cézanne enhances the severity of the impression through the uniform and highly finished brushwork of the entire picture and, unusually, cuts the chiselled contour of the mountain free from the sky, which is painted in a single clear blue. These devices serve to add even greater dignity and stability to the scene. In the Courtauld watercolour cursive strokes of green in the foreground form a mirror-image of the mountain beyond, while sparing touches of blue and ochre throughout the composition serve to establish the surface harmony of the construction. Linking all points in the landscape, they enhance its abiding serenity.

Avenue at the Jas de Bouffan

Chappuis 916

Pencil; 30.7 x 47.8 cm.

Museum Boymans-van Beuningen, Rotterdam

An expansive and rhythmic drawing which returns to the theme of the avenue lined with chestnut trees at the Jas de Bouffan, the motif of the Tate Gallery canvas of 1869–70 and the Frankfurt watercolour of 1878–80 also exhibited here [Nos. 10 and 49]. In contrast to these earlier works, the Rotterdam drawing, which dates from 1884–87, portrays the trees in winter, their leafless branches intertwining across the top of the sheet in a restless sequence of curves which testify to Cézanne's growing desire to convey both the underlying order and ceaseless complexity of nature.

Both of these are present in the Rotterdam drawing more than in any of his previous renderings of this theme. The avenue is set firmly in the centre of the composition and viewed straight-on – a vantage-point of 'fearful symmetry' which is then enlivened by the convoluted and encircling rhythms of the branches at the upper portions of the scene, whose muscular motions and intricate overlappings anticipate the even more dynamic rhythms of the artist's *Big Trees* of *c.* 1904 [No. 64] or his many late views of the Park at the Château Noir [No. 63 and fig. 14].

The Lime Kiln near the Pont des Trois Sautets

Rewald 392

Pencil and watercolour on white paper; 42 x 53 cm.

Musée du Louvre,
Département des Arts Graphiques
(Fonds du Musée d'Orsay)

This watercolour depicts a lime kiln which stood on the banks of the river Arc to the south-east of Aix, near the bridge of the Trois Sautets. Datable to 1890–94, it shows the Mont Sainte-Victoire in the distance and is one of two views of this motif which Cézanne made during these years.[1] In their monumental simplicity and their rigorous alignment of the geometric forms of the buildings with the surrounding landscape, both of these are among the artist's most austere watercolours of this phase and invite comparison with his two canvases of the Pigeon Tower at Bellevue of this same period [cf. No. 46].

In the Louvre watercolour Cézanne has reduced the buildings to stable, volumetric shapes of red and ochre, nestled in a group of trees, which fill the foreground of the scene. Behind them rises the broad profile of the Mont Sainte-Victoire, rendered in touches of pale blue which establish its more distant position in space. Refuting this, however, is the soaring vertical of the smoke-stack which rises from the foreground of the composition to align itself with the contour of the mountain beyond. Painted in the identical hues as the mountain, it serves to link the most distant points in the composition on the surface of the sheet. Further unifying the work are the myriad touches of blue and green with which Cézanne has delineated all points in the landscape. At the upper right corner of the paper six tack holes suggest that the artist made repeated attempts to attain so grave and harmonious an impression.

This work was among the outstanding group of paintings and watercolours by Cézanne bequeathed to the Louvre by Count Isaac Camondo in 1911. When these works were exhibited to the public three years later, Apollinaire observed of the four watercolours in the bequest:[2]

'In my opinion, Cézanne's watercolours are the triumph of the collection. Someone told me that after he had brought them, M. de Camondo wanted to return them. "These are really trifles for a collector like me", he is supposed to have said. But later he changed his mind, and he was right to do so, for nothing is more important than these watercolours for the study of the few contemporary painters who will matter in the history of art.'

1. Cf. Rewald 391.
2. *Apollinaire on Art – Essays and Reviews, 1902–1918*, ed. L.-C. Breunig, trans. S. Suleiman, New York, 1972, p. 403.

Landscape with Hagar and the Angel

Oil on canvas; 100 x 75 cm.

Galleria Nazionale, Palazzo Barberini, Rome

Unrecorded by any of the early sources, the *Landscape with Hagar and the Angel* was discovered and first published as recently as 1960.[1] Since that time it has been unanimously accepted as among Poussin's very last works, datable to the period of the *Four Seasons* in the Louvre of 1660–64. In style and mood it is particularly close to the *Deluge* [fig. 56] from the *Seasons*;

Fig. 56. Poussin, *Winter, or The Deluge*, 1660–64 (Musée du Louvre, Paris)

and, like all of these works, takes its theme from the Old Testament.

The subject is from *Genesis*, XVI, 71 ff. Hagar has conceived of a child by her master Abraham with the consent of his wife, Sarah, who had remained barren, and is subsequently banished to the wilderness by the jealous Sarah. Dying of thirst, she is suddenly delivered by an angel of the Lord appearing in the sky, who points her in the direction of a well. Poussin mirrors her miraculous deliverance by setting her in an arid and inhospitable landscape which moves from the craggy rocks and ominous clouds at the right to the verdant fields and sunlit sky on the opposite side, as though to symbolise in naturalistic terms the sudden shift in Hagar's fortunes.

Along with the *Sta Rita of Cascia* [No. 4], the picture is one of only two upright landscapes in Poussin's career. Though there is no evidence that the canvas has been cut, it is conceivable that it was left unfinished at the artist's death, for the paint surface appears particularly thin at the lower left.

Poussin had treated the story of Hagar in two earlier drawings,[2] but this is his only known canvas of the theme. The subject was popular among a number of his contemporaries, especially Claude, as a convenient means of uniting a biblical episode with a portrayal of landscape. Poussin's motivation in treating this theme may, however, go somewhat deeper than this. Towards the end of his life the artist was repeatedly drawn to the general subject of a pregnant woman, or a mother with a young child, imperilled by a journey through the wilderness. In addition to the *Hagar*, this forms the theme of Poussin's many late drawings on the obscure subject of the *Finding of Queen Zenobia*,[3] the 1658 *Flight into Egypt*,[4] and the episode of a mother struggling to save her child from the rising waters of the Flood in the Louvre *Deluge*. In the vulnerability of all of these innocent figures, whose fate is pitted against the inexorable forces of nature, Poussin expressed the pathos of the human condition at its most elemental. Although unrelated in theme, the late landscape drawing of two saints in the wilderness exhibited here [No. 58] likewise centres upon the notion of man returned to a state of nature, seeking succour or salvation in a world beyond human control.

Adding to the mystery and uncertainty of the *Hagar* are the bleak and sombre hues of the picture and the decentralised composition, which leads towards an unseen point at the left. Poussin repeatedly employs such unstable pictorial schemes in his last years, as though repudiating the symmetries – and certainties – of his works of the 1640s. Guided forward by the benevolent gesture of the angel, the helpless and expectant figure of Hagar appears to symbolise frail humanity, delivered from the wilderness by an act of grace from the Lord.

1. André Chastel, 'Un fragment inédit de Poussin?' *Actes du Colloque International Nicolas Poussin*, Paris, 1960, Vol. II, p. 239.

2. *CR* I, p. 3, No. B 3; V, pp. 63 f., No. 383.

3. *CR* II, pp. 16 ff., Nos. 131–33, A 34–36; IV, p. 48, No. 287; V, p. 96, No. 422. See also the late painting of this theme attributed to Poussin in the Hermitage (reproduced in *CR* II, Fig. 15).

4. Anthony Blunt, 'A newly discovered late work by Nicolas Poussin: "The Flight into Egypt",' *The Burlington Magazine*, CXXIV, 949, April 1982, pp. 208 ff.

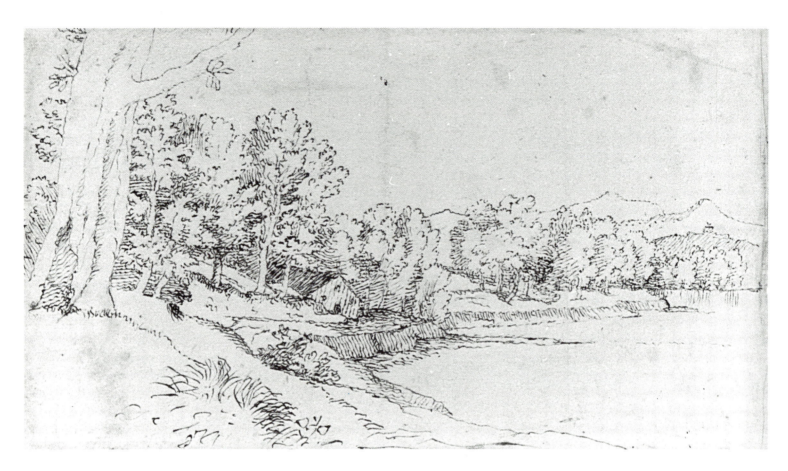

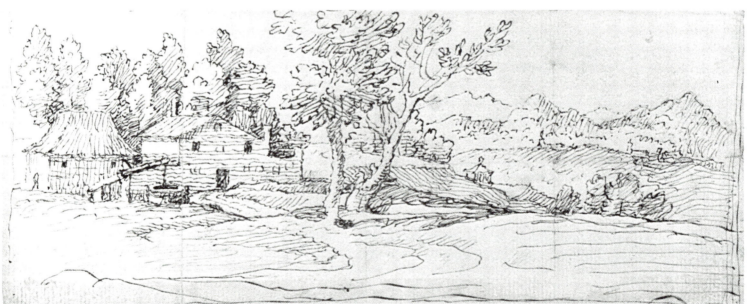

A River Bank

Pen and ink; 15.5 x 27 cm. (*CR* 288)

The Hermitage, Leningrad

57

Cottages among Trees

Pen and ink; 9.5 x 23 cm. (*CR* 289)

The Hermitage, Leningrad

These two drawings are Poussin's last surviving studies from nature and would appear to date from *c.* 1660. Executed with a series of parallel hatchings, they reveal a delicacy and fragility characteristic of the artist's last years. In both works the lines appear as though stitched into the paper and bear evident signs of the nervous tremor from which the aged Poussin suffered. As early as 1642, the artist complained in a letter to Cassiano dal Pozzo of his 'shaky hand'[1] – a disability which may have been the result of Parkinson's disease, which frequently arises from the infection Poussin had contracted around 1630.[2] The effects of this are particularly noticeable in the artist's last drawings, poignantly testifying to his statement to Chantelou of 2 August 1660:[3] 'I pass no day without sorrow and the trembling of my limbs increases with the years'.

Undeterred by his growing infirmity, Poussin appears to have made occasional excursions into the countryside even in his final years, seeking solace in nature, much as Cézanne would do at the end of his life. As the Hermitage drawings suggest, however, the aged Poussin was attracted to the most unprepossessing aspects of nature, rather than to its grandeur and majesty. There is no precedent among the artist's early landscape drawings for these two views of cottages, hills, and trees, which reveal Poussin immersing himself in scenes of mundane nature with a lyricism and humility characteristic of his late landscape paintings. Devoid of references to the classical past, the Hermitage drawings are also more bucolic in mood and relaxed in construction than Poussin's earlier landscape studies, though *Cottages among Trees* still employs that three-part division of the scene into buildings, trees, and mountains, which recalls the artist's imaginary landscape drawings of the 1640s [Nos. 25 and 28] – a broad scheme which Cézanne would also adopt, more than two centuries later, for his early *Railway Cutting* [fig. 29].

1. *Correspondance*, p. 168.
2. Doris Wild, *Nicolas Poussin, Leben, Werk, Exkurse, Katalog der Werke*, Zürich, 1980, Vol. I, p. 105.
3. *Correspondance*, p. 450.

Two Figures on a Wooded Hill

Pen and ink, and black chalk; 19.5 x 25.5 cm. (*CR* 291)

The Hermitage, Leningrad

A very late compositional study by the artist, this drawing may be intended to portray St Paul and St Anthony Abbot in the wilderness or the Temptation of Christ. A copy of a later stage of this same composition, which is squared for transfer, is in the Uffizi (*CR* A141). Otherwise, nothing is known of this project, the last and most visionary of Poussin's depictions of biblical figures in a landscape setting.

Nothing marks the change in Poussin's spiritual and creative development more than a comparison between the Hermitage drawing and the Windsor *St Mary of Egypt and St Zosimus* of c.1635–37 [No.7]. In the early work, the artist sets his hermit saints against an orderly screen of trees, which still seem arranged by the civilizing hand of man and permit one to escape into the distance. In the late drawing, however, the figures are seen against a dense and impenetrable view of mountains and trees which encroaches upon them from all sides, its untramelled energies vividly evoked by Poussin's fractured and unsteady lines. Adding to the primeval grandeur of the setting is the looming mountain peak beyond. Like the majestic silhouette of the Mont Sainte-Victoire, which it uncannily resembles, it appears to symbolise those elemental forces in nature to which all of existence must ultimately submit.

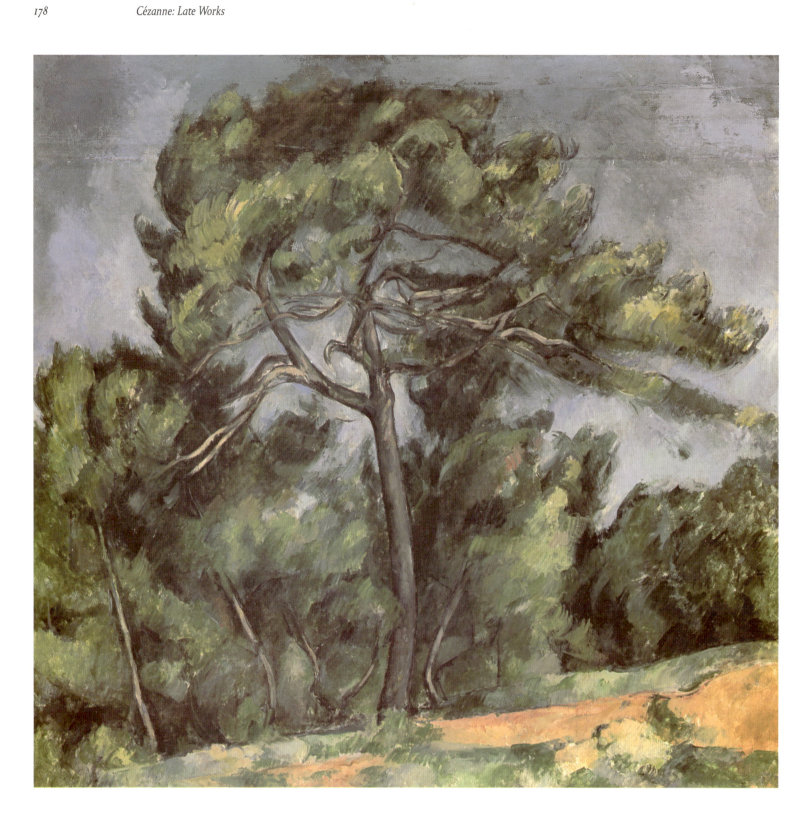

The Great Pine

Venturi 669

Oil on canvas; 84 x 92 cm.

Museu de Arte de São Paulo, São Paulo, Brazil

One of the most stirring and impassioned of Cézanne's mature landscape paintings, the *Great Pine* of 1892–95 portrays a group of trees which stood at the edge of the estate of the artist's sister and brother-in-law at Bellevue, south-west of Aix. Dominated by the dramatic motif of a large pine tree, its twisted branches defiantly unfurled against the sky, the picture reminds one of Cézanne's youthful love of the trees of his native countryside and remains one of his most personal creations. Though Cézanne painted a number of other canvases of solitary trees during these years, none appears so romantic in conception or so emotionally charged as the São Paulo painting.

Evidence of the uncontainable emotion which may have accompanied the gestation of this picture is the fact that Cézanne added two strips of canvas to the top as he went along. The first of these, 8 cm. high, includes the top of the tree; and the second, of 4.5 cm., the strip of sky which frames the scene. Although such additions to a canvas are known elsewhere in Cézanne's art [No. 37], they suggest in this case that the picture grew by stages as his own immersion in the subject increased and he strove to give it satisfactory visual form.

The motif itself anticipates a long sequence of works in Cézanne's later career which concern themselves with the most violent and destructive forces in nature. Though windswept pines are a common feature of the Provençal landscape – victims of the mistral, the fierce wind which sweeps through Provence from the north, often for days at a time – the São Paulo picture is Cézanne's supreme portrayal of this subject. In it, the artist appears to exult in the indomitable spirit of this solitary pine, which rises from the earth like some sole survivor of an earlier and more vigorous race, the smaller trees around it parting to make way for its thrusting upward growth.

The emotive nature of the subject cannot disguise the fact that it is portrayed with all the logic and simplicity of the *Pool at the Jas de Bouffan* of 1875–77 [No. 13] – a device which, in the end, serves to redouble its power. The tree is set squarely in the centre of the composition, its branches fanning out flatly against the sky, and framed below by a narrow band of earth. Like Poussin before him, Cézanne had no fear of the central axis. He knew what added grandeur it could bring to even the most heroic subject.

The *Great Pine* was among the pictures by Cézanne included in Vollard's pioneering exhibition of the artist's works in 1895. It was subsequently owned by Joachim Gasquet, the Provençal poet who befriended Cézanne in his later years and subsequently wrote a book on the artist, which affords a vivid – if not always reliable – account of his character and teachings.[1]

1. Joachim Gasquet, *Cézanne*, Paris, 1921.

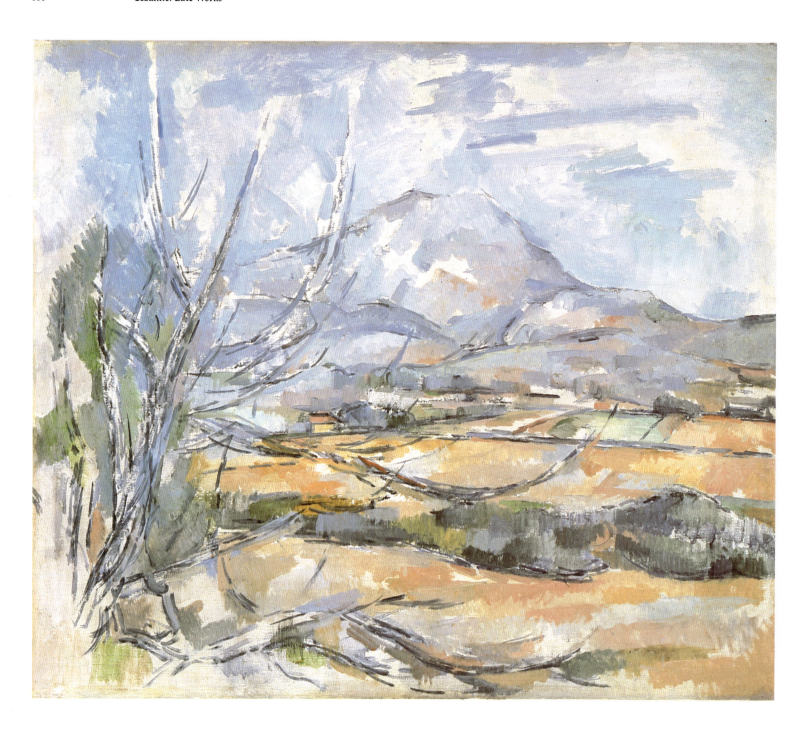

La Montagne Sainte-Victoire

Venturi 661

Oil on canvas; 54.6 x 64.8 cm.

The National Galleries of Scotland, Edinburgh

Cézanne painted more than a dozen views of the Mont Sainte-Victoire during the last decade of his career. A further six canvases of this subject are datable to the early 1890s. Unlike his works on this theme of the preceding decade, the majority of his late paintings present unobstructed views of the mountain, seen either from the Tholonet Road or from the studio at Les Lauves which the artist had built for him in 1902. The present, unfinished canvas is an exception to this rule. Showing the broad face of the mountain framed at the left by trees, it was most probably painted from a position to the south-west of Aix, overlooking the Valley of the Arc, like the canvases of 1885–87 from New York and Washington also exhibited here [Nos. 38 and 41].

The Edinburgh picture is executed with broad, fluid strokes of the brush laid upon a white ground. In its incomplete state, with areas of bare canvas visible throughout, the picture reveals the close relationship between Cézanne's oil painting and watercolour techniques at this stage of his career. With a few contour lines to guide him, the artist builds up the forms of the landscape through thin layers of pigment which enable the white ground beneath to show through, adding to the luminosity of the impression and endowing the picture with a lightness and transparency akin to that of Cézanne's watercolours.

Although the composition of the Edinburgh canvas recalls the heroic views of the Mont Sainte-Victoire framed by trees of the mid-1880s, the degree of integration between background and foreground exceeds that of Cézanne's earlier works on this theme. This is most immediately apparent in the curved branches of the trees in the centre of the picture, which form a mirror-image of the contour of the mountain itself and seem to beckon it forward.

Further strengthening this link are the areas of blue pigment which Cézanne has included at the bottom of the picture, which carry the hues of the mountain into the foreground landscape, linking space with surface. At the upper left, where the trees overlap with the mountain, cursive strokes of deep blue appear to indicate both the pattern of the branches and the contours of the hills beyond. Adding to the cohesion of the composition – even in its present and somewhat formative state – is a sequence of parallel horizontal accents which rise from the branches at the lower centre to the line of trees and houses in the middle of the valley and, eventually, to the mountain's base. Complementing these is a vertical area of greens and blues at the extreme left of the canvas which frames and contains the composition and unites the hues of the valley and mountain in the foreground of the picture.

The Edinburgh canvas has been variously dated to 1890–94 and 1900–02, a discrepancy which is partly explained by the picture's unfinished state. Although this would tend to suggest a later date, other aspects of the work are more in keeping with Cézanne's style of the 1890s. Among these are the broad, summary brushwork, which lacks the faceted effect of Cézanne's very last views of this motif, and the unbroken blues of the sky and (largely) of the mountain itself. In Cézanne's final treatments of this theme, these areas are typically intermingled with the hues of the land [No. 66].

A further argument for the earlier date is the viewpoint from which the artist painted the Edinburgh canvas. So far as we know, Cézanne never portrayed the Mont Sainte-Victoire across the Valley of the Arc during the last years of his career, whereas such views predominate in the 1880s and 1890s.

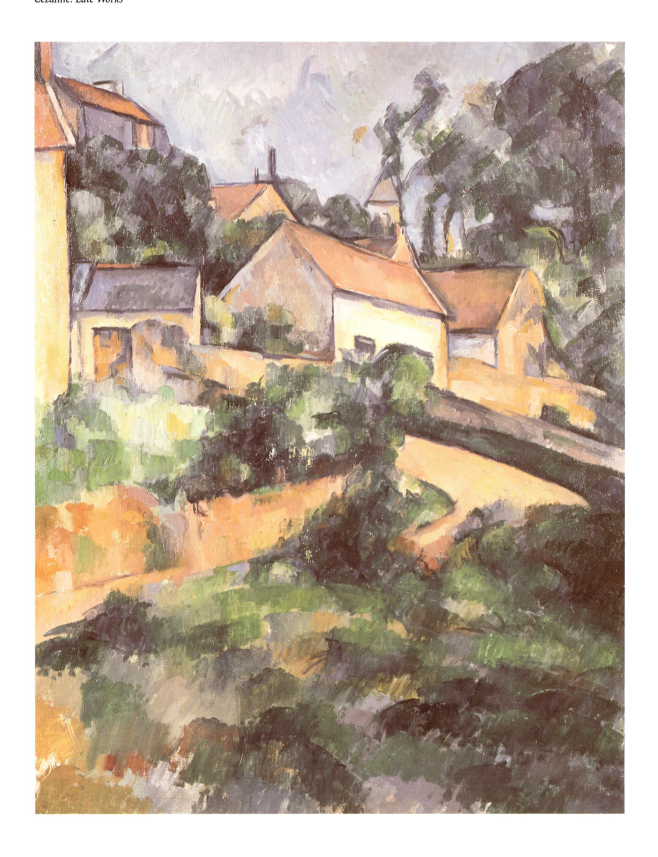

Bend in Road at Montgeroult

Venturi 668

Oil on canvas; 80 x 65 cm.

Mrs John Hay Whitney, New York

John Rewald has described this picture as 'one of the last important and completely finished landscapes that Cézanne painted in the North before more or less permanently retiring to Aix; its yellow-ocher tones and deep blue-greens, however, show a close relationship to many late works of the South, such as views of the Bibémus quarry and panoramas of Sainte-Victoire seen from Les Lauves'.[1]

Montgeroult is a little village outside Pontoise, to the north-west of Paris, where Cézanne worked during the summer of 1898, the date of this picture. Despite the success of his exhibition at Vollard's in 1895, Cézanne continued to seek seclusion during these years, seemingly unaware of the increased critical and commercial importance of his art and prey to every suspicion about his own worth. Two incidents which occurred during his stay at Montgeroult serve to illustrate this. Flattered by the attentions paid to him there by a young painter, Louis Le Bail, Cézanne agreed to work alongside him. When a young peasant girl stopped to look at both their canvases and pronounced Le Bail's superior, Cézanne was deeply wounded. Next day, on appearing to ignore Le Bail, the young painter asked him for an explanation, whereupon Cézanne replied: 'You should pity me; truth comes from the mouths of children'.[2]

In another incident of this same time, the two artists were greeted by two men on horseback while out painting. The ever-irritable Cézanne did not take kindly to this intrusion; and, only after dismissing them, discovered that one of them was Baron Denys Cochin, a collector and admirer of his own works. Distressed by his mistake, Cézanne enlisted Le Bail's assistance in correcting this blunder.[3]

Bend in Road at Montgeroult marks a transitional phase in Cézanne's career. The solidly geometric forms of the buildings at the upper part of the picture recall such severely architectonic landscapes of the mid-1880s as the views of Gardanne [No. 50 and fig. 50], though the freer brushwork and more varied colour which Cézanne introduces into this area indicate a later date. Combined with these vestiges of the artist's classical phase are the largely unformed passages of foliage and vegetation in the lower portion of the picture, which evoke the more animated and unpredictable forms of the natural world with a breadth and freedom characteristic of Cézanne's final years.

Between these two areas is the line of an ascending and turning road rendered in a style which unites both halves of the picture. At the lower left it is loosely painted in a series of greens and ochres which combine the colour of the buildings with the hues and handling of the land below. As it rises and bends upwards at the right, however, the road acquires the pure, local hues and decisive contours of the houses immediately above it. Setting the geometric against the organic, Cézanne succeeds in preserving the essential qualities of both of these areas without sacrificing the picture's unity – or continuity. Aiding him in this are the passages of foliage above the buildings, which mirror those of the foreground landscape. Moreover, in the blue-roofed house at the left and the side wall of the large, central building, areas of vegetation encroach upon the cubic forms of the architecture, as though gradually reclaiming them for nature – a preoccupation which becomes increasingly apparent in the art of Cézanne's final years.

1. *Cézanne, The Late Work*, ed. William Rubin, Museum of Modern Art, New York, 1977, p. 391.

2. John Rewald, *Cézanne, A biography*, London, 1986, p. 201.

3. *Letters*, p. 263.

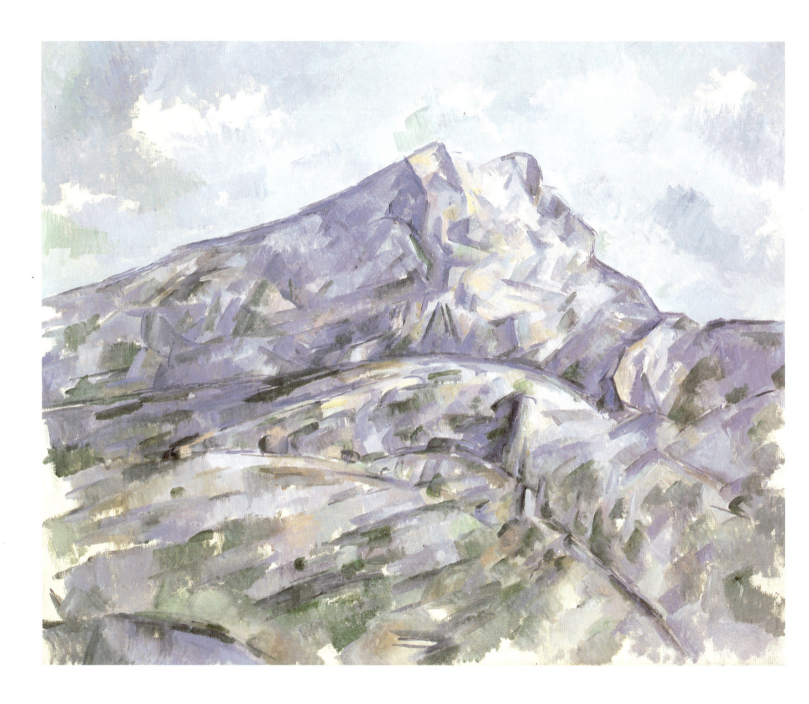

La Montagne Sainte-Victoire

Venturi 665

Oil on canvas; 65 x 81 cm.

Edsel and Eleanor Ford House,
Grosse Pointe Shores, Michigan

'Not since Moses has anyone seen a mountain so greatly', wrote the German poet, Rilke, of Cézanne's views of the Mont Sainte-Victoire.[1] Few of the artist's canvases provide a more impressive testimony to this than the picture from Ford House, one of the most tremendous of all Cézanne's portrayals of his favourite landscape subject. Painted at close range from a grove near the terrace of the Château Noir,[2] the spectacle of the mountain rising above the rocky hills which lie at its base is one of overwhelming majesty. Cut off from the land below, and largely devoid of vegetation, the profile of the mountain possesses a primeval grandeur which casts the mind back to those geological upheavals which originally shaped our planet. Enhancing the timelessness of the impression are the bold planes, of grey, blue, and green out of which Cézanne has hewn the form of the mountain. These endow it with an abstract and monolithic quality which transcends both time and place and locates it in a more symbolic realm.

The picture is datable to the second half of the 1890s and depicts a view of the Mont Sainte-Victoire which Cézanne repeated in five watercolours of c. 1900.[3] In no other oil of this subject, however, did the artist present so isolated and heroic a view of the mountain, or one so restricted in colour. As in the late landscapes of Poussin, the prevailing monochromaticism of this picture conveys an awe-inspiring impression of nature's original state – barren, rocky, and inchoate.

Though rarely reproduced and relatively little known, the Ford House picture, which passed from an English private collection to the heirs of the Ford family, ranks among the towering creations of Cézanne's final years. Even the great Cézanne scholar, Lionello Venturi, appears not to have known of the picture's whereabouts when he provided the following, memorable account of its dramatic power:[4]

'[It] shows what energy of representation, what depth of emotion, the artist found in nature and in the apparently decorative transformation of the natural motif. Here the mountain no longer closes off the broad valley: dominating the composition, its mighty bulk becomes almost menacing. The rocky mass is brought closer by the sketchiness of the foreground and the simplified forms of the rocks have the controlled tension of arrested movement. Again passion prevails over contemplation: the serene vision of the broad valley gives way to the cry of the pent-up forces of earth.'

The emotional intensity which Venturi detected in this picture is mirrored in certain of Cézanne's own moods during these years. In a letter to Joachim Gasquet of 3 April 1896, the aged artist reproached his youthful friend for appearing angry with him in what amounts to a cry of pain:[5]

'Could you see inside me, the man within, you would be so no longer. You don't see then to what a sad state I am reduced. Not master of myself, a man who does not exist – and it is you, who claim to be a philosopher, who would cause my final downfall? But I curse the Geffroys and the few characters who, for the sake of writing an article for fifty francs, have drawn the attention of the public to me. All my life I have worked to be able to earn my living, but I thought that one could do good painting without attracting attention to one's private life. Certainly, an artist wishes to raise himself intellectually as much as possible, but the man must remain obscure. The pleasure must be found in the work. If it had been given to me to realise my aim, I should have remained in my corner with the few studio companions, with whom we used to go out for a drink ... Anyway, I am as good as dead. You are young, and I can understand your wish to succeed. But for me, what is there left for me to do in my situation; only to sing small; and were it not that I am deeply in love with the landscape of my country, I should not be here.'

1. Rainer Maria Rilke, *Letters on Cézanne*, ed. Clara Rilke, New York, 1985, viii.

2. For a photograph of the motif see John Rewald, 'The Last Motifs at Aix', *Cézanne, The Late Work*, ed. William Rubin, Museum of Modern Art, New York, 1977, p. 89.

3. Rewald, Nos. 496–98, 500–01.

4. Lionello Venturi, *Cézanne*, Geneva, 1978, p. 149.

5. *Letters*, p. 245.

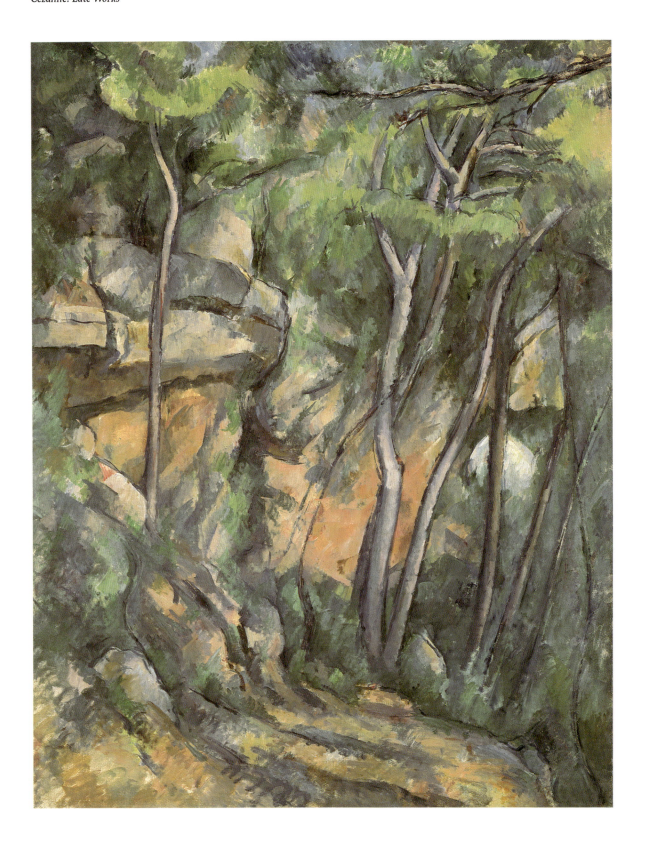

In the Park of the Château Noir

Venturi 779

Oil on canvas; 92 x 73 cm.

Collection Walter Guillaume,
Musée de l'Orangerie, Paris

In Cézanne's late years, he was increasingly drawn to motifs which revealed the unbridled force of nature – and, above all, its relentless powers of destruction and renewal. One of these was the Château Noir, an uninhabited estate on a wooded slope overlooking Aix, also known as the 'Château du Diable' because legend had it that it had been built by an alchemist in league with the devil. Cézanne painted five views of this house during the last years of his career, which show its crumbling façade concealed by dense foliage like some sinister relic of the ancient past gradually being devoured by nature.[1]

In the secluded park surrounding this house Cézanne discovered another subject which mirrored his own loneliness and isolation during these years. At least four views of this wild and inhospitable site survive from this period, among them the canvas in the Orangerie exhibited here, which dates from *c.*1898.[2] In certain of these – such as the well-known version of this theme in the National Gallery, London [fig. 14] – the artist confines himself to a monochromatic palette of greys, browns, and deep greens to convey the brooding power and mystery of the site, as though finding solace for his own dark moods in the oppressive grandeur of nature.

The picture in the Orangerie adopts a wider and more naturalistic palette of greens, browns, reds, and ochres and concerns itself instead with the ceaseless vitality of nature. Here Cézanne focuses upon a group of trees growing alongside a rocky ridge – a secluded and impenetrable site, untouched by man, where nature may pursue the elemental struggle for survival.

In the twisted trunks of the trees and the tangled patterns of their branches seen against a background of craggy rocks, the artist evokes the primeval power of the living world in all its harshness – and beauty.

In keeping with the greater emotionalism of Cézanne's art during these years, *In the Park of the Château Noir* is a densely wooded scene, broken only by a tiny patch of sky at the upper centre. In this respect it contrasts dramatically with the *Avenue at Chantilly* of ten years earlier [No.44], which portrays a more balanced and objective view of nature and appears more consciously composed. Rather than relying upon the formal devices of the 1880s, Cézanne unifies the Orangerie canvas through fractured strokes of green and ochre which evoke in themselves the formative powers of creation and remind us of Cézanne's own strength and fortitude at this late stage of his career.

The exultant mood of *In the Park of the Château Noir* is echoed in certain of Cézanne's letters of these years. On 21 July 1896, the artist wrote to Joachim Gasquet:[3]

'I commend myself to you and your kind remembrance so that the links which bind me to this old native soil, so vibrant, so austere, reflecting the light so as to make one screw up one's eyes and filling with magic the receptacle of our sensations, do not snap and detach me, so to speak, from the earth, whence I have imbibed so much even without knowing it.'

1. V. 667, 794–97.
2. V. 779–80, 787–88.
3. *Letters*, p. 250.

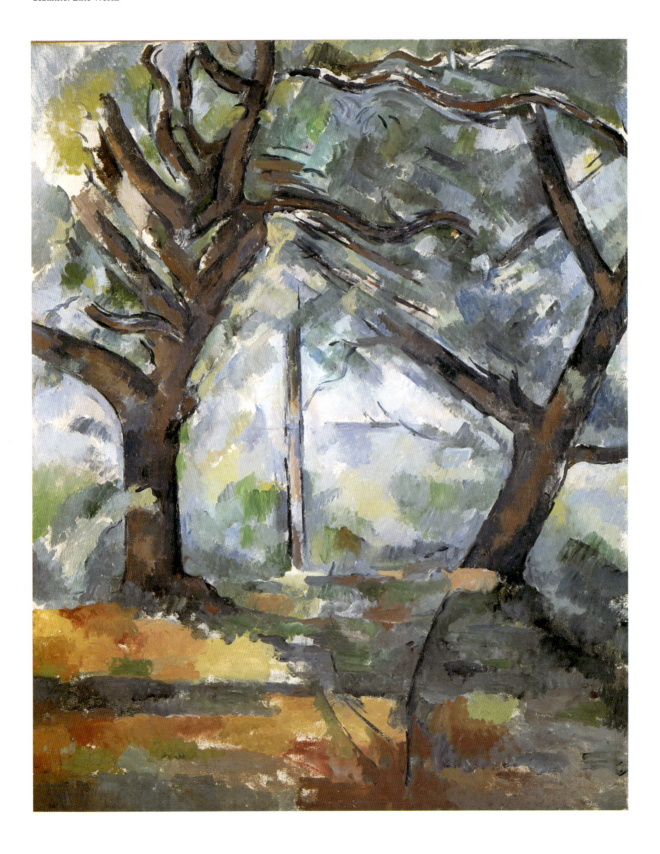

The Big Trees

Venturi 760

Oil on canvas; 81 x 65 cm.

The National Galleries of Scotland, Edinburgh

During the last decade of his career, Cézanne's choice of motifs tended towards two extremes. In one of these, exemplified by his many late views of the Mont Sainte-Victoire, the artist portrayed open and expansive scenes, whose freedom and spaciousness appeared to mirror his own states of exultation before the limitless domain of nature. In the other, Cézanne focused upon densely wooded scenes of wild, untrammelled growth, which seem to reflect his awareness of the regenerative powers of nature. The Edinburgh *Big Trees* of *c.* 1904 belongs to the latter category; and, along with Cézanne's many late views of the Park of the Château Noir [No. 63], testifies to the artist's preoccupation with the most dynamic forces in creation.

The canvas is dominated by the forms of two great trees whose muscular branches intertwine in the upper centre of the picture as though locked in some age-old struggle for survival. Mediating between them is the slender vertical of a third tree, which rises in the centre middle distance. Though the broad arrangement of the scene is symmetrical, Cézanne has avoided creating too static and balanced a composition by choosing as his protagonists two very different trees. One of these is upright, while the other rises from the earth in a dramatic diagonal, defying the laws of gravity to assert its presence in the scheme. The result is an image of dynamic equilibrium – of those antagonistic forces of growth and destruction which maintain the balance of nature.

The reconciliation of these opposing tendencies in nature finds its counterpart in the dynamic equilibrium of Cézanne's composition. In the upper half of the canvas, interest is sustained through the rhythmic patterns of the interlocking branches of the trees, painted in a restricted range of browns and greens. Paralleling their own energies at the base of the picture is a correspondingly wider range of colours, dominated by the reds, yellows, and ochres of the Provençal soil. At the lower left a diagonal area of multi-coloured brushstrokes, seemingly infinite in variety, mirrors the dynamic diagonals of the tree at the upper right. And, at the centre of the design, in the patch of land between the trees, all of these colour changes quicken and lighten to mark the fulcrum of the composition.

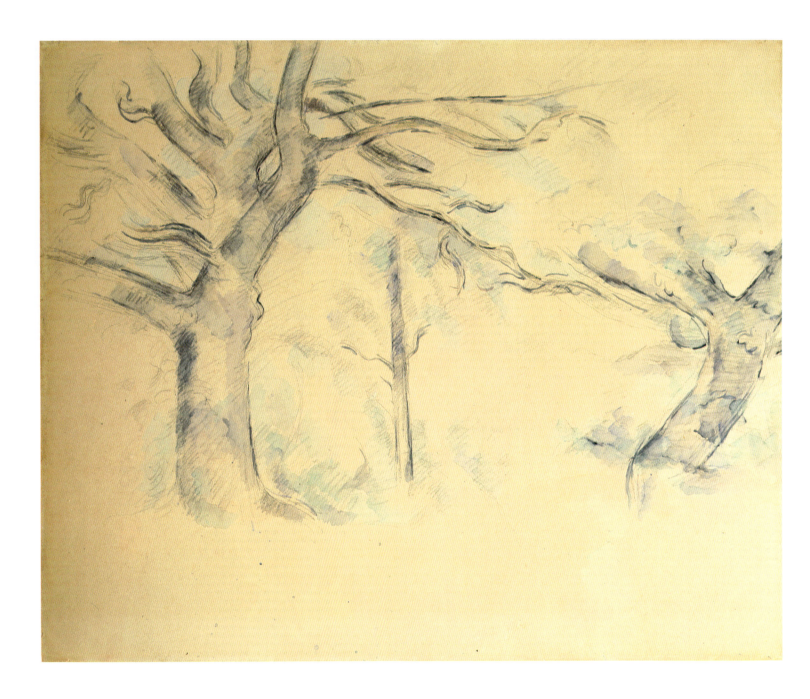

The Big Trees

Rewald 574

Pencil and watercolour on white paper; 47 x 58.5 cm.

Private Collection,
courtesy of Barbara Divver Fine Art Ltd, New York

This watercolour was presumably made as a preparatory study for the National Gallery of Scotland's *Big Trees* of *c.*1904 [No.64] and is somewhat more naturalistic in conception. This may be seen in the more intricate pattern of the branches on the tree at the left and the spindly branches which arise from the sapling in the middle distance. In the Edinburgh canvas, the latter appears devoid of subsidiary branches and resembles instead a telegraph pole, whose strict verticality mediates between the twisting trees to either side. But the most revealing differences appear in the tree at the right, which is brought closer to the centre of the composition in the finished picture in order to increase its active participation in the scene. Moreover, this strangely misshapen tree twists dramatically downwards in the watercolour at exactly that point where its trunk is 'suppressed' in the Edinburgh canvas. This suggests that it was located further forward in space than the tree at the left and that the alignment of their two trunks which Cézanne introduced into the Edinburgh picture was necessitated by a desire to maintain the compositional balance and equilibrium of the scene, making nature conform to the requirements of art.

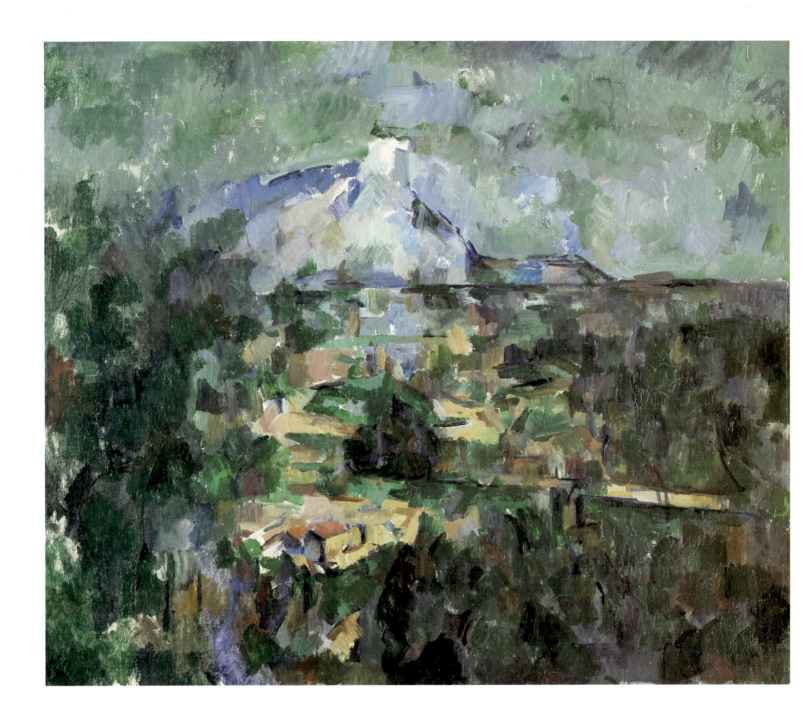

La Montagne Sainte-Victoire

Venturi 1529

Oil on canvas; 60 x 72 cm.

Oeffentliche Kunstsammlung Basel, Kunstmuseum

Cézanne painted more than a dozen views of the Mont Sainte-Victoire during the last six years of his career, the majority of them from the hill at Les Lauves where he had a studio from 1902. This viewpoint shows the most dramatic profile of the mountain, which rises to a sharp peak above the plain of Mont de Cengle [fig. 57]. In contrast, when seen

Fig. 57. Mont Sainte-Victoire seen from Les Lauves

from the south-west of the city, the site Cézanne preferred in the 1880s [Nos. 38–42], it appears as a broad and blunted cone crowning the valley beneath rather than rising into the sky.

This distinction is strikingly apparent in the magnificent version of this theme at Basel, which dates from 1904–06, in which the majestic form of the mountain floats weightlessly above the earth, separated from the edge of the plain below by a firm boundary line. To the left, a dense area of foliage provides the only obstruction in this otherwise unimpeded view, its deep greens setting off the ethereal blues of the mountain, which is ringed in the landscape below by darker, earthy tones encircling the extremities of the plain. Only in the centre of the canvas does Cézanne admit an area of lighter and brighter colours which form an inverted image of the mountain itself and serve to release it from the earth below. Enhancing this impression is a patch of bare canvas around the peak of the mountain, where its shimmering blues appear to be discharged into the vault of the heavens.

In isolated brushstrokes of unfathomable richness and complexity, Cézanne evokes the pulsing life of nature together with its limitless mystery. Increasingly awed by the world unfolded to his senses in his later years, the artist frequently refers in his letters to the difficulties he experienced in realising his sensations before nature. 'I cannot attain the intensity that is unfolded before my senses', he confessed to his son in September 1906, 'I have not the magnificent richness of colouring that animates nature'.[1] Later that same month, Cézanne declared to Bernard: 'I am in such a state of mental disturbance, I fear at moments that my frail reason may give way ... Will I ever attain the end for which I have striven so much and so long?'[2] One month after writing this, Cézanne was dead.

From another letter of these years it is apparent that Cézanne regarded this quest as a spiritual struggle – as a search, in short, for salvation. 'I am working doggedly, for I see the promised land before me', he declared to Vollard in January 1903, 'Shall I be like the great Hebrew leader or shall I be able to enter? ... I have made some progress. Why so late and with such difficulty? Is art really a priesthood that demands the pure in heart who must belong to it entirely?'[3]

Cézanne's late views of the Mont Sainte-Victoire embody his spiritual and emotional strivings of these years in a remarkable range of moods. Though his vantage-point upon this landmark of his native countryside may alter little during this period, his responses to it appear ever-changing. In certain of these works, it seems to express the artist's own inner strength and resolution, in others his deepest torments. But in the majority, among them the Basel picture, it appears to embody a mystical belief in the transcendent beauty of creation, justifying Rilke's assertion that Cézanne set himself before a landscape 'drawing religion from it'.[4]

1. *Letters*, p. 327.
2. *Ibid.*, p. 329.
3. *Ibid.*, pp. 293 f.
4. Rainer Maria Rilke, *Letters on Cézanne*, ed. Clara Rilke, New York, 1985, xxiii.

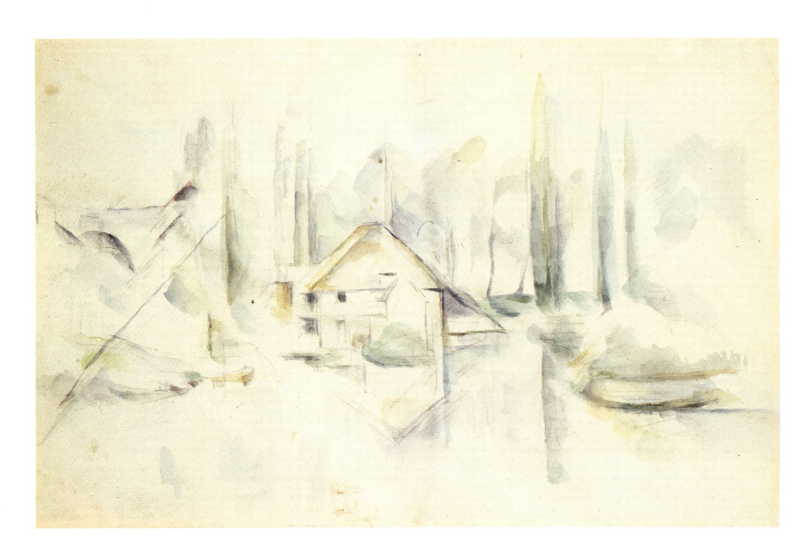

House beside the Water

Rewald 540

Pencil and watercolour on white paper;
29.8 x 46.4 cm.

Private Collection

The pellucid clarity of this watercolour results from the utter simplicity of its composition. The design centres upon a house surrounded by tall trees and viewed across a calm stretch of water. From the horizontal, vertical, and diagonal axes of this building Cézanne derives a system of parallels which permeate the entire sheet. At the left the inclined trunk of a tree, seen before the arc of a viaduct, aligns itself with the roof-top of the house; while, to either side of this building, a rhythmic screen of trees frames it. Reflected in the water below, these elements lose none of their poise or alignment. As a result, the sheet appears subdivided into a rhythmically intersecting sequence of verticals and horizontals linked by the diagonal lines of the roof-top and sloping tree. The delicate equilibrium achieved by this recalls that of Cézanne's *Lac d'Annecy* of 1896 in the Courtauld Institute Galleries [fig. 58], where trees, mountains, and buildings appear reflected in the surrounding lake to an almost prismatic effect, which creates a similar impression of nature in repose.

House beside the Water dates from c. 1898 and reveals the extent to which Cézanne retained an intuitively classical response to nature into his final years. Another version of the motif of c. 1888 (Rewald 410) is more informal in construction and naturalistic in handling and lacks the crystalline clarity of the work exhibited here.

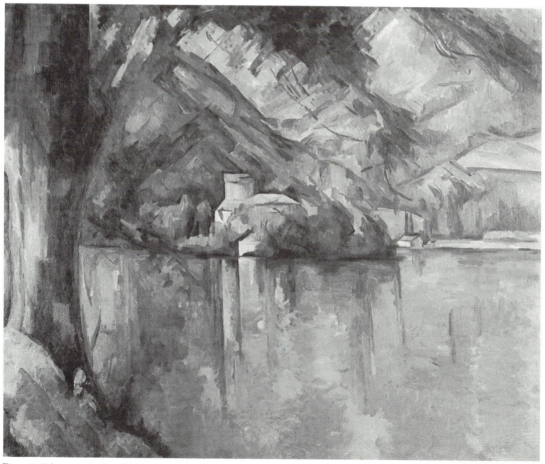

Fig. 58. Cézanne, *Le Lac d'Annecy*, 1896
(Courtauld Institute Galleries, London)

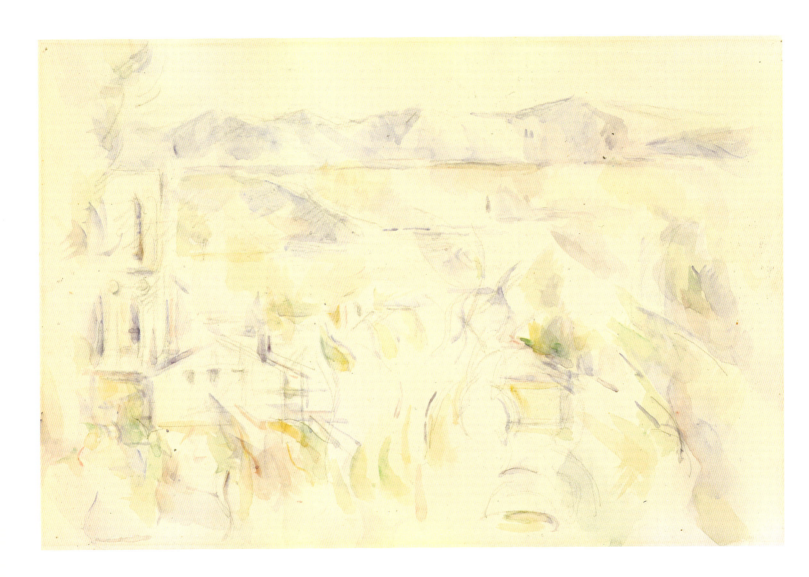

The Cathedral at Aix seen from Les Lauves

Rewald 581

Pencil and watercolour on white paper;
31.7 x 47.6 cm.

Philadelphia Museum of Art:
The Louise and Walter Arensberg Collection

The completion of Cézanne's studio on the hill at Les Lauves in 1902 afforded the artist with an opportunity to explore the surrounding area in search of new motifs, among them the dramatic views of the Mont Sainte-Victoire seen from Les Lauves to which he devoted so many oils and watercolours of these years [Nos. 66 and 69]. The present work depicts a panoramic view of the town of Aix seen from the vicinity of Cézanne's studio, with the tower of Saint-Sauveur at the left, and is one of a series of watercolours of 1902–06 devoted to this general view.[1] Somewhat surprisingly, Cézanne did not make any paintings of this subject.

With light, cursive strokes of green, blue, lavender, and yellow, Cézanne delineates the sweeping recession of the landscape and the intricate series of colour relationships which link all elements of the scene. Rhythmically applied over the entire sheet, these sparing touches of colour float over the page like some secret form of notation born of a lifetime's experience into the contiguities between things. Reaffirming the surface harmony of the composition at every point, Cézanne's freely rendered strokes of colour seem to inhabit a realm of pure relationships and remind one of a statement in his letters concerning another watercolour of these years. 'I started a watercolour in the style of those I did at Fontainebleau', Cézanne wrote to his son on 14 August 1906, 'it seems more harmonious, it is all a question of putting in as much inter-relation as possible'.[2]

Kurt Badt has observed of Cézanne's approach to colour in his late watercolours:[3]

'Cézanne's method of working differed greatly from that of the older masters, in whose compositions solids were so arranged and grouped that their outlines produced an impression of unity and integrity; different too from those who brought formally organized masses into a harmonious relationship with one another by means of particular colour combinations and colour contrasts, based on the colours of the objects themselves; different yet again from those who employed a unity of space or of lighting to carry the burden of a composition; in his compositions he created relationships of a type completely independent of objects, by means of a few patches of colour strewn over the surface of the picture and only loosely associated. It is true that his pictures were constructed with components taken from the real world; he did not, however, take these from the particular forms, colours, or outward appearances of individual things but from an analysis of their colour context in space.'

1. Cf. Rewald 580, 622 and 637.
2. *Letters*, p. 323.
3. Kurt Badt, *The Art of Cézanne*, trans. Sheila Ann Ogilvie, Berkeley and Los Angeles, 1965, p. 39.

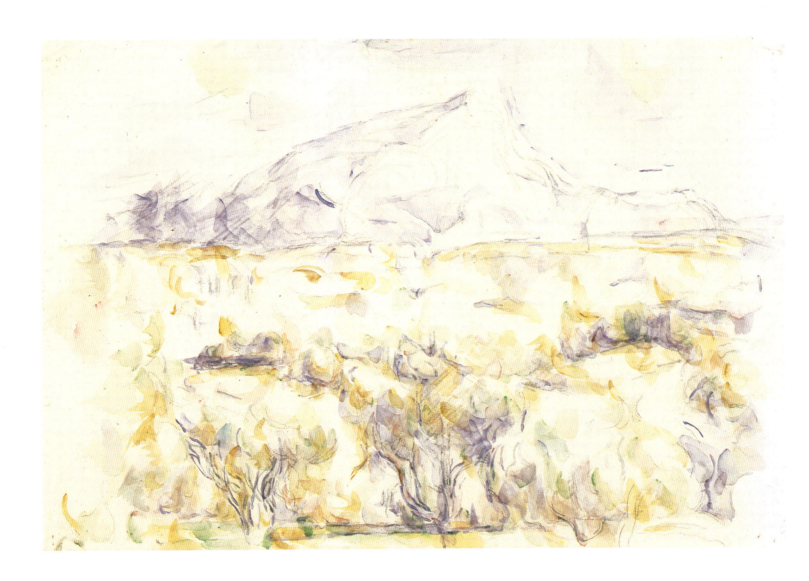

La Montagne Sainte-Victoire

Rewald 587

Pencil and watercolour on white paper;
36 x 55 cm.

The Tate Gallery, London

The Tate Gallery watercolour is one of twenty-eight views of the Mont Sainte-Victoire which Cézanne executed in this medium between *c*.1900–06, the majority of them done from the hill at Les Lauves, the site of the late painting from Basel exhibited here [No. 66]. From this vantage-point the artist enjoyed an uninterrupted view of the soaring peak of the mountain floating above the valley, like a distant mirage on the horizon. As so often in his watercolours of this theme, the Tate picture possesses a delicacy and lyricism seldom encountered in Cézanne's oils and vividly conveys the artist's exhilaration before his favourite landscape subject.

In myriad flame-like strokes of violet, blue, ochre, and green, Cézanne depicts the curling branches of the trees in the foreground reaching upwards, towards the mountain. Rising from a central tree at the base of the composition, these fan out to form an arc embracing the middle of the valley, which appears as a mirror-image of the contour of the mountain beyond, linking foreground with distance in a shimmering sequence of coloured touches. Through the rhythmic placement of these abbreviated strokes over the entire sheet, Cézanne also establishes the surface harmony of the composition with a purity and lucidity denied to him in oil. 'Water-colour was developed by Cézanne in a very new and personal way', observed Roger Fry in his classic study of the artist:[1]

'He recognized that this medium allows of certain reticences which are much less admissible in oil-painting. In that the smallest statement is definitive. The smallest touch tends to deny the surface of the canvas and to impose on the imagination a plane situated in the picture-space. In water-colour we never can lose the sense of the material, which is a wash upon the paper. The colour may stand for a plane in the picture-space, but it is only, as it were, by a tacit convention with the spectator that it does so. It never denies its actual existence on the surface of the paper. In oil, then, one is almost forced to unite together in an unbroken sequence all the separate statements of colour of the various planes. In water-colour the touches are indications rather than definite affirmations, so that the paper itself may serve as a connecting link between disparate touches of colour.

'Here, then, was a favourable condition for the necessity which Cézanne felt so strongly of discovering always in the appearances of nature an underlying principle of geometric harmony. On his sheet of paper he noted only here and there, at scattered points in his composition, those sequences of plane which were most significant of structure; here, part of the contour of a mountain; there, the relief of a wall, elsewhere part of the trunk of a tree or the general movement of a mass of foliage. He chose throughout the whole scene those pieces of modelling which became, as it were, the directing rhythmic phrases of the total plasticity. One might compare the synthesis which Cézanne thus sought for to the phenomenon of crystallization in a saturated solution. He indicated, according to this comparison, the nuclei whence the crystallization was destined to radiate throughout the solution.'

1. Roger Fry, *Cézanne, A study of his development*, London, 1932 (2nd ed.), pp. 63 f.

Selected Bibliography

NICOLAS POUSSIN

Kurt Badt, *Die Kunst des Nicolas Poussin*, Cologne, 1969. 2 vols.

Anthony Blunt, *Nicolas Poussin*, The A. W. Mellon Lectures in the Fine Arts, London, 1967. 2 vols.

Anthony Blunt, *The Paintings of Nicolas Poussin. A Critical Catalogue*, London, 1966.

Anthony Blunt, *The Drawings of Poussin*, New Haven and London, 1979.

Anthony Blunt, 'The Heroic and the Ideal Landscape in the Work of Nicolas Poussin', *Journal of the Warburg and Courtauld Institutes*, VII, 1944, pp. 154 ff.

National Gallery of Scotland, Edinburgh, *Poussin, Sacraments and Bacchanals, Paintings and drawings on sacred and profane themes by Nicolas Poussin, 1594-1665*, Edinburgh, 1981.

Félibien's Life of Poussin, ed. Claire Pace, London, 1981.

Walter Friedländer, *Nicolas Poussin, A new approach*, New York, 1966.

Walter Friedländer and Anthony Blunt, *The Drawings of Nicolas Poussin, Catalogue Raisonné*, Studies of the Warburg Institute V, London, 1939–74. 5 vols.

Centre Nationale de la recherche scientifique, Paris, *Actes du Colloque International Nicolas Poussin*, ed. André Chastel, Paris, 1960. 2 vols.

Musée du Louvre, Paris, *Exposition Nicolas Poussin*, Paris, 1960.

Correspondance de Nicolas Poussin, ed. Ch. Jouanny, Paris, 1911.

Villa Medici, Rome, *Nicolas Poussin, 1594-1665*, Rome, 1977.

Jacques Thuillier, *Tout l'œuvre peint de Poussin*, Paris, 1974.

Doris Wild, *Nicolas Poussin, Leben, Werk, Exkurse, Katalog der Werke*, Zürich, 1980. 2 vols.

Christopher Wright, *Poussin, Paintings. A Catalogue Raisonné*, London, 1985.

PAUL CÉZANNE

Kurt Badt, *The Art of Cézanne*, trans. Sheila Ann Ogilvie, Berkeley and Los Angeles, 1965.

Paul Cézanne, *Letters*, ed. John Rewald, 4th ed., Oxford, 1976.

Adrien Chappuis, *The Drawings of Paul Cézanne, A Catalogue Raisonné*, Greenwich, Conn. and London, 1973. 2 vols.

P. M. Doran (ed.), *Conversations avec Cézanne*, Paris, 1978.

Roger Fry, *Cézanne, A study of his development*, London, 1927.

Royal Academy of Arts, London, *Cézanne, The early years 1859-1872*, London, 1988.

Erle Loran, *Cézanne's Composition*, Berkeley, 1943.

Museum of Modern Art, New York, *Cézanne, The Late Work*, ed. William Rubin, New York, 1977.

Gaëtan Picon and Sandra Orienti, *Tout l'œuvre peint de Cézanne*, Paris, 1975.

John Rewald, *Cézanne, A biography*, London, 1986.

John Rewald, *Paul Cézanne: The Watercolours, A Catalogue Raisonné*, London and New York, 1983.

John Rewald, *Cézanne and America, Dealers, Collectors, Artists and Critics, 1891-1921*, London, 1989.

Meyer Schapiro, *Cézanne*, New York, 1965.

Richard Shiff, *Cézanne and the End of Impressionism*, Chicago and London, 1984.

Lionello Venturi, *Cézanne, son art, son œuvre, catalogue raisonné*, Paris, 1936. 2 vols.

Judith Wechsler (ed.), *Cézanne in Perspective*, Englewood Cliffs, New Jersey, 1975.

CÉZANNE AND THE OLD MASTERS

Klaus Berger, 'Poussin's style and the XIX century', *Gazette des beaux-arts*, I, 1955, pp. 161 ff.

Gertrude Berthold, *Cézanne und die alten Meister*, Stuttgart, 1958.

James Carpenter, 'Cézanne and Tradition', *The Art Bulletin*, 1951, pp. 174 ff.

André Chastel, 'Nicolas Poussin et l'art français', *Médecine de France*, No. 106, 1959, pp. 17 ff.

André Chastel, 'Poussin et la posterité', *Actes du Colloque International Nicolas Poussin*, Paris, 1960, I, pp. 297 ff.

Herbert Read, 'Cézanne and Classicism', *The Listener*, 6 January 1932, pp. 18 f.

Theodore Reff, 'Cézanne and Poussin', *Journal of the Warburg and Courtauld Institutes*, XXIII, 1960, pp. 150 ff.

Theodore Reff, 'Cézanne et Poussin', *Art de France*, 3, 1962, pp. 302 ff.

John Rewald, 'Cézanne au Louvre', *L'Amour de l'Art*, 1935, pp. 283 ff.

John Rewald, 'Sources d'Inspiration de Cézanne', *L'Amour de l'Art*, 1936, pp. 189 ff.

Robert Rey, *La Renaissance du sentiment classique dans la peinture française à la fin du XIXᵉ siècle*, Paris, 1931.

Daniel Catton Rich, 'Two Paintings revealing the Kinship of Poussin and Cézanne', *The Art News*, 20 December 1930, pp. 67 f.

Theodore Rousseau Jr., 'Cézanne as an old master', *Art News*, April 1952, pp. 28 ff.

Charles Sterling, 'Cézanne et les maîtres d'autrefois', *La Renaissance*, XIX, No. 5–6, May–June 1936, pp. 7 ff.

Katia Tsiakma, 'Cézanne's and Poussin's Nudes', *Art Journal*, 37 Winter 1977/78, pp. 120 ff.

List of Lenders

HER MAJESTY THE QUEEN 7
MR ERIC ESTORICK 16
GROSSE POINTE SHORES, Mich., Edsel and Eleanor Ford House 62
HOLKHAM HALL, Norfolk, The Rt. Hon. the Viscount Coke 27
NEW YORK, Mrs John Hay Whitney 61
NEW YORK, Private Collection, courtesy of Barbara Divver Fine Art Ltd 65
THE EARL OF PLYMOUTH (on loan to the National Museum of Wales, Cardiff) 18
PRIVATE COLLECTION (on loan to the Fitzwilliam Museum, Cambridge) 35
PRIVATE COLLECTION 67
SUDELEY, Glos., Sudeley Castle Trustees 24

AIX-EN-PROVENCE, Musée Granet 8
BASEL, Kunstmuseum 30, 47, 66
BERLIN, Gemäldegalerie Staatliche Museen 5
CAMBRIDGE, Mass., Fogg Art Museum 12
CARDIFF, National Museum of Wales 34
CHICAGO, Art Institute 42, 45
CLEVELAND, Ohio, Museum of Art, 46
EDINBURGH, National Galleries of Scotland 60, 64
FLORENCE, Gabinetto Disegni e Stampe degli Uffizi 26
FRANKFURT-AM-MAIN, Städelsches Kunstinstitut 49
GLASGOW, Burrell Collection 29
HELSINKI, Ateneumin Taidemuseo 37
LENINGRAD, Hermitage 25, 56, 57, 58
LIVERPOOL, Walker Art Gallery 19
LONDON, Courtauld Institute Galleries 52
LONDON, Dulwich Picture Gallery 4, 21
LONDON, National Gallery 1, 2, 20
LONDON, Tate Gallery 10, 69
MADRID, Museo del Prado 23
MONTPELLIER, Musée Fabre 6
MONTREAL, Museum of Fine Arts 3
NEW YORK, Metropolitan Museum of Art 38, 43
NEW YORK, Museum of Modern Art 50
OTTAWA, National Gallery of Canada 11
OTTERLO, Rijksmuseum Kröller-Müller 32
PARIS, Musée du Louvre 22
PARIS, Musée du Louvre, Département des Arts Graphiques 54
PARIS, Musée de l'Orangerie 63
PARIS, Musée d'Orsay 14
PARIS, Musée Picasso 36
PHILADELPHIA, Museum of Art 68
POUGHKEEPSIE, Vassar College 9
ROME, Galleria Nazionale, Palazzo Barberini 55
ROTTERDAM, Museum Boymans-van Beuningen 39, 48, 53
SÃO PAULO, Museu de Arte 59
SHEFFIELD, City Art Galleries 13
TOLEDO, Ohio, Museum of Art 44
TURIN, Biblioteca Reale 28
VIENNA, Graphische Sammlung Albertina 40
WASHINGTON, D.C., National Gallery of Art 33, 51
WASHINGTON, D.C., Phillips Collection 41
ZÜRICH, Kunsthaus 15, 17, 31